Social and Critical Practice in Art Education

Social and Critical Practice
in Art Education

Edited by Dennis Atkinson
and Paul Dash

Trentham Books
Stoke on Trent, UK and Sterling, USA

Trentham Books Limited
Westview House 22883 Quicksilver Drive
734 London Road Sterling
Oakhill VA 20166-2012
Stoke on Trent USA
Staffordshire
England ST4 5NP

First published 2005

British Library Cataloguing-in-Publication Data
A catalogue record for this book is available from the British Library

ISBN-13: 978-1-85856-311-4

Cover: *KOS: War of the Worlds*

Designed and typeset by Trentham Books Ltd and printed in Great Britain
by Henry Ling Ltd, Dorchester.

Contents

Contributors

Nicholas Addison is a lecturer in Art, Design and Museology at the Institute of Education, University of London and teaches on the PGCE, MA, EdD and PhD courses: he is Course Leader for the MA Art and Design in Education. For sixteen years he taught art and design and art history at a comprehensive school and a sixth form college in London. He has lectured in art history on BA courses and was Chair of the Association of Art Historians Schools Group (1998-2003). He co-edited, with Lesley Burgess, *Learning to Teach Art and Design in the Secondary School* (2000) and *Issues in Art and Design Teaching* (2003). His research interests include: critical studies, intercultural education, sexualities and identity politics. He has recently directed an AHRB funded research project, 'Art Critics and Art Historians in Schools'.

Dennis Atkinson is Senior Lecture at Goldsmiths University of London and Head of the MPhil/PhD Programme in the Department of Educational Studies. He taught for seventeen years in secondary school and was Head of Art for twelve years. He gained his PhD from the University of Southampton in 1988. He was the course leader for the PGCE Art and Design Secondary Course at Goldsmiths for ten years and still contributes to this programme. He is MA tutor for modules in *Visual Culture and Education, Culture, Pedagogy and Curriculum, and Contemporary Art, Identity and Education* which is taught in association with Tate Modern in London. His research interests include art and design in education and initial teacher education. He has a particular interest in employing hermeneutic, post-structural and psychoanalytic theory to explore the formation of pedagogised identities and practices within educational contexts. He is currently principal editor of *The International Journal of Art and Design Education* and has published regularly in academic journals since 1991. His recent book, *Art in Education: Identity and Practice*, is published by Kluwer Academic Publishers.

Sarnath Banerjee is a comic artist: he addresses issues through the graphic medium of comic imagery. His work explores relationships and issues of exclusion, both physical and psychological. He has initiated a scheme in the south Asian community of Tower Hamlets in east London which will see Bengali

women make comics about their lives and thoughts. He is developing a similar scheme among several ethnic minority communities in the Brixton area of south London. His first comic novel is forthcoming from Penguin.

Folami Bayode was born in London to Jamaican parents. She gained a BA Hons degree in embroidery textiles at Goldsmiths College, London, then worked as a freelance artist and designer. After training as an art teacher at Goldsmiths College in 1966 she has taught art and design in secondary schools across inner London. As head of department, she worked in collaboration with Goldsmiths PGCE course, mentoring beginning art teachers. She has written teaching packs, conducted INSET and workshops for galleries and museums and is advisor on the 198 Gallery Management Committee.

Lesley Burgess is a lecturer in Art, Design and Museology at the Institute of Education, University of London. She is Course Leader for the PGCE courses in Art and Design and teaches on both the MA Art and Design in Education and Museums and Galleries in Education courses. Before moving to the Institute she taught for 15 years in London comprehensive schools. She is a fellow of the Royal Society of Arts and a trustee of Camden Arts Centre. She co-edited *Learning to Teach Art and Design in the Secondary School* (2000) and *Issues in Art and Design Teaching* (2003). Her main research interests are curriculum development, issues of gender and Contemporary Art and Artists in Education. She has recently co-directed with the Victoria and Albert Museum a DfEE funded research project 'Creative Connections', which investigated the use of galleries and museums as a learning resource.

Paul Dash is a Lecturer in Education at Goldsmiths University of London and formerly worked at the Institute of Education, University of London. He taught in schools for 21 years before moving to the Institute. His research interests are in the area of art and design education and children of Caribbean origin. He has published research on this topic in a number of journals and his autobiographical work *Foreday Morning* is published by BlackAmber Books. As a practising painter, he has participated in a number of group exhibitions including the Summer Show at the Royal Academy in London and the Whitechapel Open in east London. He has a studio in east London.

Lucy Davies is the Director of 198 Gallery, Brixton, where she has worked since returning from Kingston, Jamaica where she taught art and contextual studies at Edna Manley College for the Visual and Performing Arts and developed her artistic practice. Born in Bristol she trained in painting at Slade School of Art, London and New York Studio School, USA. She gained a PGCE in Art and Design (secondary) at Goldsmiths College, before moving into gallery education. She developed the *Urban Vision* Progamme at 198 Gallery in 2000 in response to the needs of young people in the area.

Rob Fairley After studying at Edinburgh College of Art Rob moved to a small island on the west coast of Scotland where he lived alone for four years making work based on the land. After moving to the mainland in 1979 he undertook several residencies one of which in 1993, led to him being invited by Jackie Cameron and Tina Love, the two students who initiated the Room 13 project, to become their first artist in residence; he has been associated with the project ever since. His own work has been exhibited widely.

Viv Golding is lecturer in the Department of Museum Studies, University of Leicester. Her PhD focused on Multicultural Museum Education. Her research interests are concerned with challenging racism through forging creative partnerships with teachers, artists and museum collections. Her research is concerned with raising self-esteem, motivation and achievement in young people who experience high levels of social exclusion and she has published widely in this field.

John Johnston works with the Protestant communities in Belfast. Through the use of visual practices he has been working with young people in a variety of community sites to explore issues of identity, a difficult educational challenge given the history of Northern Ireland. He trained as a secondary school art teacher at Goldsmiths College and taught in London for six years. He has worked with young people in Lebanon, Romania and Zambia. He is Ireland representative on the education committee of the Euro-Mediterranean Human Rights Network. He represents Northern Ireland as an artist at the Venice Biennale 2005.

susan pui san lok is an artist and writer and is currently Research Associate in the Department of Film and Visual Culture at Middlesex University. Her work is concerned with notions of place, displacement, memory, authenticity, migration and translation. Recent and forthcoming projects include, 'Golden' (solo exhibition, Chinese Arts Centre, Manchester, 2005), 'Cruel/Loving Bodies' (Duolun Museum ofModern Art, Shanghai and 798 Gallery, Beijing, 2004), 'The Translator's Notes' (Café Gallery Projects, London, 2003), 'New Releases' (Gallery 4A and Art Gallery New South Wales, Australia, 2001), and 'Cities On The Move' (Hayward Gallery, London, 1999). Publications include articles and reviews for the journals *Third Text* and *parallax*. Contributions to books include, essays for *Discerning Translation: Vision Texts, and Contexts* and *Shades of Black: Assembling the Eighties*.

Deirdre Prins is a passionate educator, believing that education in particular heritage education can play a pivotal role in transforming the lives of individuals and communities in a real and effective way. She works with a new generation of heritage professionals who understand and believe in community development, and has trained museum educators from across Africa and published and presented numerous papers. She has degrees and diplomas in Education and

Training at both adult and secondary school level. She was a finalist in the prestigious South African National Shoprite/Checkers/SABC Women of the Year award in the category of Education in 2003 due to the impact the educational work of the Robben Island Museum. She is Vice President of the South African Museums Association.

Tim Rollins studied fine arts and art education at University of Me, The School of Visual Arts and New York University and worked as a special education art teacher with the Board of Education of the City of New York. In 1981 Rollins founded his after-school Art and Knowledge Workshop and the youth-based art making team KOS (for Kids of Survival) in the South Bronx. Rollins and KOS maintain working spaces and relationships with youth in the Chelsea section of Manhattan, San Francisco, Memphis, and now Philadelphia. Since 1985 Rollins and KOS have had over 90 solo exhibitions worldwide and have conducted over 60 intensive community-based art making workshops with youth internationally. Rollins received the Joseph Beuys Prize in 1990 and was recently given the Distinguished Achievement Award from the National Art Educators Association. Rollins has been Distinguished Visiting Professor at the Universities of California, Virginia. and Kansas and is Drexel Resident Professor of Art and Education at Drexel University in Philadelphia. He lives in the South Bronx.

Danielle Souness became involved in Room 13 in 2000. She has promoted the ethos of the studio in lectures and conferences throughout the UK and will present a paper at the IDEN conference in India. She was one of the three filmmakers who filmed and produced the critically acclaimed 'What Age Can You Start Being An Artist' for Channel 4 TV. Her own artwork is primarily in the form of textworks, which deal with some of the deeper philosophical problems of the age and she also has an interest in Internet art. She has been invited as artist in residence to the Museum of Modern Art (IMMA) in Dublin during the summer of 2005.

Introduction
Art in Education: critical and social practice

Dennis Atkinson and Paul Dash

This book explores innovative approaches to teaching and learning in selected sites of art education: the school art studio, museum and gallery education, community education and teacher education. A key pedagogical function is to provide inside insight into how art practice in such contexts can produce a rich and valuable form of social and critical enquiry. We are not arguing that this should be the only purpose of art in education but we do believe that art practices have an important part to play in developing pupils' social and critical understanding.

Considering art practice in educational sites such as schools engaging with social and critical practice means that the identities of teachers and learners and the nature of practice itself have to be conceived differently from more traditional understandings that apply to developing particular skills and techniques. We are certainly not advocating abandoning the traditions associated with art practice but we suggest that art in education as a form of social and critical practice requires a different approach to pedagogy and practice and thus a different pedagogical relationship. In practices such as painting, drawing, printmaking, collage, 3D construction, ceramics and so on, a major emphasis is upon the acquisition of skills through the manipulation of materials and tools, and a disciplining of perceptual-cognitive processes to produce particular visual outcomes. The teacher often demonstrates the skills to be acquired and guides pupils as they attempt to achieve them. In this traditional approach the teacher is considered to be 'the subject supposed to know.'

The pedagogical relationship in many of the chapters contained here is entirely different. The starting point is often the exploration of ideas and how they might be transformed into visual form. Thus the space of practice and enquiry is initially more open ended. The materials for practice are not

necessarily pre-determined but stem from the pupils' struggles to transpose their ideas into visual form. The relation of skills and techniques to formal outcomes is more uncertain and part of the teaching function is to support the pupil's quest to materialise ideas in visual form. The teacher becomes more bricoleur than deliverer of pre-selected skills and knowledge, as he or she responds to the different demands of pupils' enquiries. Obviously this constitutes a different learning and teaching environment than one in which outcomes are pre-determined towards specified practices, skills and techniques.

The notion of critical and social practice is not to be confused with earlier curriculum models of *Critical and Contextual Studies* in the UK (Thistlewood, 1990) or *Discipline Based Art Education* in the USA (Eisner, 1988). These models argued persuasively that school art education should not consist solely of practice but that all pupils should develop critical and contextual understanding of the work of artists, designers and craftspeople, which might take the form of historical, critical or aesthetic understanding. What this book is about is a fusion of the practical with the critical, whereby art practice is critical practice. So we do not prioritise the practical over the critical or vice versa. Rather we wish to posit a dialectical relationship in which practical and critical mutually inform the other, where critical ideas are given visual form and where visual form provides impetus for more refined critical practice, and so on. The old myth of art being concerned with the practical and not with the theoretical is banished because the practical and the critical are inseparable in this relationship.

Critical practice for educators

Art in education as critical and social practice has indirect but radical implications for implementing and renewing the systems within which teaching and learning take place. Through such practice it becomes possible to critique the social systems and structures by which it is spawned and thus constantly to survey and interrogate the boundaries of practice. Part of its pedagogical project for educators is therefore to consider their own work and what they are initiating with their pupils. This implies a more transient and contingent approach to curriculum planning and development than, for example, that demanded by the National Curriculum for Art in England. It is an approach in which the boundaries of practice and understanding practice are constantly being renegotiated.

Learners

A further concern of this book is the concept of the learner and the need to position them at the centre of the pedagogic project. Recent government policy in England for a centralised school curriculum to be 'delivered' to

pupils is based on a pedagogical model in which teachers are conceived as little more than operatives handing down a set of instructions and where pupils become surrogate identities of their teachers. Such a model, dominated by didactic practice, offers no space for trying to understand the different ways in which pupils act and learn, *their practices of learning*, and developing appropriate responses to meet this diversity. Assessment in the National Curriculum for Art in England or the GCSE assessment matrix, for example, is based on a one-size fits all model.

So while the subject matter under enquiry in an art curriculum concerned with social and critical practice produces a different approach to and understanding of practice, it also invokes a requirement to understand the different kinds of learning practices in which children and older students engage. This requires an empathy with the different logics of learning that structure students' learning practices.

Critical and social practice

The contributors to this book come from a wide range of backgrounds. Some are academics with expertise in linking theory and practice, while others speak largely from a position of engagement with practice. Several are based in clubs, one is in the school system and others are involved in community, museum or gallery education. Accordingly the feel of the book varies from chapter to chapter but each author is centrally concerned with encouraging learners to engage in art practice in order to negotiate an understanding of themselves, others and their social contexts. Developing a critical understanding of the diversity and disparity of social existence through art practice has become an important pedagogical project for art education in the early twenty-first century.

Daily we consume information and representations with which we associate and identify. We mostly do so uncritically, because such material frames our existence and forms an unquestioned part of our lives. A Hollywood cartoon series may seem like innocent fun for some, for example, but for others its treatment of the characters may demonstrate political bias that is at odds with the aspirations and self-image of people in the *Favelas* of Rio, say, or the front room of an African American family. Similarly the political and paramilitary murals that have a dominant presence within some communities in Belfast signify an accepted way of life for some while appearing to others as a malediction.

For so-called 'Western societies' their world is rapidly being reshaped by global communication systems and the possibilities for international travel. Equally, migration during the twentieth century has transformed populations to create diverse social contexts. Modern transportation is used to breach

borders 'illegally' and allow those who were once regarded as 'foreign' or 'other' to occupy 'our' living spaces. The other is now inside. One reaction to porous boundaries has been to protect the inside by constructing stronger boundaries such as the wall separating Israel from the Palestinians and the tightening of the boundary around the European trading community.

These social and cultural evolutions indicate that issues of identity, including those of self, other, community, group and nation, have become more complex and more significant. In educational contexts such issues cannot be ignored and indeed educational policies and practices have recently been implemented to develop pupils' understanding that different communities hold different values, customs and traditions. Such educational programmes are concerned that learning should not just be about developing awareness of other places and peoples but about coming to terms with who one is in relation to others.

Such critical reflection can be challenging and unsettling, particularly where it involves those in communities that have traditionally occupied positions of authority and privilege. Many of the chapters in this book engage with such issues by exploring, in visual terms, how particular social identifications are formed and how, if necessary, changes can be made in order to embrace a more equitable social reality. This might entail a consideration of how particular individuals, groups or communities become disenfranchised or marginalised within the dominant social order.

The approaches to pedagogy and learning taken by each contributor thus add to the critical debate about 'inclusion' in art and design education. This term is not straightforward. We need to ask what we mean by 'inclusion' and who is being included? By implication the term also implies the notion of exclusion. So who is being excluded and how or why? These are difficult questions to answer because it is not easy to perceive the boundaries that are established by promoting such policies.

The contributors to this book speak from their own experiences of practice, teaching and learning. Tim Rollins provides an account of the origins and subsequent development of *Kids Of Survival* (KOS), a community-based educational project that began in the Bronx, New York City in the early 1980s. Rollins began to work with disaffected high school students who had virtually abandoned their school education. The work illustrates how these young people were able to engage with social and personal issues through art practices, developing a method of visual practice that uses well-known novels as a starting point. Gradually their practice engendered greater self-awareness – although it was not plain sailing. The work produced by KOS has always adopted a critical perspective on social and cultural issues, as we see from the examples based on *Animal Farm* and *The War of the Worlds*.

John Johnston works in the problematic context of Belfast. His chapter is concerned with how art practices can be employed with young people to explore their identities as formed within the sectarian struggles in Northern Ireland. Johnston believes in the power of the visual as a way to encourage teenagers to confront and explore difficult social issues and the violence that surrounds them. Often working in adverse circumstances and under intense political surveillance, the teenagers are encouraged to look beyond the parameters that define their social existence towards a more tolerant and equitable social context.

In chapter three Dennis Atkinson takes a critical look at art education in English schools. Adopting the general critique of essentialist notions of subjectivity, he questions the idea of self-expression and associated conceptions of authenticity and originality that still underpin so much school art education. He associates a passionate attachment to these notions with a failure to mourn them and, consequently, the parameters of understanding practice that they impose. Although school art practices understandably tend to rely on the security of tradition, such traditions bear little relation to contemporary social realities or to ways in which art practice, the artist and the art work are currently being developed to respond to these realities. This creates difficulties. A key issue therefore is to consider ways in which art teachers and other educators can develop curriculum and assessment strategies which have sufficient reflexivity and criticality towards understanding how practice might be constituted and how learning might thus be effected.

As an antidote to Atkinson's critique, Henry Ward, head of art in a south London secondary school, describes how his students are adopting ways of developing art practices influenced by the work of contemporary artists. Ward's writing affords us a glimpse of the thinking of an art educator as he tests new ways of engaging children in contemporary art practice. His students investigate contemporary art work alongside play with materials, and explore issues that impact on their lives. This creates a stimulating three-way dialogue, some of the excitement of which is in seeking solutions to problems thrown up by the various avenues of enquiry. Ward's chapter allows us privileged access to some of the thinking inherent in his approach.

Danielle Souness and Rob Fairley give an account of the remarkable *Room 13*, a dynamic space for art practice at Caol Primary School in Fort William, Scotland. Here children are producing art work that has been acknowledged by leading critics and major contemporary art galleries. Starting with discussion of their ideas, the children, helped by adult facilitators, are producing art work that explores issues of personal and social identity, and work that takes the form of a critical analysis of events in the wider world. It is difficult for adults to comprehend that *Room 13* is run by the children themselves and that

they have secured generous funding and have given keynote talks at national conferences – as well as co-writing this chapter.

Working with younger children, Viv Golding describes gallery/museum educational practices in which the museum space is understood through the metaphor of a 'clearing' where identities of artefacts and objects are problematised. This generates reflection upon human identifications and how these have been formed historically by museums and galleries. Such practices allow children to develop their critical awareness of how we understand ourselves and others.

Chapter seven comes from South Africa, where Dierdre Prins manages the Robben Island Museum. She describes the work of the educators in the museum and some of the art-based projects they have initiated with children and older students. The main project discussed here concerns a mural produced to evoke the memory of Robben Island when it served as a brutal prison colony for political prisoners. Through their visual practices and discussions with former prisoners, students investigate the background and history of the island, with a view to understanding the past in relation to a possible future of democracy and equality.

Next, Folami Bayode and Lucy Davies, who work at the 198 Gallery in Brixton, South London, describe a project in which young offenders and students who are disaffected with their schooling come together to develop visual practices through which they explore issues of social awareness and self-identity. The project, *Urban Vision*, has been highly successful in helping young people to address their personal difficulties and to acquire the skills to proceed into further and higher education or secure forms of employment. Their work at this small south London gallery demonstrates the huge part such environments can play in providing secure spaces where vulnerable young people can find a voice. And the students make powerful statements which throw new light on what it means to be young and a member of a targeted community in the inner city.

Originally from India, Sarnath Banarjee has been working in London's East End, exploring issues of identity and conflict with its communities. His chapter consists largely of a visual/comic narrative. He has chosen a language of communication which enables him to address issues through the suggestive form and power of the visual to signal, yet leave undefined, statements and inferences that are completed by the spectator. In this unusual contribution to the book, Banerjee places the reader as voyeur in the life of a traveller whose Kafkaesque existence of travel and non-arrival seems endless, as he sits on the 36 bus in south London. His journey is as much metaphysical as physical. We are invited to conjure the inevitability of time passing and reflect on moments that illustrate the absurdity of human existence. Gesture and inference are the

foundation on which much of the material is built, the spread fingers trapping a sheet of paper, the coiled end of a rope, a noose echoed in the knotted tie of our narrator. The work is as precise and yet as open as a good poem that leaves you exploring each mark and gesture for meaning.

susan pui san lok is concerned with the notion of identity in relation to Chinese and English-Chinese identifications. She considers how certain contemporary artists use video, installations and other visual/textual media to explore how hybrid identities concerning people of Chinese origin are mythically represented in Western social contexts. lok's writing presents a powerful critique of the mythic representations of Chinese people as they are portrayed and consumed in the West. She touches on universal themes of subjugation, representation and exclusion through her interpretations of works of art. Running through her account is the theme of being Chinese and British in environments over which she has minimal leverage, apart from a creative voice and solidarity with others in the struggle for fullness. Her chapter is imbued with a clear view on our shared humanity.

Originally from Barbados, Paul Dash has taught in England in schools and Universities for the last four decades. His work has always sought to enfranchise the social status of Caribbean heritage children and students within a curriculum framework in which their histories and cultures have largely been marginalised or become invisible. His evocative chapter uses the metaphor of 'boundary' to discuss parameters through which understanding is made possible and to invoke the power relations that establish binaries of inclusion and exclusion. He argues that within a richly plural social context, difference must be accommodated within school curricula and that disparities must be ameliorated so that the curriculum becomes one in which all learners perceive they have a stake.

Turning to the context of initial teacher education in England, Nicholas Addison and Lesley Burgess examine the relationship between the school subject, art and design and the field of contemporary art. They investigate ways in which the dominant values of art within schooling support or contest the critical practices of many contemporary artists. They report their findings from a one-year artist-teacher PGCE programme in which students familiar with contemporary art and its critical edge undertake their teaching practice. They discuss the critical tensions that permeate the different identifications of 'artist' and 'teacher' as these coalesce and disturb the institutional context of school art education. The authors show how the critical stance of the artist-teacher can, when they work in partnership with other educators, form a crucial site of intervention in the school art curriculum so that art education can be developed as a form of social and critical enquiry for teachers and learners.

Thus the book draws on a variety of leading edge educational contexts. It provides practical accounts and theoretical discourses in which art practice functions as a powerful form of critical and social enquiry. Visual practice and theory are shown to be reciprocal once they become interrelated practices, engagement with visual practice develops critical understanding, and this in turn leads to further visual-critical engagements.

1

One's Joy in One's Labour

Tim Rollins

I t's high noon on September 12, 2001. Rick is here with me in our down-town studio on the ninth floor of an industrial building in New York's Chelsea neighborhood. Rick has worked with me and our youth arts collective *Kids Of Survival* (KOS) since he was thirteen years old. Today is his 30th birthday, of all days, and we are celebrating by being here together in our small but beautiful space facing the southern end of Manhattan. What was the World Trade Center yesterday is, now, a slo-mo tornado of Zinc White smoke. It looks like a cloud that fell to the ground sideways on its head, all wrong and unnatural.

During the last few days, KOS and I have been working furiously to complete a large new painting inspired by Shakespeare's 'cursed play' *Macbeth*. The studio floor is covered with studies, gossamer book pages of the best paper cut from beautiful bound editions of the play, all splattered with animal blood. Looking to our left, to the symbolic slaughterhouse floor and then to our right, out the large windows to the south, framed by the glistening Hudson River and all the sunlight, onto a real nightmare so manifest, the irony is sickening. And then the wind suddenly blows north ways, through our open window. There it is. That smell.

I know this smell from somewhere, sometime before. Can't immediately place it... this smell of something newly gone, dead and now rotting, an indelible odor. 'Rick, what is it?' He looks at me weary, worried and wise. 'Tim, don't you remember?' Yeah, I get it. This is what our neighborhood stank like each and every day back when we first met, when we first began.

We first began around 1981 when I was all of 25, born and raised in rural central Maine, five years in New York City and fresh out of art school in

Manhattan. Inspired by the likes of John Ruskin and William Morris, Marx of course, John Dewey and Jane Addams, Paulo Freire and Robert Coles, Conrad Atkinson and Joseph Kosuth, Bruno Munari and Joseph Beuys and, first and foremost, my childhood and still adulthood hero, the Rev Dr Martin Luther King, Jr, I had this crazy idea that education could serve as a kind of artistic medium – much like paint or sculptural material, with the potential of making a direct imprint on the happiness and progress of individuals and communities. So upon graduation from college I immediately took on the sado-masochistic act of electing to become a teacher for the New York Board of Education, working part-time in a citywide experimental arts program called *Learning to Read Through the Arts.* I possessed little experience in the classroom, but I was sufficiently naive, adventurous, competent, enthusiastic and arrogant to qualify. I also had a great sense of humor and would work for next to nothing.

Every day was a different site in a different neighborhood: Monday was Jamaica, Queens. Tuesday was the Lower East Side of Manhattan, then the heroin capital of the city. Wednesday had me in Bed-Stuy in Brooklyn. My favorite days were Thursdays in the South Bronx; the kids and the energy were phenomenal. I had Fridays off so I could be considered part-time and have no security or benefits of any kind, but that was all right because I was certain I would be a major art-star on my own in the next two or three years. I was mistaken.

On one of those great Thursday mornings in the South Bronx, I'm caught in action by George Gallego, a dynamic Puerto Rican American, the principal of a junior high called Intermediate School No. 52 on infamous Kelly Street. 'I want you for our school, full time.' I was hesitant to commit. First, I had done some teaching in the South Bronx and walking to and from the subway, white enough to get a moon burn, I found it all fascinating but often scary. Still, I was moved, curious and flattered. What did he see in me? I had the perfect plan. I agreed to work as a free-lance consultant for two weeks the beginning of the new school year. In this time I would develop a structured art program for the special education students, place the classes in the hands of the regular teaching staff and take my self congratulatory leave, no strings attached.

Gallego agreed... possibly knowing. I did not sleep one minute the night before my first day at 52. I was already conjuring intricate strategies for reaching the hearts, minds and souls of my new, temporary students. I was building a pedagogy both radical and grand. I was going to be Peter O'Toole in *Goodbye Mister Chips*; the white Sidney Poitier from *To Sir With Love.* I was going to be Anne Bancroft in *The Miracle Worker* and Glenn Ford in *The Blackboard Jungle*, and Sandy Dennis in *Up The Down Staircase*, and Jon Voight in *Conrack*

and Cicely Tyson in *The Marva Collins Story*, Edward James Olmos in *Stand By Me* and Morgan Freeman in *Lean On Me*. All at once.

On my first day in the crisp September air, I got to my first destination on the way to the school. It's a station on the number 2 subway train called Prospect Avenue. I can smell the place even before I get out of the train – a bad breeze over everything burned. Walking towards the school, everywhere are once-beautiful shells of buildings, now blackened, carbon. The wind blew through these hollows and they wheezed. On the broken sidewalks, moms were walking the youngest children to school.

Finally I get to Kelly Street, to 52, and enter the giant metal doors into – well, pandemonium. Kids running violently through the halls, lots of bells and alarms and shouting. I get to the main office to sign in with security and principal Gallego is beaming. 'You see, I told you he would show up!' (I think there was wagering going on on whether I would make it.) 'Let me take you to your room. It's great ! It even has a sink in it !' In my mind: 'Thank God I only signed on for two weeks.'

Up to room 318, and yes, there was a sink, but the problem was there was no drainage plumbing, just a pipe that emptied out into a large plastic bucket that had to be dumped at least three times a class. There were no windows – they had been knocked out months before and now were covered with raw unfinished sheets of plywood covered with pedestrian graffiti done in black marking pens. But the ceiling, at least 15 feet above the floor, was the best. On the ceiling was far more advanced graffiti tags, this time executed in charcoal. I had to ask. 'George, how the hell did the kids get up there to do all this writing?' Story had it that the boldest of the student artists, in the full but helpless presence of the previous, short-lived art teacher, taped large sticks of charcoal onto the ends of the long wooden poles used to pull open the high windows during the summer months and, in the manner of Matisse on his death bed, just started drawing on high. 'You know, George, if your kids are creative enough to think of this...' Gallego countered. 'You'll see.'

Ten minutes later the bell rings... and rings...and rings. I can hear a stampede up the hallway and a SLAM SLAM SLAM on my classroom's metal door. In they come ... fourteen thirteen year olds and I am immediately fresh meat. Using my whole two years of classroom experience at once, I put on my expressionless teacher face and ask only for the following. 'Using the paper and pencils I'm providing, I want you to make the best drawing you have ever made in your life in the next hour. No pressure.' Ten seconds silence. And then the entire group, without complaint, went to furious work.

I'm trying to stay calm throughout the class, but it's difficult. Here are kids who have been classified as learning disabled, emotionally handicapped,

academically at risk and – best yet – 'attention deficit disordered,' despite the fact that these same kids can play video games six hours straight without a bathroom break. And here are the very same students creating some of the most exciting, original, impassioned and vital drawings I've ever encountered.

At the end of the session, one of the students, Roberto (the alpha dog of the group) speaks up. 'Can I ask you a question ? We're good ain't we ?' I'm trying to be cool. 'You're all right.' 'Hell, no, we know we're good and you know it too because it's all over your face.' I confess. 'You're the best I've ever witnessed.' Roberto: 'Let me ask you another question. Are you gonna stay with us or are you gonna leave like all the rest?' I'm dodging. 'I'm only going to be here two weeks... that's the deal.' 'Would you stay?' And here I'm left speechless.

After the class I'm down to Gallego's office and there he is with a big grin in his big office chair. 'They're good, aren't they?' He's boasting and he deserves to. 'George, they are the best I've ever worked with. What's the deal?' 'Art is the only thing these kids have ever been good at, and we need someone here who appreciates that and can extend that talent into other arenas of their lives. You can do it. Will you stay?' Ouch. And what a terrific manipulator.

Then and there in that office on Kelly Street in the South Bronx in 1981 I said the one word that gets so many teachers, and artists, and activists and community organisers, and parents, and ... well, everyone into so much trouble. That word was 'yes.' And so I, and many of that original group, stayed, and some of us stay to this day, witnessing the transformation of a community through the power and life-force of art making.

Within two weeks after that 'yes' I was working with 100 special educational needs students every day using art as a means to knowledge. We promptly began reading classics of world literature in order to generate paintings that related the grand themes of these books to the grand themes of our living here and now. And in the beginning I find it odd but then maybe completely rational that KOS were so attracted and responsive to elements of English literature. Maybe it's the drama, the gothic intensity of so much of the writing and it's imagery that related to our lived reality in the South Bronx at the time; books like *Frankenstein* and *Dracula*, Orwell's 1984 and *Animal Farm*, Anna Sewell's *Black Beauty* and Bronte's *Wuthering Heights*, *Journal of the Plague Year* by Defoe (with so many loved ones in the shadow of AIDS), Carroll's *Through the Looking Glass* and, most recently, our new visual dialogues with Shakepeare and H.G. Wells.

Beginning at I.S. 52, my students and I eventually decided to break with the public school system to begin our own community based, after school studio called *The Art and Knowledge Workshop*. The group members knighted them-

selves KOS (for Kids of Survival) and in the last 23 years, art products made by the collective are in the permanent collections of over 65 public museums worldwide. Everything in the neighborhood has changed. 'That smell' exists only in memory.

Through our collective experience together, we've learned that through the transformative power of art, any negative experiences in life give weight, authenticity and credibility to positive effect. Through the restorative power of art, the often unspeakable joy of living and pressing on, no matter the circumstances, can be shared to inspire others. Art can be hope made manifest, vision made visible and determination made material.

Through our art, we survive – in the long run. In the here and now of what we do daily, we work to create neighborhood, communities, maybe someday nations where we can all rely on Ruskin's definition of creativity. Art is simply one's joy in one's labour.

One of my most influential philosophical and spiritual mentors, the great Paulo Freire, consistently warns educators against inventing and replicating an ossified pedagogy or teaching system that does not organically respond to the ever changing educational needs and social context of people and communities. In the two decades of working with youth from distressed neighbourhoods worldwide, KOS and I are witnesses to the wisdom of Freire. A method in the madness of collaborative art making, a pattern in the process, has started to emerge.

First, my students and I require genuine inspiration to begin work; not a fixed curriculum devised and handed down to us from on high by people who do not understand or know or truly care about us. We do not respond to assignments or specific commissions either. But without structure there is no freedom. Long ago, we decided to allow ourselves to be moved by works of literature and music judged to be above and beyond our comprehension, works that had been locked away in the closet of the classical canon, works that had often been taught to death, whereas our intention was to bring them to life, at least for ourselves and our immediate community.

We are often asked who chooses the text that we use to play with, to paint on, to learn from, to internalise, to honour and transcend? These inspirational texts are selected out of a collective intuition, responding to something direct and present in the air of our individual and community lives. One operating rule is that we work with another work unfamiliar to us.

Another direction is that there has to be a genuinely compelling *need* to make a new work of art. We never educate or produce work simply to sell or meet exhibition deadlines. Contrary to expectations to be childlike, we never make work 'just for the fun of it.' (We're not dour; we just all do our fun stuff outside

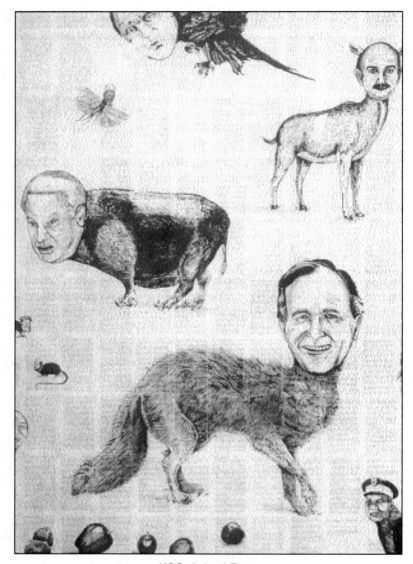

KOS: Animal Farm

the KOS studio). Resisting the politically correct expectations and restrictions produced by superficial notions of multiculturalism, identity politics and ethnic essentialism, we also seek literature or music that we aren't supposed to be particularly interested in. Black and Latino teenagers reading and painting on *The Scarlet Letter*, Kafka's *Amerika*? Oh, my God, the *Winterreise* song cycle by Schubert? We have learned that while it is essential to know where you come from, it's also essential to realise that you are not ONLY where you come from. You are where you are right now and, prophetic and most important, where you are going.

Our engagement with George Orwell's fable for adults, *Animal Farm*, was a response to several situations we found ourselves in. First, after making a series of highly abstract and conceptual paintings based on Melville's *Moby Dick*, Anna Sewell's *Black Beauty* and *The Autobiography of Malcom X*, members were asking, 'Isn't it time we prove to people that we can draw?' – a reasonable concern for talented young artists. Also, these were the mid 80s, the days of Ronald Reagan and Margaret Thatcher, P.W. Botha and Shamir, Gorbachov, Waldheim, Kohl, Mitterand and Haughey. We had another concrete reason to involve ourselves with Orwell's parable. I found that the kids' ignorance of world geography, global history, current poltical events and personalities deeply disturbing and belonging to those who choose to be victims and not creators of History.

After finding inspiration in a text, we then go through a collective process of research and development of ideas that will be manifested in works of art. We look for an affirmation of what we first intuit together. And we always look backwards too, in order to move forward. We always get an idea first, and then find the art history of that idea later before beginning making art.

Since many of the KOS members are chronically poor, or resistant, readers, I usually make my own *Books on Tape* by recording my own reading of the book. Now in audio and far more intelligible to the kids, we listen to Orwell's story while drawing and drafting ideas for our paintings.

The idea of referring to people as animals is not new to the group. At that time, that is what many teachers, administrators and the outside culture called poor kids from the South Bronx. A current television series starring Ed Asner as the principal of a Bronx public school, was actually titled *The Bronx Zoo*. We had many dialogues about how art has historically been used to inflate the powerful. Was it possible to do the reverse? To deflate elites? To ridicule power towards freedom? We began searching the art history of zoomorphic caricature: the pathos of Frida Kahlo's self-portrait as a wounded deer, the subordinating energy of Picabia's *Portrait of Cezanne* featuring a stuffed toy monkey, the satires of Posada and John Heartfield. We became especially excited on discovering the great cartoons and lithographs of 19th century French caricaturists Daumier, Traviers, Phillipon and – most influential – Grandville.

Our next step was to arrange an appointment with the curator of rare books at the New York Public Library, who allowed us to go through the original collected volumes of *Le Caricature* and *Charivari*, for example, encouragement and inspiration. In the library's picture collection, we scoured the files for photographs of current world leaders.

Back in the Bronx we talked often about the history and nature of political satire and the tendencies of political power, subjects never brought up during

the kids' regular school day. A group decision was made to depict world leaders as animals, taking visual cues from the physical appearance of each leader for maximum comic impact and effect. Using photocopies of faces and animal bodies, collages were made and then transparencies so that the caricatures could be projected and drawn onto a ground of book pages cut from copies of *Animal Farm* and glued in a grid onto stretched linen. The figures were painted in a monochromatic brown paint suggesting the colour of common earth and, even commoner, excrement. We wanted the painting to possess a calculated clumsiness – graffiti-like, artless without affecting the primitive. We all delighted in the making of these works.

As soon as the paintings left our studio, the impact of their reception was as educational as their production. Our painting of an Ecuadorian dictator as a braying donkey that we made for the Ecuadorian Biennial was impounded at the airport and censored from the exhibition. Phil Donohue, the host of a popular TV talk show at the time, featured our portrait of US Senator Jesse Helms as a barnyard dog on his show and invited us to debate with conservative congressmen and pundits on the air. Many art critics found the paintings too topical and crude and claimed that we had abandoned our 'capacity for beauty.' A national museum of modern art in Washington DC cancelled a planned exhibition of the *Animal Farm* works, fearing government reprisals. It was hilarious. Despite the negative reactions, the Washington exhibition did finally take place, to both the anger and delight of the Washington community. And a prominent London collector commissioned portraits of the G-3 and G-7 groups. The paintings are now in the permanent collection of the Tate Modern.

The newest KOS series began at the suggestion of Iranian-American KOS member Ala Ebtekar (now a fine arts graduate student at Stanford University) immediately after the events of 9/11. Intrigued simply by the title of H.G. Wells' science-fiction classic *The War of the Worlds*, our usual way of working commenced. While we had been considering communing with Wells for years – we were particularly attracted to *The Time Machine* – nothing visual emerged from our brainstorming and discussions. Returning to the 'Worlds' text, its themes had now become visceral and far more relevant: the fear of invasion by the impossibly alien, the perpetual cataclysmic clash between incompatible cultures, the aesthetics of terror. And then there were the questions; What forces determine how a nation is visually represented? Who conceives and designs the flag of a particular country? Why is the symbolism of these flags so often abstract, irrational and sometimes just plain bizarre? How can we react to the faddish and superficial notions of 'globalisation' currently so popular in the art world? What would total war look like?

Opposite: KOS: War of the Worlds

Well

...son... ha... t...

...early night, ...lo...le... fu...

...ught th... upp... ...us... nd
...permost... war...
...us. Di... y gr...
...llio... ...ined...rking tog... ...ey
in...rp... ...in... ...d...sting of c... ...ad...
...un... r encamp... ...ee sh... ...us...man...it...
of ...disturbed... ...dr... they...
...that... ...neede...
...t...gu... stru... I war...
...st... An... ...d wa...
...force... ...ard. Had th...
...ed... ...s at He... ...ly as a s...
th... ...e th... ...ando ma... ...eate...

...ty... ...ovince
...r an...ermina... ...o us... uck... ...ar
...g b... ...hedg... ...so... ...e dist... ...o
...gun. ...en ...te... ...h... th...
...us r...l his... ...char...
...th... ...e. The...owa... Stan...
...wer... ...das... ...oke... ...oa...
...on...

I wa... ...gu... ...e another
that... ...ona... scal... ...s us to
...d sta... d so a
...d r... big... ...ards
...at... ...ke...fir...
...e of... ...de...
...solita... ...a... ...m...
And the... ...ng ex... ...e siler.
restor... ...ne... ...ce.

Once again we ask art history for answers. We remember the crossed swords and lances from *The Battle of San Romano* by Uccello... and the same imagery in the battlescenes of dozens of popular films, from *Star Wars* and *Starship Troopers* to *Lord of the Rings* and *Troy*. We revisit the compositions of the Russian Constructivists: the mid-career paintings of Malevich, the brilliant, and still underrated, paintings of Popova, Goncharova and Stepanova, and the work of El Lizzisky, especially his print, *Use the Red Wedge to Beat the Whites*. The paintings of Barnett Newman and Jasper Johns are of use to us, along with the flag works of Faith Ringgold and David Hammons. And then there is Blinky Palermo's great series, *Homage to the People of New York City* that we just saw at the new Dia Center for the Arts. We recall Boetti's airplane paintings and colourful embroidered world maps. Our way was paved even by the album cover of a recording called *Hymnen* by Karlheinz Stockhausen, an audio collage made from fragments of national anthems worldwide.

Two years after Ala's initial suggestion, the entire group is researching, down-loading and digitally creating compositions of national flags cut into long stiletto-like spears and lances that will be projected and enlarged to be painted using mat-acrylic onto large canvases laminated with pages from the *War of the Worlds*. While clearly battle scenes between disunited nations, these paintings are ironically dynamic, exciting and visually spectacular in their rendering of the ultimate interdependency of nations, even if conflict is all they now have in common. The world, past and present, is our inspiration.

2

Art in Contentious Spaces

John Johnston

The Let's Talk Project in Northern Ireland

Let's Talk *is about young people. It is about the relationship between art, young people and contemporary society. It is about young people, art and politics and making art in contentious spaces.* Let's Talk *is about young people, human rights and human development...*

Let's Talk is a human rights education project that seeks to help young people understand more about issues of human rights and human development at local and global levels. The project is a partnership programme involving a variety of non- governmental organisations based in Northern and Southern Ireland as well as other areas of the UK and Aboriginal Australia. As project manager for Northern Ireland, and in particular East Belfast, it is my task to initiate and promote debate about such issues with young people from the Protestant/Loyalist community.

The project was born out of the current Northern Ireland peace process and originally aimed to bring young people's views on the future development of the process to the fore by engaging with the issues that continue to divide each party of the conflict. The concept was developed by 80:20 Educating and Acting for a Better World, a Dublin based NGO. Our Belfast office has been operational for just over one and half years and we have recently established a studio and gallery space within a local secondary high school.

Since introducing the programme we have faced challenges that are directly related to the conflict in Northern Ireland. The legacy of the conflict and in particular the issue of 'paramilitarism' has created a unique set of circumstances that continues to interrupt the lives of young people and their development as active and questioning citizens.

This chapter illustrates how the project has engaged with these challenges and, in doing so, has developed a variety of creative processes it has used to confront issues of identity, belonging and selective history. Presenting these methodologies highlights the role of art and imagination in the development of individual and community confidence in a context where confidence is extremely low.

Two distinct projects highlight the aims of our work. The first examines the process of developing individual confidence in order to recognise the self within the group. The second illustrates the difficulties of entering into a public dialogue about rights and responsibilities and how these relate to a community in transition.

Setting the context – East Belfast

Recently I was talking to a group of young men who have been involved in the *Let's Talk Project*. Aged between fourteen and sixteen, they live in the inner city districts that hug the edge of the eastern shore of Belfast's river Lagan. I asked them if they could imagine a future without paramilitary organisations and sectarian division. The group looked at me as if I had described something beyond their imagination and in unison they replied sharply: 'no'. I asked them if they could ever imagine forming friendships with contemporaries from a Catholic background. Again the answer was a firm, 'no.' The answers led to a discussion about why they could not begin to imagine such a future. Eventually it led to talk of school and how the public education system separates Catholic from Protestant and how this alone made it difficult to know 'the other side' let alone to form friendships. With regards to the para-militaries, the group saw them as heroes or icons, figures of respect and value. These young men are typical of a cohort of young people from both sides of the sectarian divide who live in a real world of division both physical and psychological.

The working class estates that encircle Belfast are testimony to the damage caused by thirty-five years of violent conflict. The prevailing image of the Northern Ireland troubles will be forever linked to the closed environments, working-class estates and back street ghettoes of Belfast. The neighbourhoods where these young people live have become the power base for a variety of groups who operate under the guise of Republican or Loyalist 'freedom-fighters'. Paramilitary imagery in the form of emblems and historical murals dominate the walls of these communities, each identifying with a particular group, a cause or a historical 'truth'.

The Loyalist estates are further divided between the two main paramilitary organisations that claim to represent the interests of the Protestant com-munity, the Ulster Volunteer Force (UVF) and the Ulster Defence Associa-

tion (UDA). The Peace process has left each of these armies with no war to fight. The absence of war has led breakaway leaders to set up their own private armies. In recent years tensions between these groups have resulted in a number of killings and mass evictions. These internecine conflicts are born out of a desire to control Loyalist areas and to raise capital from the illegal sale of alcohol, cigarettes and drugs. Young people who are particularly susceptible to the influence of those in power have become a primary target for such operations.

To belong to or at least be aligned with one of these groups is an important part of being able to survive on these estates. The added fascination of the group identity is of particular attraction to young men. This sense of the group identity is further reinforced by broader historical issues that serve to separate both communities in Northern Ireland: being Irish, or, in the case of Loyalism, being British. This 'Britishness' is, like all national identities, constructed on highly selective interpretations of nationhood. In this case of imperial power, a time of global dominance in which the loyal sons of Ulster

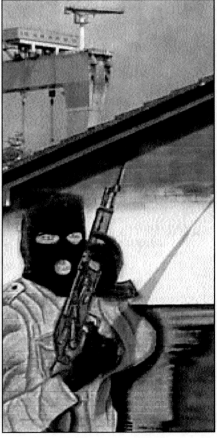

played a significant role. This sacrifice made on foreign battlefields cuts to the very heart of a people who believe that the motherland owes them a debt payable through the security of a Northern Ireland state free from foreign invasion or influence. The union flag dominates the skyline of the estates in Protestant Belfast and has become a symbol of defiance, a reminder to the 'other side' that their desire to remain British has not diminished.

The use of the national flag also symbolises a collective identity. It acts to

secure a belief that as a people they will prevail against the mounting external pressures to yield their position in favour of a more liberal European sense of identity. Such a move would lessen the difference between being British or Irish, a difference that remains the essence of the conflict. The peace agreement of Belfast has done little to ease the fears of the Loyalists and in many respects has served to fuel mistrust and deepen their feelings of exclusion. While Nationalists have accepted the accord, Unionists and in particular working class Loyalists, have seen the agreement as a step toward a united Ireland.

This has helped the paramilitaries to maintain a reason for their existence and offers the opportunity for young men in particular to take their place in order to defend their history and identity. The bond of defence has helped cultivate a collective identity that takes precedence over any notion of self. Additionally, the fear of loss has helped nurture a dependent culture, 'a need to stick together,' that feeds a desire in young people to belong. It provides security and helps develop confidence while offering a sense of duty and worth that reaches way beyond the importance of self. And all in one neat package.

The notion that identity can be packaged is hardly new, and neither is the way it provides an obvious attraction for young people who are in the midst of a natural struggle to recognise who they are. The pressure to assume a ready-made identity, with all its historical and cultural significance, is too great and tempts many to place themselves willingly in the box.

The work – 'Box Portraits'
Into this city of conflict I introduced a project originally designed for a youth programme in Eltham in London. The objective of the project is to challenge and question simplistic and holistic notions of identity that allow 'the group' to abuse its position. The concept of the box evolved out of series of discussions in which this shape was identified as a secure space, a private container where we can be ourselves.

A group of eleven young men and I began by discussing and recording the concept of 'belonging'. The work took place outside formal educational space and was processed by writing notes, making sketches and pasting cuttings into a sketchbook. The first few weeks of the programme followed the usual pattern of 'shadow boxing' common to situations in which relationships are uneasy and in need of construction. The group resorted to playing the role they felt represented them best in the company of their peers: tough, uncompromising, sexist, racist, sectarian and at times fairly violent. Meanwhile, in the background, the artwork slowly took shape. Working from flat pieces of scrap card, the group quickly built their individual boxes and prepared them

for stage two of the process. As objects, the boxes make imposing sculptures and their new presence helped the group develop confidence in their abilities to complete the tasks and in my capacity to help them realise their intentions.

Stage two of the process is exclusively about identifying with those images that are central to our perceived identity and therefore secure it. The surface of the box is used like a skin, as the individual collects and collates images relating to their personal interests, likes and influences. Influences are included for the first time but the concept of influence is re-visited throughout the process.

Drawings and photographs of the streets where the youths live began to surface. Street names and primary-sourced photographs merged with secondary images from magazines that would be common to most teenage boys. Football clubs, semi-naked girls, cars, motorcycles, jewellery and other desirable items were collected and collaged to form the skin of their portrait. Eventually the symbols of paramilitary organisations appeared and took their place alongside the others. When it came to constructing the final collage, these images took centre stage.

The subject of our conversations became more intense, as the group began to introduce me to family and friends through their work. The influence of family and environment became a recurring subject and was imaged in its turn through the collection of secondary and primary source photographs. We began to talk about places of importance and moments that helped shape their lives. A mural commemorating a dead boy appeared on one box and was soon adapted by the others. There was violent disagreement about the allegiances of the boy and to which paramilitary group he belonged, which eventually caused two boxes to be destroyed.

The discussions about family led to an exploration about what family means and to what extent our family shapes our identity. Again paramilitary images began to appear. I asked the group to be specific and to find out about their grandparents, collect photographs of uncles or aunts who are significant to them and to name these people symbolically in their work.

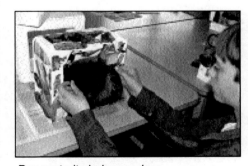

At this point a small but influential group began to distance themselves from the process. The group had been involved in the dispute over the dead boy. Clearly the project was going into a place beyond their comfort zone. They decided to disengage from going any deeper into the process. In-

Box portraits being made

stead they concerned themselves with the surface images in both conversation and action.

Eventually, we arrived at a point where placement had to be decided. How do you prioritise a life while recognising those who help to shape it? This question presented problems for the youths as it forced them to make judgements about the value systems by which they live. Each of the chosen images was transferred onto separate acetates and displayed, layer upon layer, in the interior of the box. This helped each individual recognise the complex nature of how influences are formed. The process of selection also made one youth explore his value and judgement systems to determine what is central and what is peripheral to who they are.

By week twelve the boxes were complete and ready for exhibition, a process that was integrated into the work. The youths decided to create an installation space so they could control the lighting and the environmental experience of the viewer. The boxes were suspended from a low ceiling, one in front of the other. To explain this positioning, the group said they wanted people to see them as individuals first and as a group second. To achieve this they were compelling their audience to change their point of view continuously in order to read the imagery. When the display was put in place everyone recognised the difficulty of seeing any single one of their images in isolation. To uncover the full story of each person, their box ultimately needed to be viewed as a three-dimensional object, studied while held in the hands.

The three young men who opted out of the project did not wish their work to be part of the exhibition. During the summer they were seen painting a large swastika on a wall in the school grounds. I have just begun to work with these three youths to develop a new project that will eventually result in the reworking of the swastika to create an image that challenges the intention of graffiti.

The Ballybeen Mural

In July 2003 the *Let's Talk* project completed its most challenging artwork to date. A wall mural measuring approximately eight metres by four was mounted on a wall situated in the heart of the Ballybeen estate. The painting on wood replaced an existing UDA/UFF mural. This was the first time such a project had been attempted on the estate and it required many months of negotiations with political representatives and community leaders who had links to the group. The entire process took ten months and raised some important issues that will dictate the success or failure of such initiatives in the future.

In September 2002 I was approached by an arts organisation and asked if I could use the skills of a visiting artist from El Salvador in East Belfast. The artist, Gilberto Arriaza, is known for his work with young people in San

Salvador who have been affected by the past war and continuing gang violence. It was an unusual request because this sort of collaboration is more common between Nationalist/Republican groups in Northern Ireland than Loyalists. After some negotiation a group of fifteen to seventeen year olds was formed to take part in the project.

Over one intensive week the group discussed, sketched, negotiated and agreed on a design that would reflect their vision for the future of East Belfast. After much debate they decided to place a large red hand at the centre of the composition. The choice of the red hand was to prove extremely controversial and provoked challenges between the intention of the project and the intention of the paramilitary groups who shadow the work that we do. Both of the main Loyalist paramilitary groups use the red hand as central image in their insignia. The UDA's military wing, the UFF, use a closed red fist, and the UVF the open red hand. The closed fist of the UFF symbolises the threat of violence carried by the group.

The young artists argued for some time over the use of the symbol and how the design should be employed within their mural, if at all. Significantly, it was the boys who argued for the inclusion of the symbol while the girls argued against it. Eventually a compromise led to a half open hand. For purely compositional reasons a map of Northern Ireland was placed in the centre of the hand. The completed mural was colourful and visually appealing, but although it was celebrated by the school it remained in storage for the best part of the following year.

It was not until July 2003 that I received a phone call telling me that the mural could go onto the wall originally designated by the UDA the previous September. But only if we decorated the space surrounding the mural with a number of flags. I was told that the inclusion of the flags would make the mural more palatable to a certain group in the UFF. The request was an understandable and highlighted the significance of the move by the UDA. So I agreed and began to prepare the wall for the mural work with five young people.

During that week I was approached again and asked to add a selection of text to the wall: words like *Justice*, *Peace*, *Security* and *Culture* should be integrated into the back-

The Ballybeen Mural

ground composition. Although the combination of words seemed appropriate, I couldn't agree to the request because it would have irretrievably politicised the mural. To prevent confrontation, I opted to disagree on aesthetic grounds, pointing out that the text would interfere with the visual reading of the painting. Throughout the week the pressure mounted for inclusion of further images and texts that would make the mural more acceptable to the paramilitaries. On each occasion I declined to carry out the changes, on grounds that the mural must remain intact as a painting.

On the day of the unveiling a number of conflicting interpretations of the symbolism within the picture became evident, most of them concerning the central image of the red hand and the map of Northern Ireland. A connection was made between the design and the physical struggle that young Loyalists would be prepared to embark upon if there is a future threat to Northern Ireland's constitution. One of the young artists disagreed with the interpretation and challenged the view publicly.

Such fundamental disagreements about symbols and images are characteristic of the Northern Ireland conflict. However, the public challenge is rare and was made possible by the fact that what was being debated had stemmed from a work of art. The experience underlined the difficulties in making public art that challenges the perceptions of those who end up having to live with it. The consequences of the challenge have since led to several difficult encounters. As yet the difference of opinion remains unresolved, but the work has served to open up a vital debate within communities far beyond that of a mere 'art work'.

Since that summer a number of new initiatives have been developed in East Belfast to change the image of Loyalist murals. The Ballybeen mural cannot take any credit for this, yet the change in policy is a clear indication that debate is now at least taking place.

From Belfast to Lebanon
In September 80:20 was asked to present workshops at the Euro-Mediterranean Human Rights summer school in Lebanon. While in Beirut I was asked to comment on a planned photo-pack being assembled to tell the story of life in the Palestinian camp of Shabra-chatilla. Before coming to any conclusions I was taken through the camp to see the conditions of life for its inhabitants.

Like most artists when they visit a school, I was drawn to view the artworks of the children that surround the classroom walls. On display could be seen the usual little drawings, common to primary school children, of stick-like men and women, plants and flowers and representations of family and friends. In the midst of the drawings I became aware of a number of small A5

posters. On closer examination I could see the face of a dead child, the head wrapped in white bandages and the eyes marked with congealed blood.

The image did not shock me, but the context did. Looking around the room, I saw other images of similar content juxtaposed between potato prints and crayon drawings. The innocence of the images disturbed me and as I took photographs of the children and their teachers at work I wondered about the impact of such imagery on the future development of the five year olds who sat in the room.

That night I recalled the imagery of Belfast, the guns and masked men I had been surrounded with as I grew up. The wall murals, the posters, the television reports and, of course, the terrible reality. I remembered seeing my sister wrapping the head of a young soldier in a white bed sheet in a vain attempt to stop the contents of his head falling on to the street after an IRA gunman had shot him. I also remembered how she was abused by her friends for comforting the young man in his final minutes. I tried to place each experience into some sort of creative equation, to use my training as an artist to see creativity where there was only destruction. The task was impossible – and so it should be.

The images of Shabra-chatilla and Belfast serve to remind us of the realities of our modern world. Art is not real. As a subject it is misunderstood and greatly underused. In my view art teachers and educators should not hide from the realities of life. The violence of war is no longer contained to the battlefields of a declared space. The potential for mass violence is on all our doorsteps. September 11 2001 has seen to that. The image of the twin towers burning was all too familiar to those who have witnessed the violence of the Serb bombardment of Sarajevo, the civil war in Lebanon and the mass genocide in Rwanda.

How then can art help us understand such events and prevent similar actions in the future? Quite simply – it cannot. Art could never be so arrogant as to claim that it holds the answer to such difficult worldwide problems. Nor need art try to find a solution. However, the actions of being creative are in direct opposition to those of being destructive. If art helps us understand who we really are it has made a significant contribution to helping us understand others and how their identities are constructed.

This recognition empowers us with the capacity to take command of our own lives and understand how our lives impact on others. Such awareness will challenge the power of those who wish to control the destiny of others, be it paramilitary or government. The young people of East Belfast have a long journey to make, but they can take heart from the knowledge that they share this journey with millions of their contemporaries around the world.

Acknowledgements

The *Let's Talk* project is coordinated by 80:20 Educating and Acting for a Better World, Bray, County Wicklow ROI and is funded by The Peace II European Programme for Peace and Reconciliation and The Joseph Rowntree Charitable Trust.

3

Approaching the Future in School Art education: Learning How to Swim

Dennis Atkinson

Introduction

It is interesting to observe how the increasing rate of social and technological change of recent decades has been accommodated by institutional structures such as schools. Western social contexts have become more plural; communications have become faster and, with the advent of cell phones, satellite TV and the internet, more ubiquitous and invasive. Computer technology has changed both work and home practices. The effect of such developments and the changing socio-economic order from older industrialised traditions to newer information and communication-based practices has been immense. Technological innovation, coupled with greater opportunities for communication, information and travel, has generated new and emerging social contexts and also social identities, although this is not the case in every part of the world.

The development of TV, video and digital technologies has spawned new visual media in which we engage and participate. Amongst the new forms of visuality is 'reality TV'. Hardly an evening goes by in the UK without programmes that are devoted to an aestheticising of the body (*10 Years Younger, Trinny and Suzannah*), the garden (*Ground Force* and countless others) and the home (*Changing Rooms* and others). These programmes point to a cultural phenomenon concerned with a fascination with identity in terms of the visual in ways that differ from earlier epochs. Such programmes have invaded our psyche, our social imaginary, in ways that precipitate new desires and new myths of identification to such an extent that demand for them seems insatiable. This fascination with the visual can be understood as an enchant-

ment with identity, with who we are, how we look, who we desire to be and how we appear to others. We have become bewitched by the image.

The new technologies of communication and information emerging in plural socio-cultural contexts suggests a highly complex social space in which boundaries and representations of identity are constantly shifting so that once reasonably stable essentialist myths of identity concerning ourselves, others, groups, communities or nations have been severely disrupted.

The challenge to essentialist notions of identity is well established in social and cultural theory. Generally speaking the idea of an originary and auto-nomous individual is discarded in theories stemming from Marx which posit the subject as a production of historical and material processes. Freud's intro-duction of the unconscious in psychoanalysis made it impossible to think only in terms of an essential conscious self. In the field of semiotics Peirce and then Saussure and others disrupted the essentialism of the relationship between language and meaning.

This chapter considers the implications of this problematising of identity and meaning for school art education. In the English National Curriculum for art the practices and discourses within which the identities of teachers and learners are produced tend to reproduce essentialist myths relating to the self and expression.

Contemporary art practices

The effects of new technologies, ways of understanding identity and in-creasingly plural social contexts have engaged the interest of artists. Many contemporary artists[1] are concerned with the notion of identification and processes of human interaction. Their work might be seen as a form of critical engagement with developing social contexts, as is the work of many current social and cultural theorists or novelists, for example. Nicholas Bourriaud (1998: 27-28) provides a brief historical overview of paradigms of art practice that helps to situate the focus of much contemporary art. He describes three epochs of practice. In the first, 'artworks were situated in a transcendent world,' where art was a means of communicating with 'the deity' and revealed 'divine designs' by exploring and understanding nature. Gradually aban-doning this enterprise, artists explored the 'relations existing between Man (sic) and the world'. From the Renaissance on new visualities produced by visual techniques such as linear perspective allowed artists to explore the relationship between human beings and their world. Underpinning such rela-tions was a view of time and space consistent with the physics of Newton. With the advent of cubism this relationship was made more problematic as it imbued fragmented notions of time and space, and thus experience, more consistent with emerging ideas on relativity and phenomenology. Today, Bourriaud argues,

Artistic practice is now focused upon the sphere of human relations ... so the artist sets his sights more and more clearly on the relations that his work will create among his public, and on the inventions of models of sociability. (p.28)

He is referring to current art practices that consist of collaborations, meetings, encounters, events 'in a word all manner of encounter and relational invention (p.28),' which are now art practices and considered as such. The temporality and space of such practice is radically different from paintings and sculptures. Traditional conceptions of artist, work and spectator are thus disrupted, the most obvious form being 'the performance'. Many artists are concerned with exploring social and cultural identities and use a wide range of media to do this including video, installation, performance, the internet as well as more traditional media such as drawing and painting. Such work confronts issues concerned with race, gender and sexuality; it challenges stereotypes, the ways in which social relations are played out and how subjectivities are formed. It is thus constantly challenging the boundaries (myths) of social identification including the boundaries (myths) of art practice itself, how we understand such practice and also the artist. In making such challenges this kind of art practice opens up new possibilities for understanding ourselves and others and this includes how we understand art practice. Much of this work is concerned therefore with social critique, with the politics as well as the possibilities of identity. It abandons more essentialist notions of authenticity, originality and the self by illustrating their uncertain and shifting ground.

School art education in the UK: conservation and practice

We have seen that the work of contemporary artists deals with issues of social identities and human inter-relationships, ranging from everyday practices to global political issues. Artists are engaging with issues, experiences and realities of their time. They are constantly redefining art practice as well as how we understand the art work and the artist. When we turn to art education in schools we find a rather different picture of practice. The systemic character of the art curriculum is essentially conservative; understandably so in that its practice is distilled from traditions of practice and knowledge which are valued and which form a secure source on which to establish curriculum content. Thus traditional practices such as drawing and painting from observation, imitations or pastiches of past movements such as cubism, surrealism or pop art, or pastiches of the work of particular artists (favourites being 20th century modernists) or of other cultural traditions ('aboriginal' art, American Indian art and so on), collage, printmaking, ceramics and to a lesser extent 3D construction, tend to form the bedrock of the art curriculum in many secondary schools.

These art practices and their attendant skills and techniques provide a stable basis for pedagogy and assessment. They provide teachers with a secure knowledge and skill base from which to teach and so facilitate their pupils' learning and to identify and position the pupils' abilities. They subscribe to a particular modernist understanding of practice, the art object and the artist. Such practices and knowledges constitute what Foucault (1977) termed practices of normalisation within which pupils, and teachers, become formed, disciplined, and regulated as pedagogised subjects (see Atkinson, 2002). Current inspection regimes such as Ofsted apply constant pressure on teachers to ensure that their practice conforms to the requirement of the National Curriculum for Art whose text assumes a notion of art practice and artist that is rooted in modernist conceptions of the individual.

Examination league tables and concerned Head teachers exert even more pressure for good results, so many teachers feel a need to play safe. Steers (2003:24) points this out, refering to Eisner (1985:367) and his concern about the stifling effect of testing and standardisation upon teaching and learning. Over the last decade the dominant methodology of the GCSE and A level examinations, whereby students investigate and develop an initial idea through to a final outcome, illustrates bleakly that school art practice has in many schools become formulaic (see Hardy, 2003; Binch, 1994:124). The methodology constitutes the parameters through which art practice is understood as practice; in effect it produces a particular caricature of practice.

The general picture therefore painted by many, though not all, writers on school art education is of an insular practice largely detached from the wider social world of current art practices. However this certainly is not a universal state. Some school art departments which are informed by more contemporary debates and practices are questioning the boundaries of practice. Generally speaking though, the dominant understandings of practice, the art object and the artist that pervade the school art curriculum presuppose a notion of cultural reproduction. But this is not a simple mechanistic process. The power evoked by particular traditions of practice involves a moral dimension in the sense that in order to 'acquit oneself effectively' a particular kind of performance is required. This in turn establishes particular desires for practice and particular subjects of practice.

A melancholic subject

A second feature of the school art curriculum that exerts a powerful but elusive aura when coupled with modernist understandings of practice, object and artist and thus produces a diffuse melancholic effect on the curriculum, is the powerful notion of 'self-expression.' Behind this term lies a particular, humanist notion of the human subject that has a long provenance in aesthetic discourses, along with associated notions of authenticity, originality, unique-

ness and the creative individual. Such discourse is centred upon the figure of an autonomous self, able to express an inner identity, an inner self of feeling/ emotion/idea through the art medium to be encoded in the art work. Similarly the process of interpreting the work of other artists is a matter of getting in touch with or revealing the meaning of the work deposited there by the artist. This notion is therefore deeply embedded and is frequently used to justify the purpose of art education in schools. But why or how has it become so en- trenched? It is almost as though this conception has become synonymous with art practice itself so that it cannot be relinquished.

One way of thinking about this passionate attachment to the elusive aura of self-expression is to consider it in relation to the Freudian concepts of mourn- ing and melancholia. Freud calls the psychic process identified with the difficulty of relinquishing the past, and the failure to mourn lost objects or ideals and therefore to preserve them as 'passionate attachments' melancholia (see Freud, 1953-74). Butler (1996) develops Freud's work to show how this psychic process is important to the forming of a reflexive conscience in which the power of social norms is dissimulated within the psyche. For Butler (1996) melancholia

> describes a process by which an originally external object is lost, or an ideal is lost, and the refusal to break the attachment to such an object or ideal leads to the withdrawal of the object into the ego, the replacement of the object by the ego, and the setting up of an inner world in which a critical agency is split off from the ego and proceeds to take the ego as its object (p.179).

Butler reworks the idea of psyche, away from a nebulous inner process to- wards one formed by the internalising of social power. In effect the psyche is formed through the dissimulation of the power of social norms, which appear 'natural'. Thus the psychically embedded power of past ideals and practices constitutes a melancholic effect that makes them difficult to mourn success- fully. We are used to the notion of power being exerted from external sources whereby relations of dominant and dominated ensue. Following Foucault (1980), Butler describes the paradoxical operation of power, whereby power forms the subject as well as 'the trajectory of its desire' (*ibid* p.2). Here power is not something we impose or oppose but something that defines our very existence and which we therefore hold at the centre of our being. Power is productive and forms the core of our being. As subjects we are only able to understand our existence through the parameters of those discourses, prac- tices, ideals and so on, to which we are subjected and, simultaneously, through which we achieve subjectivity.

One can appreciate how the power of traditions and ideals of art practice, whose initial purpose and function have disappeared, provide stability and security to the school art curriculum. Such traditions establish a form of re-

flexive conscience rooted within particular methodologies, ideals and ethics of practice that define its boundaries. They constitute the parameters through which practice is understood. It is as though passionate attachments to particular practices produce policing mechanisms according to which practice is conceived and regulated. We can thus conceive the notions of the autonomous, self-expressive individual, originality, authenticity and uniqueness so central to the humanist discourse of many school art educators as melancholic identifications, that is identifications that cannot be mourned successfully and which still constitute a powerful pedagogic ideal at the heart of the school art curriculum. The difficulty in trying to avoid the stasis of such melancholic power seems to be about loosening the hegemony of such identifications whilst simultaneously confronting future possibilities for practice that avoid the sentimentality and security of past traditions. It is nearly a century since Duchamp introduced the 'ready made' object into the gallery and so challenged, head on, notions of authenticity, self-expression, the artist, the art work, originality and uniqueness. Clearly, there is a tendency to promote possibly out of date curriculum models that are held in place partly by the power of caricatures of past practices.

We are in a position where the pedagogic stability required for practices of teaching and learning is dependent upon the power of those sedimented traditions in which practice and subjects of practice have been spawned. Such traditions generate passionate attachments to particular forms of practice and understanding within which practice and subjectivity can be understood and regulated. The work of many contemporary artists, on the other hand, is concerned with *challenging and resisting* these very traditions and the notions of subjectivity that are implicit to them. It could be argued that they are concerned with disrupting the very idea of tradition. So teachers do not always find it easy to conceive pedagogic rationales for practice and assessment when engaging with contemporary art. Nor is resistance or challenge to existing pedagogical models easy within current curriculum and inspection frameworks. In this situation what is the purpose of school art education?

Approaching the future: learning how to swim

In the last chapter of his book, *The Man Without Content*, Giorgio Agamben (1999: 109-110) describes two images, one by Paul Klee (supplied by Benjamin) and the other by Albrecht Durer. Klee's image, *Angelus Novus*, depicts 'the angel of history', a winged figure that is propelled backwards into the future by the wind of progress. A pile of debris, the agglomeration of history, forms at his feet. Durer's image, *Melancholia*, depicts a winged figure in deep contemplation. Scattered around it are tools and utensils of life. Both images involve a sense of alienation. As the events of the past become indecipherable to the angel of history so the tools of daily life have become redundant to the

melancholy angel but they have become charged with an elusive property, what we might call 'culture'.

Agamben is concerned with the transmissibility and the intransmissibility of tradition. In what he calls traditional systems there is no distinction between the act of transmission and what is transmitted, that is to say, processes of living and tradition are inseparable. Such systems lose their vital force when the act of transmission is separated from what is transmitted. This is a characteristic of what he calls non-traditional societies and constitutes the accumulation of culture[2]. But this does not mean that the past is lost or devalued, rather that only then is the past able to be revealed, but in an alienated form. What is lost is transmissibility. Thus the past collects behind us and we lose the once stable basis of developing principles for action that are able to accommodate present and future circumstances. In periods of transmissibility, when social and environmental change is slow, moving towards the future presented few problems. Losing transmissibility, for example when the rate of social change increases, entails a loss of reference points and so we become positioned between the indecipherability of the past and a future that is difficult to predict. Many art practices in schools pay homage to particular practices and visual forms whose embedding social context is now unknowable.

Any rationale for current and future practices of school art education has to take into account how practice, teaching and learning are conceived. Such issues cannot be divorced from tradition nor from current and emerging social worlds in which teachers and learners live. Thus any attempt to embrace new discourses and practices is likely to create uncertainty and anxiety. Furthermore, in a world of increasing social change and evolution any new curriculum is likely to be out of date before it is employed.

Considering the linguistic framing of practice and subjectivity may suggest an approach to the future. Whilst humanist discourses in art education celebrate self-expression as a natural process in which authenticity resides, more radical theoretical discourses such as post-structuralism abandon such essentialist notions of individuals and conceive the subject as multiply determined and contingent upon socio-historical discourses and practices. Teachers' and pupils' identities are therefore held in place by the way in which they are formed within the symbolic order. So when we assess a pupil's work or ability we are not revealing some inner essence but constructing this through the particular discourse we employ. Contemporary critiques of subjectivity have abandoned the idea of a natural or essential self that possesses an inner core in favour of a more fragmented understanding in which human subjects achieve their identities, their 'selves' in specific discourses and practices. Our subjectivities are formed differently in various social contexts such as families,

schools, leisure pursuits, hospitals and so on. Applying such critiques to the notion of self-expression provoke the question, 'which self is being expressed?'

One implication for school art education of this contingent idea of subjectivity is that previous rationales that were built on more humanist/essentialist philosophies are outmoded, so a different sense of agency is required. For instance, in the 1970s and 1980s Ross (1983), Witkin (1974), Abbs (1987) and others provided a powerful rationale for practice by justifying art education on the grounds that it provided a means whereby pupils could explore the world of their perceptions and feelings. Whilst science education dealt with the world of facts and concepts, the arts were vital for understanding our affective domain. But if we subscribe to an understanding of subjectivity that denies the notion of a natural inner self that can be transposed into art practice and its outcomes, if we reject such a self in favour of one where agency, as well as perceptions and feelings, are effects of social power, then the humanist model becomes problematic because the distinction between self and social become blurred.

In the 1980s and 1990s the advent of critical and contextual studies in school art education was premised on the notion that pupils should be encouraged to develop a critical understanding of art works that would complement engagement in practice. This rationale was premised on the notion of an 'individual who comes to interpret' and the idea that through critical practice the meaning of the work or the intentions of the artist could be attained. In current theoretical understandings of subjectivity both notions have become problematic. Firstly, assuming a prior subject who comes to interpret neglects the point that subjectivity is actually formed through the process of interpretation, so that the discourses within which pupils are encouraged to make interpretations produce particular subjectivities. The rationale for critical studies failed to understand its ideological power to produce specific pedagogised subjects. Secondly, the critique of essentialist ideas on meaning is so well established that any attempt to reveal the meaning of a work or the intentions of the artist cannot be sustained. Interpretation is always affected by the social and historical conditions in which it is made.

Both rationales therefore become untenable today if we acknowledge the contingency and fluidity of subjectivity, the transience of the boundaries and myths of subjectivity and the critique of meaning. Both have become untenable because of the effects of the rate of social change and the consequent need to find new ways of understanding social existence. So how might we conceive of a workable rationale for school art education, one that responds to the changing nature and boundaries of subjectivity, the relativity of meaning and the acceleration of social and technological developments?

A third approach to subjectivity and social practice suggested by Zizek (1989) re-inserts a sense of agency by recognising a permanent gap between the linguistic framing of practice and what, after Lacan, might be termed the Real of practice. Here the Real relates to that which cannot be encapsulated or represented by language or other symbolic means. We can get a sense of this notion when we try to embrace practices such as teaching and learning; our language never fully captures these practices. This inadequacy suggests that we can conceive the linguistic framing as closer to fantasy or a particular reading than to any firm truth. And this allows the possibility of interrogating the linguistic framing that structures our understanding of reality and of tackling the holding power of hegemonic discourse. Linguistic framing and practice can be constantly negotiated, and this in turn conceives this relation in a state of flow rather than stasis. In such a flow system, stability is achieved through an ongoing process of negotiation, reflection and transformation. This negotiation also has to include recognising the power of reflection to produce particular subjectivities, that is to say, recognising that the reflective discourse is itself subjectivising. Inevitably this approach involves more instability because it requires trying to see beyond the linguistic framing through which we understand human identities and practice. This is made even more difficult when government policy is to provide a definitive curriculum for all teachers to comply with and deliver, and a one-size-fits-all model of assessment. To stand outside these all-embracing discourses is not easy. But the new understanding of the relation between subject and social points towards a way of conceiving curriculum practice as a negotiated and collaborative project in which boundaries and certainties could be challenged.

A negotiated and transformative curriculum

A difficulty with discourses and practices that subscribe to a modernist or humanist aesthetic is that, like the angel of history, they face the future backwards and, like the melancholy angel, they are suffused with redundant tools or concepts. This is a problem with aesthetic discourse itself when confronted with new forms of art practice that resist and challenge its conceptual and ideological underpinnings. The value of engaging with new forms of art for school art education is that such art often challenges the boundaries of practice and therefore our understanding of practice. It embraces a critical project on several levels and includes the content of art practice, the idea of the practitioner, the artist, and the outcomes of practice. This continual process of challenge, resistance, debate and transformation is a consequence of practice occurring within socio-cultural contexts in which change and diversity seem endemic. Equally, therefore, this constant process of negotiation that responds to the embedding social context is important for school art practices if they are to engage pupils with their contemporary realities. However the mode suggested here anticipates more fluid boundaries and so runs counter

to the pragmatism of current government policies for precise and universal structures.

In a negotiated system teaching and learning would be a matter of developing awareness of, acknowledging and perhaps trying to rework the power through which we gain our existence as teachers and learners. In the practice of many contemporary artists this is precisely what seems to be happening: constant interrogation of the boundaries that structure identity, practice and understanding.

Thus it seems inappropriate for teachers to be handed down a ready-made art curriculum because it is likely to be out of date before it is implemented. Teachers, as professional practitioners, need to work together with other parties to negotiate their curriculum, to consider how they conceive art practice in schools developing. The possibilities for networking with other teachers, with galleries and museums, with higher education sites, with practising artists and so on, using new technology, and for developing communities of critical practitioners on more local levels is not difficult to imagine or put into practice. In some schools it is already happening. This generates a new way of thinking about 'the art curriculum' and assessment and a new politics of practice, turning away from formulaic discourses that presuppose a particular notion and aesthetics of practice and subjectivity and towards discourses that are negotiated and transformed by educators and others in their local spaces. In this process, the boundaries of practice, meaning and subjectivity are open for negotiation and transformation. Forms of stability can be developed by conceiving forms of curriculum discourses that are able to respond to the flux of social practices and change. It means learning how to swim within different and changing currents of the social.

Notes

1 I use the preface 'contemporary' simply as a descriptor for current art practices that form a kind of *avante garde* of the late 20th and early 21st centuries.

2 Similar issues were dealt with by Margaret Mead in her book *Culture and Commitment* (1972) where she offered a way of understanding the 'generation gap'.

4

Championing Contemporary Practice in the Secondary Classroom

Henry Ward

Introduction

am standing in a school art and design studio. Around the floor in front of me are the outcomes of a year 12 examination, the results of two days' intensive labour: paintings, sculpture, collages and photography. At the back of the room, a chicken wire model inspired by the Tower of London rises from a base made of garden turf. Pinned to the wall is a series of police evidence bags, each containing a small object or photograph and some accompanying text. On one table is a series of beautifully composed photographs depicting the storyboard of a rail crash. Closer inspection reveals that each photograph is taken from a carefully constructed miniature set-up, using model railway buildings, train carriages and people. At the other end of the room is a standard globe, as found in every geography classroom. There is a sickly sweet smell surrounding it. Every single country on the globe has been modelled in chewed bubble gum and chewing gum, creating a surreal and disturbing alternative landscape. The pupils were required to respond to a brief about the city, to create works inspired by cities and the idea of creeping urbanisation.

Contemporary practice is having a profound effect on our pupils. If I think back to my own art education I can only remember drawing spider plants or still life set-ups of deodorant bottles and pairs of trainers. I had no idea that it was possible to be an artist. I had no conception that there were people making art. Art was something that happened in history. I couldn't see a possibility to make art which truly reflected my own feelings and ideas. But this is changing. I think that the high profile contemporary art has acquired over

the past decade, particularly in the UK, is giving us, as educators, a fantastic opportunity to alter the way we teach.

Welling School, where I teach art, is a sprawling co-educational secondary school on the outskirts of London. It is non-selective, but the borough operates a selective system, so the top 20% of children are creamed off at the age of eleven by the local grammar schools and we are left with the rest. Two years ago, after a long and protracted process, the school gained Specialist Status[1] in the Visual Arts. At the moment we are functioning on a building site while the school is being extensively rebuilt as part of the PFI[2] initiative. This is where I teach alongside five other colleagues and artists in what is a dynamic and stimulating teaching and learning environment.

I can't draw

I'm stood in a room full of adults and I've just asked everyone who feels that they can't draw to raise their hands. I'm looking at a sea of hands. I guarantee that every single one of those individuals drew something before they could write or even speak. Drawing was one of their first forms of communication – an argument, then, for a back to basics approach, a skills-lead approach? Well, I don't think so.

> Inspiration (can be found) in drawings by children, where innocence of conventional skills has allowed a freedom of expression all too often denied the professional artist by his/her formal training. What an irony, if drawings by untrained people are more likely to offer fresh insights and idiosyncratic vitality than drawings by professional artists. But the untrained have no value for what they themselves can do. They, God help us! Would like to draw like Leonardo! (Oxlade, 2001)

No, my plea is for an art education that gives people faith in their own means of expression. That gives them the facility to express themselves visually. That lets them know that what they make is valid.

Genre photographic portraits with Year 7

Since acquiring our specialist status the faculty has become the proud owner of banks of PCs, digital cameras and state of the art software. But when I decided to introduce photography in year 7, we possessed a single camera, one computer, and a copy of Adobe Photoshop Limited Edition. I wanted to devise a way of getting pupils to really look at pictures, to engage with them, and make images of their own that they would be proud of. In order to overcome the management difficulties of having only a single camera, I integrated this photographic element within a broader project on the theme of Identities. The pupils drew themselves and one another, experimented with different media, produced collages and wrote about their lives. I generated an atmosphere in the studio (never referred to as a classroom) where pupils could feel

comfortable working on different things to their peers. But the core of the project was the idea of creating a photographic portrait, based on a specific genre and inspired by the work of the American artist, Cindy Sherman.

We started by looking at her work. The pupils investigated her approach and inspirations. They were introduced to the digital camera. Working in small groups, with the aid of a tripod and a couple of desk lamps, each took a few photographs of the others, experimenting with different angles and lighting. They were asked to explore the various moods they could create by cropping, lighting from below or above and changing their own position relative to the subject. The photos were printed out, thumbnail size, and the students were encouraged to annotate them, drawing on top of them to express what they felt had been successful and why.

Next we discussed the notion of genre. We looked more intently at Cindy Sherman's work. What did her photos remind them of? Why did some look like stills from early Hollywood films and others like advertisements in a glossy magazine? How had she achieved these impressions? The pupils were instantly attracted to her work as it was close to images they were already familiar with, which made it easy for them to access.

After this the pupils divided into four groups. One investigated Film Noir, early black and white movies. Another looked at fashion photography. The third had to research the horror film and the fourth were asked to look at painted portraits by famous artists. For homework they began to research their given genre. I asked them to collect relevant images and make notes about what they wanted their own photos to look like and why. They collected together the props, wigs, clothing and make-up they required for their work.

Building on the skills they had acquired with their initial experiments, the pupils began working in small groups to create their final images. As the photographs were taken, pupils began to manipulate their images on the computer. I encouraged them to restrict the effects they employed, to concentrate on using a few simple tools, adjusting the contrast, cropping the image, altering the colour balance. The results were astonishing.

It was obvious from the beginning that some genres would be very popular. Every student wanted to pretend to be in a horror film because they loved dressing up! But the greatest affirmation of the project was an incident I observed after school one afternoon. The girls who had been studying the portrait paintings genre to research had asked if they might use the studio after school. Perhaps they were shy about working in front of the others or perhaps – as I like to think – they wanted more time to concentrate.

Photograph by Emma Evans (a year 7 pupil)

They had chosen Vermeer's painting, *The Girl with the Pearl Earring*, as their subject and had raided the textiles studio for appropriate fabrics. I had a meeting in a neighbouring classroom so I left them to it. When I returned to the studio some time later, I stumbled in on a full-blown argument. The girls had not heard me coming back and were disagreeing loudly about exactly where the light was coming from in the original painting. The row was becoming quite heated and I watched in amazement as this group of eleven year old girls had a serious and impassioned debate about the light in a painting by Vermeer. I cannot think of another way of achieving such involvement. Their exposure to a contemporary artist whose work they could easily access and roughly replicate had opened the door to an appreciation of Dutch painting from the 17th century.

This story illustrates one of my core beliefs in art education, and even education in general. All human beings have enormous potential. Children all have

hidden talents and untapped abilities. Our primary role as educators must be to release this potential. To open the door. But what prevents this from happening, or at least a major factor that stands in the way, is skill or, rather, the perceived lack of it. When a child believes they are no good at something, when they expect to fail, they cannot succeed. This is the biggest barrier to understanding. By allowing year 7 pupils to work with photography to create these portraits I was removing the barrier that trying to draw would have created. It opened the door to a depth of understanding, a door that would otherwise have remained closed. This is not to belittle skills but rather to champion the unleashing of potential and foster the understanding that all children have and give them back their faith in their own capacity to learn.

I have two young daughters and one of the most rewarding things about being a parent has been watching them drawing. Their approach to making images is fascinating. It is amazing to watch them beginning a drawing, confidently integrating all sorts of information, incorporating things they can see and things from their imagination. So what happens? Why can we do this at four but feel so worthless and inadequate by fourteen?

A guerrilla approach to teaching

What is a guerrilla approach? It starts with self-belief and its most important component is passion. I am a painter and I am passionate about art. When I have time to spare I devour art books. Apart from my family, they are the first things I would rescue from my house in a fire. Although I am a painter, I have developed a catholic taste. All art interests me. Why is this important? If we are to inspire children, and surely real teaching should be inspirational, then we must first inspire ourselves. One of the most exciting and invigorating things about teaching art is our freedom to introduce and explore just about anything we like. Almost anything that we ourselves are drawn to can form the impetus for a lesson or project. I relish the thrilling brainstorming sessions that began with fellow PGCE students and continue with my colleagues now. Something we've read in the newspaper, a TV show we've watched, an exhibition we've attended or even a CD we were listening to.

So where does planning come in all this? You cannot plan to be spontaneous. If you are allowing the possibility that a conversation over a cup of coffee ten minutes beforehand can determine the direction a lesson takes, then planning becomes an irrelevance. Planning, that is, of carefully constructed three part lessons, scripted to ensure that the keywords are referred to. But in a sense I'm planning all the time. Constantly looking for new ideas, themes and artists. Constantly being inspired. When you get excited because of the show you've just been to see, it comes out. The children see it and it affects them.

I believe it's important to nurture this belief in the pupils. To make them believe that their passions and interests are just as valid, just as important. To encourage them to see themselves as artists. And why not? I am continually astounded by the work my pupils make. The girl who cast a boy's face in chocolate and proceeded to take bites out of it. The boy who inserted a cardboard cabinet into a pillow case and filled each drawer with a miniature sculpture based on one of his dreams. The video of a girl falling asleep, speeded up to become an unnerving and unsettling experience for the viewer. The photographic installation based on the signing alphabet. A maze constructed from hundreds of black bin bags. All of it confident and mature work. All of it inspired by exposure to contemporary practice, by being immersed in a culture where anything can be art.

What fascinates me about this process is the speed with which the pupils begin to show the confidence to trust their own instincts and ideas. What I think this proves is that they have – that we all have – remarkable imaginations and ideas. By introducing pupils to contemporary practice, by talking to them about the ways present day artists make artwork and by allowing them the freedom to try anything, we nurture that sense of enquiry and willingness to experiment. The results can be outstanding.

So how does this work in practice? To illustrate I shall first describe a scene. A GCSE class, year 10. At a table near the front of the studio a small group of students are busy with some chalk drawings. They are working from microscopic photographs of the body. Behind them a boy is using a hair dryer to soften the wax he is using; beside him his sketchbook lies open, revealing a half-finished relief based on the structure of a human face. Several girls are working on the floor, experimenting with mixing glues and different paints, exploring processes. Two students are sitting at computers, using the internet to research. Another group is working on small, modelled clay figures, each contorted into an expressive pose. Others around the room are busy in their sketchbooks. I am circulating the room, commenting on the work in process, answering questions, asking questions, suggesting relevant artists, challenging the pupils.

The project is entitled Pain, Medicine and the Human Condition. We began by discussing the theme. We looked at artists who have produced work inspired by the body. Contemporary protagonists like Damien Hirst, Marc Quinn, Jenny Saville and Ron Mueck, but also the history of the body and medicine in art, all the way back to Leonardo da Vinci. The first weeks of the project were spent working on activities as a group-directed work, led by me. The pupils produced life drawings of one another and were given a demonstration of modelling a figure in clay. They each produced a small figure, inspired by a specific emotion. They worked on other drawings, from primary

sources, like a skeleton or the preserved organs in jars we had borrowed from the Science department, and they also worked on secondary sources; photographs in textbooks and existing works of art. We looked at the world of microscopic imagery and compared the pictures to abstract paintings. The pupils made abstract paintings. They were shown the work of a range of process painters and experimented with different materials to create work of their own. All the time the pupils were encouraged to question the things they were looking at, to analyse the activities. If they showed signs of wanting to explore something further, or expressed a desire to develop an aspect of the work in a different way, they were encouraged to do so.

By the time we reach the point of the scene described, the pupils are working independently. Most are developing the confidence to trust their own ideas and are actively engaged in the subject and theme. One girl has started making work inspired by a piece of writing she asked her brother, who suffers from arthritis, to produce. Another, after coming across the sculptures of Sarah Lucas, has sculpted a pair of lungs in clay and is now busy decorating the surface with cigarettes. One pupil is using the photographs he took of his broken ankle, a football injury. They have ownership over their work. They are excited by what they are doing, and so am I. But what about the pupils who are not yet capable of doing this, the pupils who have not yet built up the confidence and independence? The structure of the project, with its introductory period of directed activities, provides a safety net, a safe zone. All the pupils have been given options they can readily pursue. The difference with this approach is that it opens another door. A door that can lead wherever they want it to.

There is no doubt that this guerrilla teaching is taxing on the teacher. Logistically it can be a nightmare to organise, resource and manage. When you potentially have clay, plaster, charcoal, video editing and painting all going on in the studio at once, things can get out of hand. Chaos can reign. Sometimes I feel as though I'm spinning plates, or that I'm hanging on by my fingernails. Teaching would be an easy job if all our pupils filed in and did the same thing, at the same time in the same way. But that would make teaching an unrewarding job. I think I can excuse the odd blocked sink, the occasional explosion of plaster on the floor, paint stains on the tables.

The alTurnertive Prize

I wanted to start my pupils thinking about art in a different way. To consider the impact it has on society and the affect it can have on the viewer. There is so much art made in schools, and most of it goes unnoticed. Yes, art rooms have things on the walls and most schools strive to put things up in the corridors, but it is rare for a school to have a forum in which concepts of exhibition can be explored. At Welling School we are blessed. We have a beautiful

purpose built gallery, spacious and well lit. Over the past three years we have been building a programme of exhibitions that allow the pupils, staff, parents and local community access to the work going on in the school. At the core of this programme has been the alTurnertive Prize.

I set up the prize in November 2002, timing it to coincide with the Turner prize[3] at the Tate Gallery. I wanted pupils to be aware of the relevance that contemporary art has in society. I asked teachers to nominate pupils from years 10, 11, 12 and 13 who they considered actively engaged in a contemporary approach to making art. We sorted through and came up with a shortlist of students who were invited to submit work for the exhibition. The work covered a broad range of practice. We had paintings, photographs, sculpture and video work. We printed posters and invitations, held a private view, and announced the winner, a year 11 girl who had created a video piece based on a missing person. She had drawn around a friend's body in the playground after school one evening. Then the next morning she arrived early and set up a camera to film the pupils as they came into school, to capture the mixture of bemusement and incredulity at the apparent murder scene. When edited together, the final result was both humorous and moving.

Over the following weeks we took groups of year 7, 8 and 9 pupils around the exhibition. Sometimes the pupils involved in the show would operate these tours, explaining their work and fielding questions. This helped to build their confidence and has inspired tremendous interest in the subject lower down the school. It's one thing to be excited about a piece of work made by a practising artist but quite different and perhaps more profound to be inspired by your peers.

For the 2003 exhibition, I made a documentary about the nominated candidates. Each pupil was asked questions about the work they were submitting and their plans for the future. The resulting footage was screened at the exhibition. The shortlist was smaller this time to allow each pupil to display a more substantial body of work. The winner ended up showing three pieces in three different media, including a five square foot painting of his own head, constructed out of 10,000 acrylic fingerprints.

Making the documentary and interviewing the pupils changed the way that both they and the viewers who came to the exhibition looked at the art. They started to question what things meant, and in particular how the context in which things were seen could affect their meaning. Having a gallery on site allows the pupils to experience art first hand, as well as the

Nicky Field (a year 13 pupil) in front of his self-portrait

opportunity to curate their own shows. They see exhibitions as just another facet of their lives, along with TV, shopping, magazines and playstation games.

Conclusion

Contemporary art practice is proving to have a profound impact on my pupils. Whereas art often seemed a elitist activity even a few years ago, an awareness of contemporary artists, and the freedom to experiment in a similar way, seems to be allowing more students to access the subject. By enabling them to create sophisticated work by means of a broad and ever expanding range of media, they are realising their creative potential.

We must champion this in formal art and design education in schools. All children should be given the opportunity to unleash their potential, and the curriculum should be led by them. We need a more child centred approach, a more flexible approach. We must give pupils the space to both understand and develop their own imaginations. We need to be brave as educators, to risk failing and creating chaos in order to allow things to take unexpected courses. A guerrilla approach to classroom teaching encourages pupils to pursue their own paths, with the teacher following and helping where they can, inspiring, questioning and facilitating; enabling the pupils to create works of art for themselves.

Notes

1 Specialist Status: Schools in Great Britain are being encouraged to opt to become specialist in a particular curriculum area, e.g: Sports, Languages, Technology, and Visual Arts. This means that they are able to put more emphasis on that area of the curriculum, but are still required to deliver the curriculum as a whole.

2 PFI: The Private Finance Initiative was set up by the government as a way of injecting large sums of money into state institutions such as hospitals and schools. Private businesses are invited to fund the rebuilding of such institutions. In return they manage the building, leasing it to the incumbents, but also being permitted to raise income by other means such as private hire of facilities.

3 The Turner Prize: An annual competition set up in 1984 by the Tate Gallery, intending to highlight the best young British art. Nominees have to be under 50.

5
Room 13

Danielle Souness and Rob Fairley

Introduction

Room 13 is an artists' studio in Caol Primary School near Fort William in Scotland. It was established around 1994 by two ten year old pupils who undertook the task of taking the school's class photographs. They bought a camera with the proceeds and persuaded artist in residence Rob Fairley to work with them. The studio is financially autonomous from the rest of the school and the pupils have to fund the space themselves by running it as a business. The project has grown and at the time of writing has just opened a new branch in the neighboring Lochyside RC Primary School, another in Hareclive Primary School in Bristol and has firm plans for expansion into at least one other site. It maintains contact with several similar projects that have followed Caol's lead in England, India and Nepal. Danielle Souness, Room 13 Caol's managing director during the academic year 2002/3, wrote this chapter together with artist-in-residence Rob Fairley.

Danielle Souness

Ladies and Gentlemen; So! OK.

That is undoubtedly an eccentric way to start an academic essay but it *has* got your attention and *you* must be either one or the other or both, so I haven't insulted you...

This is an edited version of a speech I gave in Fort William in the late spring of 2003 and repeated at a *Creative Partnerships* conference in Dartington Hall that November. I hope it gives an indication of where I think arts education in Scotland, but probably all of the UK, has gone wrong, and how important it is that we correct it from the viewpoint of somebody who is still enduring it.

Room 13 is, it seems, unique[1]. It is an art studio that is part of a school but has been entirely run by us pupils right from the start. We take all the decisions on everything from when we buy soap and paint to when we pay our teachers and how much. Years ago, when the pupils who started the project (Jackie Cameron and Tina Love) persuaded Mr Fairley that he should continue coming into Caol, it operated only on Fridays. Slowly we have been able to extend it so that it now never really closes. During the school holidays we have workshops and stuff or we can keep in touch by e-mail. The fact that we are in charge is very important. I think that ever since I was quite wee I knew that there was a difference between *learning* and learning in school. The first was easy but in school you have to, and I do mean *have* to, learn things that a teacher thinks you have to learn. I don't have any real problem with this – after all the idea of learning is to get knowledge from people who are knowledgeable. But in school you are only allowed to learn things up to a standard that a teacher thinks you can understand and you have to go at roughly the same speed as the rest of the class. In Caol we are extremely lucky because we have a brilliant headteacher called Miss Cattanach and the best class teacher in the world called Mrs Smith. And we have Room 13.

Every teacher and every pupil knows that in any class there are people with different skills and interests. We (the students) know that we are all good at something but all we are judged on is our ability to fill in workbooks. Some people are really good at it, some even buy similar sorts of things to fill in time on bus and train journeys – quiz and game books and that sort of thing. Some people are really bad at it. Some people find it very boring. But we all *have* to do it. However I don't think it really helps you to learn. Anybody can look at the examples given on each page and work out the answer required, and those who struggle are often just bored by the whole idea. It teaches you how to think about how to answer questions but it doesn't tell you why the question exists.

Most people my age want to learn. We want to do things. (OK there are one or two who don't but most of us do.) What Room 13 does is to allow us to take control of our learning. We can use the studio whenever we want with the only rule being that we must never fall behind with our class work – in our workbooks.

Until you, our readers, consider people my age (I am 11) as artists you can never support us. You can give us what you *think* we want, or more likely what you think we need, but at best all you provide is patronising praise.

Do you remember what it was like to be 11 or 12? Think!

You knew what was going on, *you* knew about war and sex, *you* didn't believe in Santa and the Tooth Fairy. *You* could think for yourselves. *You* occasionally

Rivers of Blood: Danielle Souness

got things wrong because you did not understand something ... but even trained adult doctors and scientists do that. Can you remember what it was like for adults to treat you as if you were something slightly different from a human being?

It was horrible, wasn't it? It still is.

Let me give you a couple of examples that are close to my heart and annoy me a lot. When we won the *Barbie Prize*, the junior version of the Turner Prize, we were in every newspaper in the country but we could look up none of the reports on these papers' websites because they are restricted on the schools internet network because they contain 'News'! Some of us have been invited to Kathmandu to work with schools there. We cannot look up Nepal on the school Internet because that is restricted because it contains 'Travel'. We cannot check our virtual share portfolios on the FT index website because that is restricted because it contains 'financial information'. Obviously some-one somewhere is telling me what I should know, what I should think and

what I should be interested in. I object quite strongly to that. Now, don't get me wrong, I am not saying that schools should have unfiltered internet access; I am saying they should look at what they filter because filtering knowledge is not educating.

I know that some adults think that teaching children to think is wrong and that it does not prepare them for the real world where all they will have to do is to do as they are told. So at what age *are* we allowed to think? At what age are we allowed to be artists? Because it is the same thing.

Picasso made some of the greatest works of the last century. They are beautiful and tell me a lot about what it is like to be an old man but even Picasso could never paint what it is like to be an eleven-year-old girl. I am *not* comparing myself to Picasso, but *I can* make art about being an eleven-year-old girl. *Your* problem as an adult is that you look at my work in a different way to the way you look at late Picasso. This I think is the biggest difference between Room 13 and other ways of working. It teaches us how to think, it treats our ideas, our dreams and thoughts seriously and, perhaps even more importantly, it allows us to find ways of expressing them.

Last year I became slightly interested in what is called *body art* made by artists like Franko B. While I wouldn't be interested in taking things as far as he does, I did realise that you could make statements about important things by using the artist's own body ... people like Gillian Wearing and Tracy Emin do it in their video piece. When I accidentally broke a blood vessel in my eye it became obvious that there was a really good piece waiting to be made. Your eye is a part of your body you can never see, so that was interesting and although my eye looked very different from usual it still worked the same so that was interesting too. I am really into text art and this is actually a text piece, though everybody who has seen it has never seen the actual text! It is called *Rivers of Blood* for obvious reasons though it also intentionally refers to Enoch Powell's racist speeches in the 1960s. It has been really interesting to see how adults react to this piece. Some just don't get it at all but others do and Waldemar Januszczak wrote that, 'It is genuinely dramatic, and

Smile: Danielle Souness

doubly so because of the obvious youth of her face. You just don't expect to be drawn into such tense mind games by an 11 year old[2]. Though this is a bit patronising, it is good that he understood it a bit. My piece called *The Skin I am In* also deals with racism and how horrible it is.

Without Caol Primary School and Room 13 and working together I would never have seen the Matisse/Picasso exhibition, the Eva Hesse exhibition. I might have discovered Barnet Newman as his work is very important to me but I would never have had the chance to see his work for real. I wouldn't even have been allowed into the gallery to see Fiona Banner's work in the Tate, let alone been taken round it by one of the Turner Prize curators. Even secondary school students needed permission ... How patronising is that? I wouldn't have discovered Norman MacCaig or James Joyce. I wouldn't have discovered myself. Surely that is what education is meant to be?

Rob Fairley

Fine art, as epitomised by drawing and painting, is the oldest form of human expression. The earliest window into what David Lewis-Williams has called 'the limitless *terra incognita* of the human mind'[3] comes from rock art and later little portable sculptures. One cannot understand the precise meaning these works had for the people who made them but they still speak now with a voice so powerful and so profound that in their presence one is moved to stillness and sometimes tears.

For 30,000 years art has been a vital form of human expression. However, from the middle of the 20th century, the importance of visual expression and the necessity to teach an understanding of its language seems no longer to be deemed important.

In some areas of Scotland a peripatetic art teacher can be expected to cover up to 30 schools, some of them on islands. In practice this means some children receive art education for one week every two years. The regime of 'doing' art on a Friday afternoon if everybody in the class has been 'good' holds true – though I have come across at least one case where even this was twisted by the promise of being allowed to play with Lego 'if you get your painting completed quickly enough'!

The ideas inherent in Room 13 began in Edinburgh College of Art in the 1970s and were developed and refined through artist-in-residence posts and through taking on apprentices. Its stimulus was exasperation at the lack of interest in teaching visual literacy as a general subject and the lack of interest in teaching the basic technical skills needed to express ideas through visual imagery. Its ethos has always been to provide philosophical and moral discipline and training through the visual arts and to maintain a state of intellectual and artistic development across all ages. Room 13 is a meritocracy that places visual

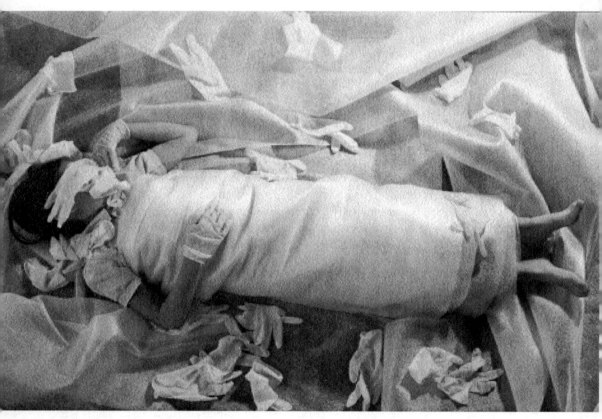

Lyndsey Martin : Performance piece

literacy, the ability to think and the skills of visual expression at its heart. Its core belief is in the importance of each individual's integrity and the expression of that individuality being essential to the health and wealth of the wider community.

There is no coercion to use Room 13. The studio's door is always open and any student can use it whenever they want for as long as they want, those in the upper school even having the freedom to leave a class to go to the studio. The only criterion for a student is that class-work is kept up to date.

Room 13 is run as a business by the pupils and is self-funding and self-regulating. The Managing Director, Secretary and Treasurer are drawn from Primary 7 (10-11 year olds). Meetings are held, votes taken and minutes kept. The AGM is held late in the Summer Term when a new management team is voted in from Primary 6. Directors are drawn from as far down the school as Primary 5 though constitutionally there is no age limit. (I was voted off the management team this year, having held a position from the beginning, as the directors

wished to bring in younger blood! The artist in residence in Room 13 Lochyside, Claire Gibb, holds her place in their management team.) The only burden placed on the school by the presence of Room 13 is the rates for the heating, lighting and water. The studio holds its own bank accounts and cheques are signed and countersigned by the Managing Director and treasurer. Until Danielle Souness, Managing Director 2003/4, and her treasurer Eileen Innes, recently applied to the National Endowment for Science Technology and the Arts (NESTA) for financial aid, funding came from money-making ventures planned and carried out by the pupils.

Funding Room 13 has always been a major problem. Many local businesses have helped and several professional artists and photographers have been wonderfully generous in passing on film, materials and equipment. In 2000, the then Managing Director, Catriona Jackson applied for an Scottish Arts Council (SAC) young person's Lottery grant and despite the SAC being at first somewhat bemused at dealing with 11 year olds (the school secretary tells with delight of the SAC phoning and asking to speak to Room 13's MD and being told that she would phone back when she had finished gym. 'You mean she is a child!!' came the astonished and alarmed response), the grant was awarded.

This award allowed the studio to stay open five days a week for the first time, and provided a lead for future MDs to follow. Fiona Cameron took on a personal crusade to have the project recognised further afield, in the belief that this would bring further funding. She gave lectures and spoke at conferences and seminars to such bodies as Scottish Natural Heritage, Children in Scotland and the Royal Society for the encouragement of Arts, Manufacturers, and Commerce (RSA), but to little effect. On the last day of the summer term she was invited to speak at a conference at the Tate Gallery organised by the National Union of Teachers and the National Campaign for Art, entitled *Creativity in Education*. The delegates included the Secretary of State for Education, the Arts minister and Professor Ken Robinson. Her pithy, direct and witty speech ended with the question 'Why is the gap between children's expectations and adult's understanding still so great?' Danielle Souness, who accompanied Fiona to the Tate, took up the crie de coeur the following year, and her unswerving belief in her philosophical approach and astute political commonsense led her to travel to London to discuss an offer from the National Endowment for Science, Technology and the Arts (NESTA) of funding for £150,000 over two years. After much discussion between London and Fort William, the offer was upped to £200,000 over three years and the ability to take the project further was assured.

None of the above seems particularly relevant to art practice and yet it is central to the ethos of Room 13. The studio teaches – if it does teach – everything from the base of visual literacy. Thus looking at a video of a Celtic v

Rangers match can lead to discussion of politics, sociology, religion, history, advertising standards, grammar (or the lack of) in post-match interviews and in newspaper reports. It can lead to lessons in geometry (the angle of a certain corner kick) trigonometry, arithmetic, accounting (how much Rangers fans contributed to the Celtic coffers by attending the match), statistics, and of course film making, photography and the use of popular culture in the work of artists like Lucas, Emin and Wallinger.

The teaching of philosophy from a comparatively early age (8yrs) is thought to be important to the artworks produced in the studio. All the students understand that their views are as important as an adult's – different possibly, but none the less important. Souness wrote '...I realised that I was *myself* and not *any* person. When I finally realised this I wanted to show everyone who *I* was[4].' This is no different to any artist. Professor Jonathan Fineberg in his groundbreaking and in some ways heretical book *The Innocent Eye*[5] shows how Miró, Klee, Picasso and Kandinsky were influenced by the collections of child art they possessed. Influenced to the extent of copying. If a copy of a young person's work by an adult is considered 'great art', why not the original? All Room 13 postulates is that a work is created with integrity if it aims at telling the 'truth' as the artist sees and believes it. Then the work stands or falls on its ability to convey this. The rules are no different for a nine year old or a ninety year old.

Many adults are disturbed by some of the work that comes out of the studio. Young artists differ little from adults in responding to world events but they do have greater ease in using arts practice to respond than a mature artist, who may be more aware of personal style or the market place. During the months the Soham murders haunted the press, the studio quietly produced a great deal of work illustrating the fears and concerns of a generation of 11 year olds. After the attack on the World Trade centre a couple of pieces attracted substantial public comment. Jodie Fraser's *9/11*, made by burning a match for every victim of the atrocity and gluing it to canvas, produced a work which the critic Waldemar Januszczak called 'elegant and eerie'[6]. Lindsey Martin's performance piece that aimed, according to the artist, at showing what it felt like as 'dust settled into being a shroud,' promoted an article in a national paper which cogently pointed out that we should not be surprised at such work, as the boundaries between childhood and adulthood have become increasingly blurred in a world in which adults collude in their own infantilism and where childhood has become loaded with all sorts of adult preoccupations[7]. Both articles agree on the premise that it is adult artists who copy the conceptualism of children and that while youngsters have always been disturbed by their imaginations, they have always been able to handle it, and handle it in many different ways, but within present society it is the adults who no longer know how to cope.

Watching 'adult' artists' reactions to the work produced in the studio is fascinating. One colleague who has a substantial international reputation looked at *The Magic Yellow Elephant*, a large colourful oil painting tenuously based on a Hindu creation myth transposed to the highlands of Scotland. She was enthusiastic and full of praise for a piece that indicated (apparently) a huge leap forward in what was seen as my work. She was totally dismissive about it when it was pointed out that the artist was eight. Why? The piece had not changed, the artist's thinking had not changed, only the information available to the viewer had changed. And this apparently transformed a fine piece of work into something to be disregarded.

Conventional art 'teaching' in schools in the UK does the arts no favours. Some years ago I had a young student who I met because she could not study art and music at school (can you imagine a system that would not allow physics and chemistry, or biology and chemistry to be studied together?) and who chose to study art with me. She was astounded to the point of tears to realise that art was a creative process. She had always been taught that it was formulaic, that you applied a particular 'correct' formula for a still-life painting and a different 'correct' formula for a pencil portrait (the latter also requiring 'correct shading'). She could do all this but could not create work for herself. After a very tearful day and a lot of re-thinking of previously unimpeachable dogma she produced a startling self-portrait and has never looked back.

Much of the exam-based system in schools relies on a student showing an established working procedure towards how he or she produced a particular image. Practically every student knows that this is not how an artist works. Unless an exam entry is presented in a particularly 'correct' way the student will not pass. In one case students were asked to produce a finished painting prior to the examination. A study of the same painting was to be made during the exam[8]. Asking students to produce a preparative study of a work that is already completed is a bizarre and pointless perversion of the creative progress. If a student does not conform then a school may not even put the youngster forward for the exam. Almost no heed is taken of contemporary movements in art (the Bauhaus and Surrealism being popular stopping points!) and little attention is given to working in new media.

Room 13 attempts to address these concerns. We take all well thought out ideas seriously and we are constantly on the look out for new ways of expressing serious ideas. We are a group of artists working together, with the only difference being that one or two of us are technically (and arguably emotionally – though this is dangerous territory) more experienced. Room 13 aims to support its artists for as long as they wish it. It works not only from the adult (nominally) in charge but across generations. It is, above all things, for everyone involved, both extraordinarily serious and quite excellent fun.

Notes and references

1 E mail correspondence with David Gribble

2 Waldemar Januszczak. *Sunday Times 'Culture'* 13 July 2003 p.6,7

3 David Lewis-Williams. *The Mind in the Cave.* Thames and Hudson 2002, p.11

4 Danielle Souness. *What Age Can You Start being An Artist?.* West Highland Museum. 2003, p.32

5 Jonathan Fineberg. *The Innocent Eye.* Princeton University Press. 1997

6 Waldemar Januszczak. *Sunday Times 'Culture'* 13 July 2003 p.6-7

7 Gillian Bowditch. *Sunday Times* October 27 2002

8 Claire Gibb, Artist in Residence Room 13, Lochyside R.C. Primary School

6

The Museum Clearing: A Metaphor for New Museum Practice[1]

Viv Golding

It started that way: laughing children, dancing men, crying women and then it got mixed up. Women stopped crying and danced; men sat down and cried; children danced, women laughed, children cried until, exhausted and riven all lay about the Clearing damp and gasping for breath. (Toni Morrison, *Beloved* 1988: 88)

Introduction

The poetic prose of Toni Morrison, Nobel prizewinning writer and Black cultural theorist, opens this chapter to privilege the creative voice of Black women in the context of the museum, where they have historically been marginalised or excluded.[2] This foregrounding in a theoretical realm outside the usual confines of the museum is part of an optimistic thesis that aims to open up the realm of museology to a wider range of critical ideas and ultimately to expand the traditional museum audience, by demonstrating how the museum can be made more relevant and meaningful to the lived experiences of a new audience.[3] I am interested to counter prejudiced and stereotypical views of 'us' as opposed to an absolute 'other', by examining how representation and understanding of a common humanity, without erasing or ignoring differences, can be progressed at a region I theorise as the Museum Clearing, through the new practice of feminist-hermeneutics.[4,5]

Feminist-hermeneutics provides a theoretical tool to critique the process of learning in the context of the museum/school borderlands. It is a useful construct for educators trying to address those whose voices are marginalised or excluded in traditional sites where knowledge and truth are displayed by the socially powerful and consumed by the powerless. Feminist-hermeneutic

femenist thermeneutics

praxis is characterised by respectful dialogical exchange between human agents who have a non-hierarchical relationship. It is constructed from the previously separate discourses of philosophical hermeneutics (Gadamer, 1981), which is abstract and politically naïve because it fails to account for the effects of power in social contexts, and the feminism articulated by Black women writers (Hill-Collins, 1991; Philip, 1992; hooks, 1992), which is pragmatic and concerned with promoting equality in the real world.

The project work outlined here demonstrates how new voices and concerns – Black people's literature, music and art – can be privileged in a previously exclusive theoretical realm dominated by white men and the middle-classes to promote social inclusion. Black women theorists urge us to build theory anew from the elements of our everyday lives that are vital to us as women. This chapter illustrates feminist-hermeneutics in practice by showing how a creative analysis of Toni Morrison's *Beloved* has inspired new ways of working in a field far removed from literary theory.

My use of the hyphen in feminist-hermeneutics draws attention to a problematic zone that many people of the Diaspora living in multicultural communities experience as Black *and* British or African *and* Caribbean for example, remaining 'multiple in hyphenation' (Trinh T. Minh-Ha, 1991: 107). The hyphen indicating this fusion demands a regard for similarity *through* difference and counters any tendency to essentialism or simple polarisation. It marks a regard for the possibilities of a 'daring' self in a constant process of becoming or a 'self in the making' (*ibid*: 113). Thus the hyphen denotes a creative in-between realm. I have been inspired to utilise creative writers such as Toni Morrison and elements of popular music alongside more traditional theory. Here I follow Patricia Hill-Collins, who points to the importance of centrally including new aspects to our theoretical position, inviting us to re-build theory from elements that are significant to the lived experience of women and Black people (Hill-Collins, 1991). I illustrate this theory-building and clarify the concept of feminist-hermeneutics through a critical analysis of the Clearing as metaphor (Golding, 2000).

In the first part of this chapter I demonstrate how the notion of the Museum Clearing reinforces Hans Georg Gadamer's concept of understanding as a 'fusion of horizons' to benefit the museum audience (Morrison, 1988; Gadamer, 1981). Employing a new metaphor is important to counter the simplistic deficit model, too often a self-fulfilling prophecy, applied to people experiencing social exclusion.[6] In section two I illustrate how these ideas work in practice with reference to a special borderland location, a field-site, where a successful programme of radical museum/school education was developed from 1995-2001 by 25 teacher/lecturer members of an ethnographic action research team at the Horniman Museum (Golding, 2000).[7] Four members of the research team developed the theoretical notion of feminist-hermeneutics

in the Museum Clearing through a series of creative projects engaging early years pupils with the Horniman anthropology collection and the intangible heritage from which this collection emerged.[8]

Section one: a Clearing location

The opening quotation from *Beloved* depicts a scene of learning that research colleagues used to challenge the historical situation at the Horniman. In *Beloved* the narrative structure circles back and forth in an imaginary time-space, a complex time-space that contrasts racist perspectives with the creative potential of the Black woman can interrogate and overthrow the oppressive psychological remnants of this historical context through the activities in a forest Clearing location. Members of a previously enslaved community are permitted personal growth and self-understanding in Morrison's Clearing. In the Clearing newly freed children, women and men are allowed to physically express their emotions, their joy and sadness. People experience ownership of their bodies. They form relationships, 'touch each other', cry, laugh and dance (Morrison, 1988: 89).[9] This Clearing is a creative territory lying somewhere between nature unrestrained and a human construction resembling an assembly-hall. In the context of the museum it celebrates the idea of a discursive forum, which is opposed to the notion of the traditional museum as 'temple' (Lavine, 1989:39).

For the research team the Clearing in *Beloved* inspires the notion of people collaborating for social equality across race and gender lines. In the Clearing people gather to transform their lives and form new self-images to replace the internalised negative reflections imposed upon them by the discourse of slavery. Crucially for contemporary museum education, Morrison takes account of the 'journey's end' with the aim of increasing social justice (hooks, 1992: 47).[10]

In the museum the notion of a 'Clearing' is employed as an inspiring metaphor to describe a new location of learning (Miles and Huberman, 1994: 250-252). Metaphor is used as a 'type of trope' involving the comparison of two things for similarities while ignoring differences, which enables an understanding of abstract ideas by mapping them onto concrete things. In the Horniman research it facilitates 'pattern-making' or ways of 'connecting' findings to theory. The research participants also use metaphor to escape simple matter-of-fact description that may result in 'intellectual poverty', since 'metaphorical thinking effectively unites reason and imagination' (*ibid,* 1994: 250-252).

Morrison's image of the Clearing is helpful to the operation of radical education in the museum context, since the Clearing is a special space of active learning in the museum, understood as full of possibilities for constructing

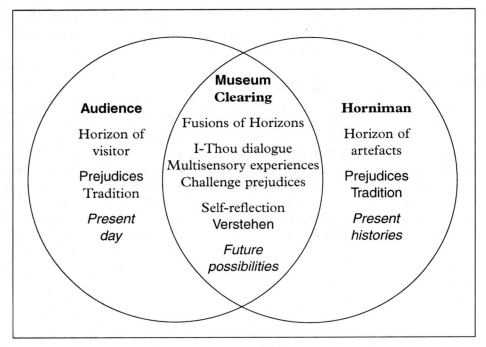

Figure 1. The Museum Clearing or Fusion of Horizons: a frontier region

new understanding, or *verstehen* in Gadamer's terminology, and thus it is vitally connected with Gadamer's notion of the 'fusion of horizons' (Gadamer, 1981; Golding, 2000). It is in the fusion of horizons or Museum Clearing that the active process of new *verstehen* can result from feminist-hermeneutic dialogue and multisensory activity. This special dialogical exchange is characterised by Gadamer's 'I – Thou' concept, which denotes respect and goodwill for the self and the interlocutor. In the Clearing space of fusion 'prejudices' that inevitably arise out of tradition can be examined and changed so that future possibilities are extended. Figure 1 elucidates these notions as they apply to the museum.

Figure 1 shows the Museum Clearing is crucially related to the notion of a frontier location between the museum and the audience, since the positive learning experiences initiated in it must extend beyond the time and space of the museum visit (Philip, 1992; Golding, 2000). It is the new Clearing context of learning that fuses horizons in new *verstehen* that extends beyond the walls of the museum in a physical, emotional and intellectual sense to present a strong challenge to prejudiced views or established patterns of behavior.

A critical dialogue

The concept of the Museum Clearing as presented here is used to denote a particular posture of radical questioning. It is sympathetic to the hermeneutic idea of negotiating meanings through dialogue, although the emphasis is rather on 'aspiring to' a more 'radical dialogism', which differs from the often shallow exchange of face-to-face conversation (Rabinow, 1989: 246). The questioning stance demanded at the Museum Clearing empowers research participants to think and act critically.[11] In particular, the 'knowledge' and assumptions received from the institution of the museum, the visiting group and the wider structures of society are critiqued. Critical dialogue makes museum knowledge an object of analysis rather than reverence, requiring the museum to be self-critical and requiring the visiting group to interrogate their own taken-for-granted assumptions, in a reciprocal movement towards openness and possible change.

In the context of the museum the notion of the Clearing opens up new spaces and possibilities for dialogical exchange and action, inside and outside of the museum. The expanded Museum/Community Clearing space can be utilised by collaborative education programmes to critique the historical presentations of the museum, and to facilitate the engagement of lived difference in the museum frame. Most importantly, the concept of the Clearing provides a dialogical location which allows the museum visitor to imagine and desire beyond the existing limitations and practices imposed by their social groups. In the Horniman research the Clearing notion permits the expression of a desire for connections across all boundaries: geographical, emotional and intellectual. It denotes an ideological solidarity with, and clearly extends an invitation to engage in, other radical projects around the world.

Overall the emphasis is on how the concept of the Museum Clearing enables visitors to move in and out of boundaries and a cross borders of meaning to construct new maps of knowledge and social relations. This rather abstract notion is illustrated with reference to a specific field site and the experiences of early years visitors, as demonstrated in their creative work in section two.[12] The school field-site is located in inner London and has a broad spread of ethnic groups, including refugees from Africa and the Asian subcontinent. English is an additional language for 68 per cent of the pupils and 40 per cent have free school meals.

Section two: an Early Years partnership

With the help of *information, imagination*, and *empathy*, the viewer can in fact share the dreams, the emotions, and the ideas that artists of different times and places have encoded in their work (Csikszentmihalyi, 1990:70, my emphasis).

Figure 2. The Museum Clearing. Chelsea (6 years)

Figure 2 is a remarkably skillful drawing by Chelsea of the Horniman. It is full of accurate *information* gained through close looking, physical investigation of the materials through touch and discussion about the building, and sketching with the museum and school staff. Chelsea pays careful attention to visual details which she expresses through composition, line, colour and tone. She brilliantly describes architect Harrison Townsend's imposing art nouveau building as well as two spaces leading up to the Clock tower. She represents the children walking towards the tower and the main entrance along the slope

from the direction of the Education Centre at the left of the painting. We can also see the steps leading from London Road at the central lower section of the painting up to the tower. Chelsea clearly depicts the railings and the posts at this entrance.

Figure 2 is intended to stand alone as a visual representation of the peopled museum site and deliberately contains no text. But many drawings produced during this research demonstrate an interest in the bus route between the museum and school and bear a textual description of this information, often simply 'we went to the museum on a bus', that reflects verbal comments to teachers and forms part of a useful strategy to develop literacy in the Museum Clearing. Many children are intrigued by the unusual objects inside the museum and this curiosity can readily be engaged in imaginative number work alongside art and literacy activities. For example many groups of masks have patterned attachments in materials such as mirror, bead or shell and children enjoy the pattern-making drawing work so much they often sacrifice the accurate textual information relayed to the teacher, 'a mask had six mirrors', in favour of *imagination* by creating many more shapes in their art than there are in the mask.

What is important is for the adult to respect each fact-finding and imaginative activity in its own right; to press for accuracy could inhibit the children and generate timid drawings. This does not contradict my argument that children need to be facilitated in a critical dialogue on what constitutes truth, for whom and why, in the Museum Clearing. Drawings at the museum site and back at school provoked spontaneous talk from vivid memories, providing powerful pathways to early literacy and numeracy, which is vital in the UK where seven million adults have literacy skills below age 11 and more have problems of innumeracy.

The research team is beginning to connect achievements in literacy by build-ing confidence with the different expressive vehicles of drawing and verbal language. Chelsea's drawing exemplifies a group of confident young friends in Year Two completely at ease in the Museum Clearing. They have a feeling of ownership after regular monthly visits since Year One. Ownership involves a spatial understanding of the museum building in relation to the school via the bus route, and a thorough knowledge of what happens inside the building, as this story dictated by Carlus to his schoolteacher Karen Mears demon-strates.[13]

> Today we went to the Museum. We saw Vivien and when we got inside we hung up our coats and packed lunches. Then we went to look around the place and then we came out and then we went to the park and got on the bus.[14] (Carlus, 2001)

This collaborative text represents a considerable oral achievement for Carlus, who has recently come from Portugal and is only beginning to learn English. Carlus's speech was prompted by discussion of his museum drawing, which represented the huge overstuffed walrus on the model ice flow, an iconic Horniman piece that caught his eye when 'looking around the place.' His friend Tan's drawing (author's collection) shows the 'magic carpets' or 'the mats', as she described them, which pupils are asked to sit on when engaged in feminist-hermeneutic dialogue in the Museum Clearing. Tan has also drawn some of her friends sitting on the mats looking and smiling at her while she is showing off a special skirt during a handling session on Clothes from around the World. These mats make a vital kinaesthetic contribution to the comfortable 'home-space' atmosphere the educators strive for in the Museum Clearing.[15]

The artwork above begins to highlight the Museum Clearing and demonstrates that the museum is not the 'off-putting' location for ethnic minorities that Desai and Thomas's research describes. Neither is it a 'white space', housing objects relating solely to the history and views of white people and 'promoting a white perspective on the world' (Desai and Thomas, 1999: 53). Rather, for the young people in Mears's school, the Museum Clearing is a special space where diverse perspectives and cultures are represented and celebrated by a multiethnic team of educators.[16] The different techniques employed by educators to progress learning may be described as a toolkit for the Museum Clearing. Csikszentmihalyi elucidates the appropriate tools for this context:

> To help the public develop the skills necessary to make the experience rewarding, the museum should – in a departure from the traditional museum presentation of art objects that implies only art historical information is relevant – provide a diversity of tools that highlight the *perceptual, the emotional, the cognitive, and the communicative* context of the works (Csikszentmihalyi, 1990: 174-5. My emphasis).

In the Museum Clearing educators aim to 'highlight the perceptual, emotional, cognitive and communicative context of the artifacts with the major aim of developing critical thinking skills to challenge stereotype and racism'. The Horniman research partners contend with Siraj-Blatchford (1994) that it is crucial to tackle the difficult issues of racism and prejudice with children overtly in the early years, since inner-city populations live with the violent effects of racism and need to develop communication skills to cope with it. The devastation of the Brixton nail-bomber is an extreme example at this field-site. Siraj-Blatchford (1994: 45) also points to the importance of discussing common unthinking comments and unacceptable language when encountered, such as, 'I'm not putting my wellies in that bag, it's got Paki writing on it!'

The topic Clothes from Around the World provides a broad focus for work across the curriculum, incorporating materials and technologies of construction and decoration, design styles and the function of clothing. Project work can be developed from initial attention to the collection of clothing, 'real things' that powerfully stimulate the senses to respond in 'almost involuntary' ways, and facilitate 'thinking', as Hooper-Greenhill notes:

> Thinking' includes 'making comparisons, remembering, making relationships, classifying, interrogating, moving from concrete observations to abstract concepts, extending from the known to the unknown and from specific observations to generalisations. (1994 pp. 102-3)

This denotes an overriding 'scientific' stance, but it is the importance of extending thought 'from the known to the unknown', or 'thinking together' in a much wider sense of philosophico-ideological questioning to challenge stereotype and racism, which the Clothes project work highlights.

Photographs of students with museum objects can provide an important aid to recalling personal museum experiences and support literacy by extending the possibilities for questioning dialogue. Photographs of students taken during the museum session spontaneously trigger dialogue. Their responses after the museum visit can be used to good effect if they are combined with text into a personalised museum-visit book. This personal aspect of the book, the named child using the museum artefact, is extremely motivating for all young readers, as we see from the high proportion of children who choose to consult 'their' museum books for literacy work. Examples of captions accompanying photographs in the 'clothes and patterns' book (author's collection) illustrate the way personalised image and responsive text works together in the museum memory book.[17]

Natalie said, *'My skirt had patterns. Squares, coloured patterns, blue and red.'*[18]

Samuel said, *'We went to the museum. I wore a hat. I think a Red Indian hat. I saw it on my telly. I saw black red, white.'*

Mears ensured that Samuel's words about the 'Red Indian hat' were not ignored or erased but brought to a mutually respectful dialogue in the Museum Clearing. Her classroom display highlights Samuel wearing the hat at the museum – and her caption states:

'The North American Headdress was so long we had to hold it up!'

Here Mears concurs with Hall, who emphases the importance of creating a supportive environment, 'an atmosphere' where people are 'allowed to say unpopular things.' Hall notes a 'natural and common-sense racism, which is part of the ideological air that we breathe' (Hall, 1980: 3-4). Samuel's words point to the pernicious, all pervading power of the media in general and television

in particular, which the museum visit addressed but could not in this instance counter. As responsible educator Mears responded with an alternative position in the extended space of the Museum Clearing, which importantly emerged 'without people feeling over-weighted by its authority'.

In the Museum Clearing a clearer, more 'empathetic picture' can be constructed from the spatio-temporal encounter with artefacts, which is determined by the world of the viewer and the world of the object, in terms of the past, present and future time, as illustrated in figure 1 (Csikszentmihalyi and Robinson, 1990: 7). The research teamwork shows how this new picture can then be utilised to challenge media stereotypes and be of lasting value if reinforced by intense attention and refocusing through a range of dialogical work back at school. Storytelling can provide a springboard for the Museum Clearing toolkit for the language development of the youngest visitors. Traditional stories cross cultures so in the ethnographic museum they can offer useful pointers to children's similarities and differences around the world and across time as part of a museum tale revisited at school.

Remi and Femi went sulky. *They was very naughty and they went anyway and they got lost and they heard a snake.*[19] *The snake said, 'go home,' but they* never listened *so the monkey went to the tree. They* got scared *because they never saw their dad and in the Clearing was the king of the animals, the lion.*

What do you think happens next? (My emphasis)

Imaginative story-rewriting or re-telling can evoke empathy through strong personal connections with the young narrator, whose smile while reading her version of Femi and Remi revealed her delight at the naughty *sulky* children who didn't *listen*, just like Year 2 who don't always concentrate. Posing a question at the end of the text offers the child an opportunity to consider her own fears about getting *lost* or *scared* in other ways in the real world and points to the perpetual discursive stance of participants, even the youngest, in the Museum Clearing. Questioning our feelings about our relationship to objects and people or our place in the world suggests different answers which can be interrogated through language, most importantly including the languages of art. Art signifies powerfully and is profitably regarded as a meaningful and empowering tool for communicating ideas rather than as merely the handmaiden of a literacy activity, especially for children newly arrived in the UK and struggling to communicate in class.

Figure 3 provides further evidence of this perspective: pertinent features of a favourite puppet, its colour and texture in richly worked pastels, which Class 1 sent to the new museum educator after a puppet handling session.[20] The preferred characters are Princess Sita or the Witch, perhaps because these characters offer a safe cathartic route for the children to address strong

Figure 3. Witch puppet being manipulated by museum educator, a pastel drawing

Figure 4. A page from Mai Linh and the magic brush.

feelings of pity, fear and anger, through the creative activity of manipulating the inanimate objects in the Museum Clearing.

Thank-you letters accompanied the pastel drawings, which also featured a favorite puppet framed by decorated borders with repeating patterns of signs and symbols such as hearts, triangles and circles around the letters. Such repetitive design is a common activity for children who are developing their writing skills but in the case of Class 1 it is made more meaningful by the act of revisiting pleasurable experiences and being directed to a real person, who also prompts positive memories of the world outside of the child's everyday experience.

The research team finds that story combined with dramatic art activity develops the child's expressive toolkit of skills and creativity. Figure 4 shows part of a photo-drama entitled Mai Linh and the magic brush that Mears constructed. She regularly has stories originally heard in the museum re-enacted by the children at school. Her artifact collection, which includes simple costumes and backdrops and also the children's own mask artwork, supply the props of a sensory threshold, so crucial for children in the early years, and imaginations can soar again.[21] The story begins with Sierra who 'gave her a magic brush' and ends with 'tea' at the king's who was delighted with Mai Lihn's magic drawings that came to life.

From the children's beaming faces in the book, we can see that drama provides two 'optimum conditions for learning – openness' and 'loss of self'. The

experience is obviously 'playful, enjoyable, and fun' (Roberts, 1997: 40). The research underpinning this chapter denies, with Roberts, any gulf between 'education and entertainment' in the Museum Clearing. Our research also suggests that dramatic entertainment satisfies 'a powerful need to experience a sense of personal power and control' (Roberts, 1997: 27).

Csikszentmihalyi notes how the linking of 'cognitive and emotional' faculties at the museum results in 'a feeling of self-acceptance and self-expansion'. We found that 'self-expansion' increases the self-esteem generated by successful project-work in the Museum Clearing.[22]

Conclusion: a new metaphor to motivate all pupils in the learning process

From our experience of developing pedagogy at the Museum Clearing, we found that privileging the arts in the context of a whole multicultural curriculum promotes self-esteem and powerfully enhances motivation and achievement. Museum Clearing pedagogy is especially helpful to pupils at risk of becoming disengaged from the learning process, too often Black children (Lambeth, 2000).

The new metaphor of the Museum Clearing helps to engage all pupils, including the disaffected, by disrupting the dominant master narratives, the discourses of deficiency which characterise discussions of Black pupils' underachievement.[23] Displacing the master narratives in this way demands fundamentally rethinking established viewpoints and political perspectives so as to emphasise the active role of the pupil in knowledge production. In the location of the Museum Clearing pupils are not considered to be objects or passive recipients of the educator's policy action but rather as communicating subjects, the active producers of art and makers of meaning.

This chapter emphasises the importance of engaging pupils and a multiethnic team of educators in the aesthetic appreciation of world art as well as making their own art in the equitable, respectful dialogical exchange that characterises feminist-hermeneutics. The to and fro of purposeful conversation is a source of pleasure – humans are relational creatures and language, which here includes the language of art, is a distinguishing feature of human communication, interpretation and learning (Gadamer, 1981). In feminist-hermeneutic praxis the structuring of conversational themes around museum objects and the 'hands on – minds on' nature of the museum experience ensures everyone is able to contribute regardless of their academic standard. This is motivating for the pupils and so is the fact that it is such fun (Roberts, 1997). The children are also motivated by constructing personal narratives and enjoying imaginative art activities and the promise of an exhibition in the museum at the close of the project.

Our research shows that all pupils can perform well when learning tasks are enjoyable, engaging and meaningful to their lives. Furthermore, as Mears notes, developing skills of looking more closely and connecting ideas and objects can enrich children's everyday lives.

> I hope that after visiting the museum and looking at the collection the children will 'look' at their own environment in a different way, and apply these ways of looking to other objects, both extraordinary and ordinary. For example visiting Brixton market, children have pointed out African and Asian fabrics and made unprompted links with fabrics they have seen previously in the museum. (Karen Mears, my emphasis)

At the Museum Clearing educators with high expectations can promote children's achievement. We need to regard pupils as builders of knowledge and work with their cultural and linguistic heritage. *neo essentialist*

Notes

1 The Museum is used as a generic term to encompass the Art gallery.

2 Capital B is used for Black people as a gesture of radical politics and I am grateful to Paul Dash for conversations on this topic.

3 Ethnic minority visitors whose negative attitudes and the barriers to their museum visiting were recently the subject of qualitative research conducted by five ethnic minority researchers (Desai and Thomas, 1998).

4 Prejudiced and stereotypical views based on mistaken or poorly thought through premises damage the white psyche, just as they harm the Black psyche. Siraj-Blatchford, (1994) shows that white children who hold racist views cannot make pertinent connections and deal appropriately with evidence in other areas of their lives.

5 For analysis of the 'museum frontiers' drawing on Philip's thoughts (1992) see Golding (2000; 2004a; 2004b forthcoming).

6 Social exclusion is cited as a term in the Eco museum movement in 1970s France. It is a useful holistic concept for understanding disadvantage and inequality in large geographical regions including what is commonly regarded as a 'museum' site. In the UK today social exclusion 'refers to the dynamic process of being shut out, fully or partially from any of the social, economic, political and cultural systems which determine the social integration of a person in society' (Walker in Dodd and Sandell, 2001: 9). The Department for Culture Media and Sport (DCMS) produced policy guidelines on social inclusion intended to impact on the museum, galleries and archives sector (DCMS May 2000) and the Research Centre for Museums and Galleries (RCMG) undertook the first research project into Museums and Social Inclusion on behalf of the Group for Large Local Authority Museums (GLLAM, 2000). This report, from over 120 museums and art galleries, supports David Fleming's declaration in the forward that museums are a 'natural engine for social inclusion work' and our research here concurs (GLLAM, 2000: 5).

7 The research team were self-selecting in that they expressed a consistently strong desire to challenge discrimination and prejudice at the museum/school frontiers through reflexive action research and participation in monthly INSET and school visits. There were representatives from primary, special and secondary schools and universities (See Golding, 2000 chapter 6).

8 The term intangible heritage here refers to in general to the oral tradition and to storytelling in particular.

9 At the Royal Academy Aztecs exhibition in June 2003, *Guardian* travel writer Dea Burkett's two year old was silenced and the family asked to leave, arousing great indignation and protest. The *Guardian* has drawn the complaints into a practical 20 point manifesto for the museum to become a more child-friendly or Clearing space, where we might use all our senses and learn to respect each other (*Guardian* Travel 12.07.03: 2-5).

10 This extends James Clifford's 'travelling' theory by promoting the desire to engage in action in the political world.

11 How educators ask pupils questions and respond to theirs is crucial in the Museum Clearing. Pupils can be encouraged to look closely and analyse material features of the museum objects and then to direct their heightened attention to aspects of the wider world, as Mears notes. Museum objects lend themselves to hermeneutic reading from the parts to the whole in an endless cycle of discovery and ever expanding meanings (Golding, 2004a).

12 The artwork refers to the museum building, the objects inside and the possibilities of interacting with them, the route between the museum and the school, the school and the home culture of the pupils.

13 Carlus is one of six Portuguese children in this class. A full-time Portuguese speaker, who works alongside the class teacher every day and is funded by the Portuguese government, supports them in developing their English literacy levels.

14 Carlus reinforces Falk and Dierking who note the importance of the place of the museum creating the right 'feel' and the strong inspiration that a museum professional 'giving attention' to each visitor is more effective than any textual assistance (1991: 147, 157).

15 They possibly reinforce a widespread view that educators 'live' in the museum they are visiting again; along with the smells of the educator's coffee reminding many children of their parent's kitchen and the drink 'my mum likes.' Young visitors to the Museum Clearing often call the educator in the home-space, who lets them eat their lunch there just as they do at home and school, 'mum'. Our research reinforces Falk and Dierking (1992:89) who point out the basic needs of the body (to eat, rest and move about) and senses other than sight (touch, listening and speaking) might be regarded as peripheral museum experiences, but are most importantly addressed to create a place that will permit the visitor to access their potential in a location I am theorising as the Museum Clearing.

16 Pupils from minority groups need to see themselves reflected in the curriculum and in the people who deliver the curriculum (see Golding, 2000, Chapters 7, 8 and 9).

17 In this book, on page 1 the teacher states 'We went to the museum to look at clothes and patterns', then each child makes a response to their museum photograph. Example pages include: Samantha said, 'I wore mirrors ' and a pattern dress.' Biambo said, 'Me, in black, blue, red, that hat.' Jerome said, 'I can see one eye ' under my head dress.' William said, 'I wore a triangle hat.' Keirisha said, 'I was putting on the hat, pattern hat.' James said, 'In the museum I wore a red hat.' Minette said, 'I wore a dress with white and pink patterns.' Lee said, 'I wore blue stripes.'

18 Drawing is a vital part of this memory-book work. The intensive attention to discussion and to the construction of individual patterns provides an activity that has obvious benefits for letter forming, as Natalie, Lee, Kerisha, Minette and James's work demonstrates (author's collection).

19 The adults in this school do not amend the language of the children into standard English when they are beginning to learn English as an additional language. Their aim is to boost confidence and the desire to write, not to instil a fear of mistakes.

20 Access to a wide range of materials, with which to practice new techniques, is vital for the children to see that their art is highly valued in the Museum Clearing.

21 A wealth of artefacts, particularly fabric, can be purchased cheaply from local markets or retail outlets. Teachers attending Horniman INSET have found trips to Brixton Market Lambeth and Soma Books good for African and Indian objects respectively.

22 This connection is reinforced by another research colleague at the Mears field-site. Gill Campbell notes how the children 'made very *good progress* and *gained confidence* from the workshops' while the artist in residence Carol Chin states that the Museum Clearing workshops can 'give the children a voice, reinforce that they have worth and thus give them self-esteem'.

23 The terms: invader, nomad, gypsy, scrounger, bogus asylum seeker or refugee, can influence the treatment of the child behind the label, as either a problem to be solved or a person requiring creative new strategies to develop their educational potential. Press reports of the Bradford disturbances aptly illustrate this (http://www.irr.org.uk/reports/index.htm. Link to *Reports, The Home Office. Building Cohesive Communities* 2001. 16.08.03)

7

The Art of Memory Making

Deirdre Prins

The reasons for memory change with every new generation. While the survivors remember themselves and loved ones, their children build memorials to remember a world they never knew, an act of recovery whereby they locate themselves in a continuous past (James Young, 1995: 285).

Introduction to heritage and memory work: Robben Island Museum as example

Museums are essentially memory makers and memory conservators. Their role in society is to collect, conserve and interpret the memories of the past to provide a context for the present and future. Robben Island Museum (RIM), which has become an international symbol of the 'triumph of the human spirit against adversity'[1], exemplifies such memory conservators and makers. The stories of Robben Island: those of the slaves punished through banishment to the island, of the fighters against colonisation that caused them to be exiled to the island, the people living with leprosy and chronic illness left to perish on the island and in more recent times, the imprisonment of the Black men who resisted apartheid in the early 1960s, provides a powerful context for the interpretation of democracy in South Africa. This began with its first democratic elections in 1994 and reflected a shared vision of a society grounded in a culture of human rights. The past in South Africa has been interpreted as what not to be and do as a nation, articulated by President Mandela when he said: 'never again shall there be tyranny of one man over another'.

James Young (1995) intimates that the past is continuous. It is present still, and can be interpreted through signs and symbols which are visible in society

today. Racism, economic disempowerment, gender conflict and geographical or spatial differences still exist in so-called post-apartheid South Africa. How these symbols and signs are interpreted by a generation and future generations who have not directly experienced apartheid is important to the work of the RIM Education Department. To the groups of young people we host on the island the reality of apartheid is so distant that their interpretation of experiences of discrimination and racism, of access to economic and other resources denied, are too often interpreted as an individual problem, not as systemic or structural. Our objective is to use heritage as a tool for social justice and development so as to empower young people to understand their contexts within the past, and thus effect creative thinking around ways of dealing with and challenging them. In its work with children and youth, Robben Island Museum is involved in the 'act of recovery' (Young, 1995).

This chapter raises some of the dilemmas and issues around using visual art as a part of the process of memory making at the Robben Island Museum. Through studying a mural created by young people on the island in 2002[2] we examine how the memory making process inhabits the present of the artists. It is hoped that through this exploration, those who are memory makers and who use art in these processes will become more sensitised, more critical of our work and aware of the difference between the past we believe we are representing or mediating and that which is currently created by young people.

The contested terrain of memory

We preserve the past at the cost of decontextualising it and partially blotting it out... the resequencing, decontextualising and suppressing of social memory in order to give it new meaning is itself a social process... (Fentress and Wickham, 1992: 201)

'The blotting out' or 'suppression' of aspects of the past for the creation of a shared past is a part of a powerful desire to create a nation or unity after a traumatic past.[3] The trauma of South Africa's past delineated clear lines between victim and perpetrator/beneficiary of injustice. In the creation of a language of national unity the lines have become blurred, as few people acknowledge privilege[4] and prefer to construct themselves as victims. The terrain of the past is highly contentious; different perceptions and interpretations influence its representation.

The past is remembered in the present, where the present provides the external context through which the past is interpreted... (yet) a society's view of the present can be anachronistic as well. Social memory is fixed in internal contexts, in images and stories. These ... stabilise social memory allowing it to be transmitted. At the same time, the images, habits and causal motifs that structure social memory provide a grid through which the present can be understood in terms of the remembered past (Fentress and Wickham, 1992: 198).

The images and stories a museum chooses to represent contribute to the stabilisation of social memory. This in turn plays a role in creating an effective mechanism for transmission of the past to future generations.

> Authenticity is not a type or degree of knowledge but a relationship to what is known... what is known must include the present – historical authenticity resides not in the fidelity to an alleged past but in an honesty vis-à-vis the present as it represents the past. (Cascardi in Trouillot, 1993: 148)

A complicating factor for the Museum is authenticating not so much the stories of Robben Island but the historical context within which they have meaning. This is largely due to the immense power and authority previous historical writings have over perceptions, understandings and representations of the peoples of South Africa in the past. In an essay titled *Writing South Africa's National Past*, Jabulani 'Mzala' Nxumalo (1992) addresses the manner in which the history of the South African nation has been written to reflect, perpetuate and provide an apology for colonialism, slavery, annihilations of nations and apartheid. These writings were influenced by 'sciences' of 'superior races', by economic and capital interests which represented Black South Africa as 'savage', 'uncivilised', 'primitive', and 'in need of Western intervention to enter the modern world'.

This was and is not peculiar to South Africa but characterised most non-Western countries in the world. The universalism of such thoughts and writings has influenced the manner in which memories are articulated at different levels of society. The desire to simplify and amplify versions of heroism or victimhood on the part of the victor, post-liberation, is a natural response, seeking to create a powerful counter-narrative to a traumatic past. But the consequence is over-simplification and the construction of a monolithic narrative of the past that does not allow for particularities, ambiguities and contestation between and of the stories. So these are the two complicating factors: the need for an institution such as RIM to re-create the past, rewrite and revise history from discourses based in racist ideologies, and needing to avoid and resist over-simplification and mega-narratives. The 'authenticity' Cascardi referred to is arguably related to the effectiveness of public institutions and other entities to balance the demands of rewriting the past so that sufficient space is allowed for contestation and multiple voices.

Another complicating factor to memory work is the repression and recasting of memories, as Helen Pohlandt-McCormack (2000) has noted. Memories fragment and are recast – they are dynamic. Conditions in which storytellers find themselves affect the manner in which they weave their stories and interpret their past. And this in turn influences the representation of these stories in specific ways. Rigorous historical and research processes are needed to create the interrogative dynamic in memory work.

Museum as Memory-maker (handwritten margin note)

> Museums like memory mediate the past and present and future. Unlike personal memory which is animated by individual lived experiences, museums give material form to authorised versions of the past, which in time becomes institutionalised as public memory. (Patricia Davison, 1998: 145)

However, in the representation of memory, there are silences or untold stories that dwell alongside those that are told. In selecting stories and artefacts, determining the questions to ask during oral interviews, deciding what to make public through exhibitions, doing the educational programming and so on, museums use objects and stories as 'carriers of authentication of the past' (Solani, 2000).

Making the interrogation a conscious process for participants is critical in educational and learning processes. It opens possibilities of 'other truths' or 'hauntings' (Gordon, 1997), of that which is not present.

Robben Island Museum within the symbolic realm

A third complicating factor for the RIM is the need to articulate the past within a symbolic realm. In the lives of many South Africans Robben Island Museum became symbolic of the imprisoned nation, the incarceration of leaders; men in a place so isolated became the symbol of the isolation and trauma of a nation. To others, it symbolised the worst in humanity, a place to which men (and women in the more distant past) could be sent so they might be forgotten. The resonances of the stories of Robben Island to that of a nation and the world make it easy to place within the symbolic realm. The association of Robben Island with the slave trade, the trade route to the East, Western colonisation processes, laws and proclamations pertaining to ill-nesses and conditions such as leprosy, treatment of the poor, the relationship to and interventions of colonisers in the natural environment and all the ideologies involved resonate with a history that is common to most colonised societies. References to the past that evoke painful experiences of repression and oppression are used to articulate the desire for a better and more pro-mising future.

> When the living takes the dead or past back to a symbolic place, it is connected to the labour aimed at creating in the present a something that must be done. (Avery Gordon, 1997: 175)

This then is the role defined by the RIM Education Department: to 'act as memory makers' but also to 'create in the present a something that must be done'. Hence, one of the objectives of the museum is to use the shared 'heritage as an agent for social change and development' (RIM Education Department, 2004).

These objectives are applied to the content, methodology and learning outcomes of all the museum's programmes, such as the Spring School. Started in 1998, Spring School is an annual event. Young people from South Africa and Namibia[5] are invited to spend seven days on the island. Spring School aims to

- impart knowledge and understanding about the legacy of Robben Island

- draw lessons from this past for the challenges today

- understand what heritage and a museum heritage site are and interrogate their meanings and roles in society

- develop life skills and leadership in the fields of art and culture

Young people are made conscious of their role and ability to influence and effect positive change in their communities, be it in school or at home, with their new skills and knowledge. This mission is in the advanced stages of conceptualisation and development of a second phase – a Leadership Academy to which these young people will graduate.

From the start Spring School has used innovative creative arts to interpret and represent the past. Young people are encouraged to participate in workshops that have included dance, performance, site art, visual art, creative writing and sound performances. When visiting sites in and around Cape Town, they have been exposed to different ways in which people remember, or do not remember, or memorialise the past.[6] During an interview with an ex-political prisoner, a graduate of the programme once said: 'now you have done your part and we are thankful, what must *we* do now? What is our struggle?' A common question from a generation who already feels distant and alienated from the not too distant past.

Spring School 2002

Spring School 2002 had as its theme *Isivivane Solwazi: through art and culture*. Participants were invited to choose a particular art form through which they would represent the stories they were exposed to about Robben Island. Participants were taken on walking tours of the island and at each site they heard a narrative about life there when the island was a prison. At each site, learners listened to and interacted with former political prisoners, who shared their experiences with them.

The political prisoners tried to sketch a picture of their life, during the time they were incarcerated and also the lives of others. These personal stories have provided the most poignant and moving moments for participants. They also had the opportunity to visit the UWC/RIM Mayibuye Archive, where they

were told about its content and purpose and undertook an information search on the art and culture of the prison period. Although the narrative content is focused on the prison period, participants are exposed to the various layers of the Robben Island legacy so are given a broader context into which the present is articulated.

Mural painting

Mural painting is used in South Africa to express a narrative or storyboard. Murals were a popular art form in the anti-apartheid struggle. Not only were they created to communicate messages of hope, struggle, loss and remembering, but they also acted as a means for Black[7] communities to beautify their surroundings. The stark grey environments of the segregated townships to which people were often forcibly removed were 'acted' on by communities to force an identity for themselves onto the space and assert their spiritual need for beauty. Thus did Black communities signal their resistance to apartheid and refuse to bow to the overwhelming social pressures to conform to a stereotype of their identity as defined by the racist state[8]. Mural painting was often done collectively, with various permutations and interpretations of particular events or messages. It was not only the domain of experienced, trained and talented visual artists, of which South Africa has many, but also of children, youths and adults. Murals became a medium through which messages, symbols and a desire for play and fun could be communicated. As an art form the mural facilitated the development of a story or multiple stories, woven together in images.

The objective of the Spring School Mural

The Robben Island Museum opened a Multi-purpose Learning Centre in September 2004. It was envisaged that the mural created by the participants at Spring School would take pride of place in this space. The mural painting exercise aimed to give its creators an opportunity to express their perceptions, their understanding of the legacy of Robben Island and its relevance to their own experiences. The mural was planned to be located in a public, educational space and would communicate to visitors an interpretation of the legacy of Robben Island. Those involved were encouraged to think about the links between the island and the mainland and their own experiences of oppression and resistance. The value of unity in resisting and fighting oppression was strongly communicated through the preparatory programme and in the mural project. In a society that has changed so much and yet so little, the expression of resistance advocates the notion that young people have a role in transforming a society into one more inclusive and integrated. They are therefore able to shift the physical space of Robben Island into a symbolic one, which has a meaning for them of 'something to do'[9]. An expression of resistance contains a sense of empowerment. The narratives of the political

prisoners in the programme and the instruction to represent the 'triumph of the human spirit' invokes a metaphor for the power resting in individuals and communities fighting as a collective against a wrong. All these messages combine in the powerful collage mural.

Lionel Davis, the arts workshop facilitator and co-project leader of the Spring School, noted that few of the young people who attended Spring School and the visual arts workshop knew how to paint, mix paints or apply them. He had to spend time showing them how to mix colour, and techniques of application. The task he set for the mural was this: the work had to reflect an understanding of a political prisoner's life in prison and, secondly, an understanding of life during apartheid and the triumph of the human spirit over adversity.

The young people were given acrylic paints, brushes, charcoal, pencils, paper and hardboard. They made preliminary sketches in pencil or charcoal on paper and then transferred these to a prepared hardboard surface. They had already been exposed to first person narratives, to the collections and to ongoing interaction with Lionel Davis, himself a former political prisoner. As the facilitator, Lionel did not intervene in the creative process except to give advice on colour mixing and painting techniques, so the creators would have freedom of expression. Materials found on site were used for stimulus.[10]

The mural was used as the backdrop for the Open Day following the Spring School. School children, parents and teachers from the surrounding area were invited to attend, view the photographic exhibition and participate in the performances of poetry and dance. It has now been used as the cover page for a birthday calendar, which each participant sells to raise funds for their schools. This ensures that entrepreneurial skills are implemented in their local communities.

The Mural and its representation of Robben Island

In the first and third paintings of the mural, the notion of 'island as prison' is reinforced by the use of walls. Walls do not exist on the island, yet they have been put into the paintings. Whilst acting as powerful symbols of separation and alienation they also create a sense of complete exclusion, even though one has sight of the mainland. They act as a powerful reminder of the exclusion and alienation experienced not only by the prisoners but also by the people on the mainland who knew nothing of what was happening on the island, except when documents and information were smuggled out of the prison. Boundaries made by walls, fences, railway tracks, roads and empty lots of land were a common feature of apartheid and reinforced the separation of 'racial' groups through physical town and city planning. Walls would resonate with the present context, which the creators and their generation would know. The boundaries still exist – townships, suburbs, rural areas are pretty much still

divided according to racial and ethnic apartheid demarcations. Economic circumstances have enabled a few people to move between these boundaries, but not many. The movement has been mainly from middle-class Black neighbourhoods to white neighbourhoods.

Boundaries and demarcations also exist at metaphorical level. Among the issues debated during Spring School sessions were notions of identity, race and racism. The past injustices and prejudices persist and young people are encouraged to challenge each other and themselves on these issues in the workshops. Combining largely urbanised youth and rural-based youth has generated interesting interactions, as they challenged each other's prejudices and preconceived ideas about what is good and acceptable. Participants are also challenged by language – English is not assumed to be the medium of instruction or communication. The young people are encouraged to speak their mother tongue, using peer translation as a means of inclusion. This has led to spontaneous teaching of sign language, particularly in 1998, 2000, 2002 and 2003. Thus as new forms of prejudice emerge, the museum challenges barriers or fences that have emerged post-1994, those of language and, related to this, culture.

These are not new forms of learning. In pedagogy and learning methods used in prison, one discovers elements of teaching which were deliberate in their attempts at breaking barriers of language[11], religion[12], culture[13], educational levels[14] and organisational affiliation[15].

In the fourth drawing, the geography of the island is inverted so that the stone quarry is shown directly overlooking Table Mountain. This inversion provides a powerful juxtaposition of what could be perceived as – and for many political prisoners was – a hopeful image of freedom. The juxtaposition of the harsh work in the quarry with the mountain, and the defiant hands emerging in the foreground, captures the sense of triumph over the hardship that Lionel Davis was asking the participants to portray. The insertion of a painful space like the stone quarry into the triumphalist picture intimates that the creators could and would not isolate the painful aspects of life in prison from the notion of triumph. The clenched fists whilst in chains proclaim a defiant spirit in spite of hardship. The coexistence is recognised of pain with joy and suffering with celebration.

The power of the stone quarry stories is captured in the manner in which young people interpreted its geographical position on the island. Although the quarry is in an extremely isolated part of the island, facing the open sea, they have drawn it closer to where it could be seen by visitors to the island. The irony is not lost on the mural's creators of the use of the stone from the quarry for building the maximum security prison by the very people who dug it out. The detail with which the walls are painted in Pictures 1 and 3 capture the power of the prisoner choosing to create beauty out of ugliness. The prisoners dug and napleined (neatened and shaped) the stone with which they decorated the prison they had built for themselves. The brutality of life in

prison and the defiance of prisoners can aptly be viewed through life in the stone quarry. The mural creators demonstrate that they have understood and valued this message of hope and resilience.

The insertion of people, or the peopling of the island in Picture 2 is very interesting. Participants are told that no children were allowed to visit the island. Some of the political prisoners were not able to hold a child for eighteen years. A particularly moving story is told by Reverend Tisane, a former political prisoner, of how prisoners working in the lime quarry heard the sounds of children in the distance. They stopped working and eventually the sounds made by the children of warders living on the island drew nearer. The insertion of a child into Picture 2 on the arm of an adult creates an image untrue to the reality but true to the political prisoners' desire or longing.

Since 2001 children and grandchildren of former political prisoners from all the prisons in South Africa have been invited to participate in Spring School. The insertion of the child in Picture 3 is the more poignant, as for many of the young people who have come to the island, the stories of their parent's imprisonment are new. The manner in which Picture 2 incorporates aspects of life on the mainland and life on the island suggests the interconnectivity between life in prison and life on the mainland. The banner 'Freedom or death' is from a slogan that reads, 'freedom or death victory is certain,'[16] again echoing the sentiments of hope and defiance in trying and traumatic circumstances. Interestingly, long serving prisoners often felt encouraged when groups of new prisoners were brought to Robben Island, as this indicated that the struggle against apartheid was continuing despite their imprisonment.

The paintings in the mural are evocative. Through their colours, textures and symbolic images, they reflect an understanding and knowledge of aspects of the Robben Island legacy. The text of the paintings is more than mere reproduction – the attempt to achieve an interpretative dimension is clear. The light emanating from the prison cells in Picture 1, the swimmer in the sea, also in Picture 1, the defiant chained fists in Picture 4, the happy schoolboy in Picture 2, the prisoner holding the pickaxe as if it were a weapon in Picture 1 versus the warder towering over a prisoner with a baton, a banner flying in Picture 2, walls so high that one cannot see the mountain in Picture 3 – all these indicate that although the narrative of Robben Island Museum is articulated within the triumph discourse, there is awareness and knowledge of the pain that accompanies this triumph. RIM is often criticised for its representation of the prison experience as triumphant while ignoring the ongoing pain and suffering experienced by prisoners. What the paintings reveal is that the young people who participated in this workshop understood the subtleties of life in prison, the contradictions and complexities where defiance lived with subjugation.

Secondly, the relationship between the island and the mainland as places of imprisonment and the island as a key symbol of that repression is also something understood and integrated into their representation. Picture 3 could easily be interpreted as a representation of any prison in the country. The emergence of the black fists in broken chains bears a strong resemblance to images of resistance and defiance in South African posters of the1970s and 1980s. Their insertion into Picture 4 shows how the past flows into the present, with symbols taking on new meanings.

'*Uvimba wolwazi*: creating a culture of human rights and responsibility'. This is the vision statement of the Robben Island Museum Education Department. The practice of *uvimba* is common in rural South Africa: taking a portion of the harvest, digging a hole and storing it there until the following year. It is used in times of emergency or when there is a need for replanting from the old crop in a new season. *Wolwazi* means knowledge. This phrase encapsulates the need for an institution such as Robben Island Museum to harvest lessons learnt from the past to generate a new kind of knowledge that can support a culture of human rights. By bringing the past into the present through creative means, we can catalyse thinking amongst young people about their role in society and inspire them to take action.

The mural art form, as it has in the past, has become at RIM a tool by which young people can communicate their understanding and representation of the past to generations to come. This communication is the more powerful as they share with each other what meaning Robben Island has for them. The strength and sense of empowerment, the social commentary on what has taken place in the past are key messages to be shared. The sense of ownership of the past and the implications of this for their own lives and struggle is well articulated through the art form. The use of murals in the 1980s to reflect and interpret life within the confines of a repressive system has now become a new way of assisting young people to re-interpret the past within the present.

Representing and communicating the past is complicated work. We still face many challenges as there are 'silences' in the Robben Island Museum collection and in our interpretation there are 'hauntings'. But the artwork presented here reflects the intensity with which new generations engage with the past and how they infuse it with their own understanding and knowledge. How to continue sharpening the interrogative nature of our work still needs constant reflection and further research.

Acknowledgements
My thanks to
Ndzuzo Luvuyo: Outreach Officer, Robben Island Museum
Lionel Davis: Heritage Educator, Robben Island Museum
Vanessa De Kock: Adult Education Programs Officer, Robben Island Museum
Noel Solani: Historian and critic
Dr Premesh Lalu: Historian, University of the Western Cape
Dr LeslieWitz: Historian, University of the Western Cape

Notes

1 The most important heritage resource for the RIM is arguably the intangible, the memories of a nation, its associations, relationship with the island. It would also be the memories of so many across the world for whom it symbolised the imprisonment of RSA as a nation through apartheid. The buildings and physical landscape have inscribed in it these memories and significances for those who lived there. For those who were actively prevented from physically being there, it has a symbolic presence. The triggers therefore are not necessarily individual spaces or a geographical location but rather a mental one.

2 Spring School 2002, *'Isivivane solwazi*: through art and culture' Memorialising knowledge through art and culture.

3 '...establishing continuity in a person's life often demands repressing or hiding certain ambiguous experiences even if they were pivotal to the individual's life', Helena Pohlandt-McCormick, 2000: 42.

4 Such as the submussions by big business during TRC hearings denying, with the exception of insurance and investment giant SANLAM, that they had benefited from or supported apartheid. This denial of involvement in apartheid and attempt to recast themselves as non-racist, non-supporters of it, claiming that they did not vote for the racist National Party and were not aware of the brutality of the system was of course a significant assertion, given the history of the mining industry with separate hovels to accommodate black workers, no safety and security mechanisms for miners, racist labour policies, etc.

5 During South Africa's occupation of what was called South West Africa, a significant number of prisoners from the South West African People's Organisation, SWAPO were imprisoned on Robben Island.

6 The overarching theme for Spring School is *Isivivane Solwazi*, 'memorialising knowledge' by different means such as arts and culture, sport, inclusive arts. The irony of 'memorialising' knowledge is a key principle: young people are taught how knowledge is best memorialised through integrating into the present, through practices, values, etc.

7 The term is used here within the Black Consciousness Movement's notion of oppressed peoples of colour.

8 Having its roots in the racist notion that Black people cannot appreciate beauty or need spiritual stimulus, in turn embedded in the notion of the 'savage' or 'uncivilised'.

9 In reference to Gordon (1997), where the achievements of the past become a mechanism which releases a level of activism and responsibility and accountability amongst young people rather than apathy and complacency in the face of new struggles such as HIV/ AIDS, poverty, etc.

10 During the prison period political prisoners created artefacts such as a saxophone, knitted jerseys and belts from materials found around the island.

11 one interesting attempt at teaching multilingualism in prison was holding one language days, where prisoners were encouraged to speak only one language a day in an attempt to learn it (personal communication: Dr Neville Alexander). As prisoners were drawn from all the provinces of RSA, a number of languages were represented.

12 Partly out of a desire to be out of the prison cells, enjoy feast days and opportunities to communicate clandestinely, prisoners often attended services of various denominations.

13 Rigorous discussions and debates on cultural practices such as circumcision preceded the beginnings of a circumcision school in prison. Which, ironically one of the warders attended.

14 In political classes a prisoner studied a particular document, before a debate on the topic in which all were invited to participate. Serious formal and informal study took place with a view to eradicating illiteracy (personal communication: Dr Neville Alexander, General Masondo).

15 Initially sport clubs were divided along organisational lines, perpetuating inter-organisational rivalry. With time it was changed to promote unity (a theme used for Spring School 2001).

16 A slogan of the South African Youth Congress, launched in 1987 at the height of the state of emergency and state repression.

Museum as memory maker
Spring School theme: memorializing knowledge
= Knowledge of the past is best memorialized by incorporating it into the present.

8

The 198 Gallery

Lucy Davis and Folami Bayode

Introduction

The London borough of Lambeth is a richly multicultural borough containing grandiose housing which sits in stark contrast to inner city public housing disasters such as Moorlands and Stockwell Park Estates. It is an eclectic place where fashionable trendsetters rub shoulders with a population of locals and residents from across the world, most noticeably people of African Caribbean origin. Since the 1950s this community has established a diverse cultural feel and provided a dynamic anti-establishment edge to the borough. Brixton today is a dynamic and pulsating environment, where one can sample the food, art and music of communities from as far away as Eritrea, the Caribbean and Peru. Brixton has become a focal point of creative expression for many local people – a space where more languages are spoken per square mile than in most places in Britain.

198 Gallery grew out of the social unrest of the 1980s, when tension and fear pervaded the community. The usual measure of racism and discrimination to be found in urban UK cities at the time was exacerbated by the introduction of SUS laws[1]. In effect, SUS meant that mostly young Black men were indiscriminately and randomly stopped and searched openly in the street. This increased conflict and tension between the local community and police. A stop and search incident in the summer of 1981 lit a powder keg of resentment and frustration, resulting in some of the most serious street disturbances seen in Britain since the war. Local businesses run by alleged police informers were torched.

Four years later, in 1985, people took to the streets and Brixton erupted again when police stormed the home of Black mother Cherry Groce and shot her

in the back. Black community leaders worked hard to bring peace to the streets while accusing the police and politicians of failing in their duty of care towards the Black community. From the debris of such social unrest arose opportunities for community leaders to have their voices heard and also to implement regenerative projects to empower the local community to express themselves politically, economically and creatively. Funding provided by government to stimulate social regeneration in the community was an important catalyst for supporting Roots Community Limited, which in 1988 became the 198 Gallery.

Roots Community began from a chance conversation between John 'Noel' Morgan and Zoë Linsley-Thomas. Zoë was a minicab driver and John, manager of Vargus Social Club in Landor Road, just another fare on a rainy November evening. Out of this first conversation developed a partnership that would grow over the coming years, forming the initial ideas that would take root and see the emergence of Roots Community Association at 198 Railton, Road, just a few minutes walk from the Brixton 'frontline' – the scene of the start of 1981 uprisings.

The Black Angels Project

Two-thirds of the population of young offenders have left or been excluded from school at the age of thirteen or under. Home office research reveals that over 80 percent of young offenders of school age are out of school either through exclusion or refusal to attend. Now all of that points to the evidence of the link between school exclusion and social exclusion. (John, 2003:13)

In collaboration with a local secondary school, Stockwell Park, *Black Angels* carried out the first 198 education project to address local issues directly. Stockwell Park, with its culturally diverse student intake and 40 different languages spoken, reflects the rich cultural profile of the borough. Like the 198 Gallery, it is set in an area of social deprivation where drug abuse, crime, poor housing and unemployment are high. Struggling with a range of social and educational concerns, a group of vulnerable students from the school were on the verge of permanent exclusion. The partnership with 198 Gallery offered these students another chance and an alternative education tailored to meet their needs and support them in their interests. In response to specific government initiatives, and with the aid of Lambeth Education Business Partnership, the 198 Gallery offered workplace-based learning to these twelve young people.

Urban Vision staff have a specific combination of skills and the project is designed so as to encourage personal responsibility and professionalism. Staff are qualified youth workers and freelance arts professionals in graphic design/ new media who can also act as peer mentors through shared knowledge and

Photograph of Danny by Catia from the Brixton Studio project,
Urban Vision 2002

experience of contemporary inner city street culture. They have put together a process, a personal journey for young people, which, while not solely focused on the end product, ensures a professional outcome while compelling them to think about their often antisocial behaviour and learn new skills.

The group of Black Angel students comprised African and African Caribbean 15 and 16 year olds. They visited the 198 Gallery one day a week for 18 months, to participate in a student-centred project that incorporated creative IT skills, music, visual and written literacy. Using software packages such as *Adobe PhotoShop* and *QuarkExpress*, the students designed and produced their own images for the cover and interior of a CD-ROM, which they wrote and recorded. They took visual inspiration from their interest in graffiti art and popular culture.

The Black Angels project and the development of the digital media studio initiated a working model. Out of this in 2000 came the project called *Urban Vision*, bringing new ideas and structures together. A new media art education programme for 7-19 year olds offered projects and training, providing participants with the opportunity to have a voice on issues that are relevant to their

lives. The 198 Gallery established key partnerships with a range of organisations, as the link became more apparent between school exclusions and crime. Organisations involved included Lambeth Youth Offending Team or (YOT) Social Services, voluntary sector organisations and Lambeth Connexions Service. They referred groups of vulnerable, disaffected and socially excluded young people to the project to explore digital media, photography, film, video and animation – often within issue-based contexts.

About 200 of these cases required a reparation element. Reparation is a major component in a restorative justice system that asks young people to pay back to their community for their crimes. Since 1998 there has been a movement towards a more individualistic approach to reparation, which involves looking at the actual offence, having input from victims and outcomes that will benefit the fabric of the community. The belief is that the best community reparation will be that which challenges young people to reflect on their offence and genuinely gives back to the community through some means to which the young person can relate. It is the last point which has been the most difficult to achieve, particularly in the inner city context where the methods of mainstream education have little success.

The Anti-crime Poster Project

Melanie Phillips (1996) argues the need to promote a culture of social responsibility. She says:

> Transforming the culture of individualism means making connections which have been allowed to atrophy. It means restoring a sense of personal and group responsibility, which means a new relationship between the individual and the state, and an enhanced role for the intermediate institutions of the voluntary sector. We need a state that enables people to take better care of each other. That means restoring the sense of the personal to structures that have become de-personalised, such as the criminal justice system for juveniles who commit the overwhelming majority of crimes. (Phillips, 1996:338)

The Urban Vision and Lambeth YOT partnership has become one of the key providers of reparation in the borough.

Grace

Grace joined the UV project three years ago. A tall, slim 16 year old, she, like most Black girls her age, was interested in fashion, music and socialising with her friends. She knew the streets of Brixton well, was street-wise, confident, sociable and polite. Placed into care at the age of 14, Grace drifted further away from school. Her anti-social antics in the classroom were not tolerated and she felt harassed by school staff to the point that she no longer wanted to attend. Her mother's mental health problems created further instability and

disrupted her family life. Grace became totally disaffected. For two years she slipped through the cracks of the system. At 16 she was involved in a fight. Grace says she snapped after being teased and tormented by another girl. She physically confronted the girl who sustained enough injuries for Grace to be charged with common assault. Because she was in care, the case was immediately taken up by Lambeth YOT. As part of her reparation, Grace had to take an anger management course and attend the Urban Vision project at the 198 Gallery for 20 hours in order to make an anti-crime poster.

When she first heard about the 198 Gallery, Grace was not impressed and she was determined to get her 20 hours completed as quickly as possible. But after her first visit, her attitude changed to wanting to get as much out of this opportunity as she could.

> She saw the Gallery as a way of making something good out of a bad situation. Grace was amazed at the equipment and opportunities She took advantage of the fact that it was all free! She found the court experience extremely traumatic and was adamant that it was the last time she'd go through anything like that. (Williams, 2003)

Young people are received at 198 Gallery digital media suite under the guidance and supervision of UV staff and produce anti-crime posters and T-shirt designs based on their offence. The posters have been displayed at public sites through two separate initiatives: The Crime Prevention Trust's Anti-Street Crime Campaign, and London Underground's Platform for Art programme.

Student/staff relationships are paramount to the project and at its foundation lies a philosophy of humanism and nurturing creativity that is value-creating[2] for all concerned. Kareen Williams, Urban Vision Project Manager, observes that, 'it is the amount of talking and challenging in the process and the fact that the project is participant-centred and not formally part of the YOT, that contributes to its success.'

Despite missing two years of education, and the instability of her home life, Grace was a student who found within herself the determination to overcome her difficulties. She got on well with the staff at the Gallery. She found the work-business atmosphere non-threatening and far more inviting than a normal school setting. Without any support from family or a school, Grace took advantage of the support on offer from the staff at Urban Vision.

Support of this type within the framework of the project is what creates an opportunity for transformation of self and of belief systems. No transformation take place without dialogue between worker and student. The process of dialogue within the project reflects what Freire (1990) described as a 'dialogical' approach. His definition of the term aptly illustrates the two aspects of the project:

FIGHTING

There are consequences

to

using these

Prison, Fines, Courtcases, Criminal Record

dialogue

> Within the word [dialogue] we find two dimensions, reflection and action, in such radical interaction that if one is sacrificed – even in part – the other suffers (Friere, 1990: 68).

The discussions between student and staff (reflection) are intrinsic to the creative design work (action) undertaken in the project. Each informs and influences the other.

Once the initial process of developing a working relationship had been achieved, students discussed images from the media aimed at young people and also posters that were created by previous participants on the project. Grace was a willing participant, becoming more confident while deconstructing the images and unpicking the design process. She was well aware of how media messages can be authoritarian and, rather than inform young people, tell them what to do. Knowing too well the failures of that type of message, Grace sought alternatives.

> As a young person it's very easy to see things one way. When we discussed the media images, I realised how people can see the same image, but respond to it differently. This let me become more open minded, and consider other people's points of view. People tend to take things literally, so you have to be careful how you present things and you have to take other people's views into consideration. (Grace, 2004)

Grace was able to transcend her initial fixed perception of art, design and media, and thus access skills and tools of understanding that enabled her to fully apply her personal experiences to her creative work. Her designs took on a more dynamic edge as her determination to find innovative ways of communicating her message to young people increased. This process enabled Grace to engage with the duality of her personal experience and technical skills and so find her own artistic expression. It is this which gives the works created at the UV project a particular dynamic energy, bringing a fresh, innovative aesthetic to the artistic world, thus putting the work produced on a level with that of professionally trained artists and designers.

The term 'communication' is inadequate to convey the depth and means of interaction that take place between students and UV staff. Freire speaks of the importance of partnership between educator and student. Of the educator, he says, 'from the outset, her efforts must be imbued with a quest for mutual humanisation. His efforts must be imbued with a profound trust in people and their creative power. (Friere, 1990:56)

opposite: Anti-crime poster by young person, from the Platform for Art series in collaboration with London Underground and Lambeth Youth Offending Team, Urban Vision 2003

The UV team at the 198 have profound trust in the young people in the scheme and this distinguishes our approach to gallery education. The issues of crime, perpetrator and victim are addressed objectively as points from which each student can navigate their way towards learning from their experiences and transforming them to create choices for their future. Given the time and space to reflect, Grace began to recognise alternatives means to violence and injuring others for sorting out her problems. Her final poster design reflects her new, more mature reflection on the conflict that brought her to the project.

> Grace enjoyed learning and was keen to continue on the project after her reparation hours had been completed. She gained a place at college studying music technology and re-visited the project to learn web design and graphic packages. (Williams, 2004)

The project provides Grace with the support to maintain her development. Without the support of family she finds personal responsibility difficult and desires the space to be a typical teenager. UV staff provide a motivational role, giving guidance and encouragement, as Kareen Williams says, 'from helping her with her CV to giving her a ring one morning to remind her to get an assignment in on time!' (Williams, 2003).

Mohammed

Not all the students on the urban vision course were perpetrators of crime, some were the victims. One such is Mohammed. He arrived aged 12 in the UK, with his younger brother. They were unaccompanied refugee children. His father and older brothers and sisters had been killed or conscripted to fight in Somalia. Only he and his brother had survived, by being hidden by their mother during a raid. His mother, a successful market trader in Somalia, managed to persuade a fellow trader to bring the boys over to the UK. On arrival, Mohammed and his brother were abandoned in a café in London. They were taken in by Social Services who placed them with foster carers. The carers were kind enough to the boys and they were glad to be together. Communication was a problem because, even though their foster carers were Muslim like themselves, they did not speak the same language. In the four months it took social services to find Mohammed and his brother a school place, the boys were left to teach themselves to speak and understand English by watching the television all day.

Finally allocated a place at Lilian Baylis School, Mohammed was referred to Urban Vision. Neither he nor his brother had any education in Somalia. Neither could read or write in their native language. They grew up playing basketball near the market and helping their mother with her trading. It was thought a smaller less formal environment with less emphasis on academic learning would suit him. Also, he was interested in IT.

Mohammed spent his time learning black and white photography, *PhotoShop* and Digital manipulation to design magazine covers, posters and other images.

> Mohammed was hungry for knowledge. His enthusiasm was insatiable. Even though his creative skills left a lot to be desired compared to the other young people, Mohammed's technical skills were second to none. He knew PhotoShop so thoroughly after a few months, that he would help the local primary school kids learn it during the after school clubs we ran. (Williams, 2003)

There was a broken enlarger at the Gallery that none of the staff could fix. After taking it apart, Mohammed reassembled it in full working order. He was a well-loved young man. Even though his enthusiasm set him apart from his peers, the other youths respected him and admired his energy. Working with a photographer, he explored his new environment Brixton through the lens of a camera and learnt portrait photography. During that time the group held an exhibition of their photography, which was professionally mounted and hung at the Ritzy Cinema in Brixton. The private view was attended by teachers, school friends and the school Principal. Mohammed spoke about going back to Somalia to find his mother one day when he is older, and taking her photograph.

Three years later he is still in touch with Urban Vision, receiving support in his college applications to study computer engineering. He is also learning other new media packages on the programme. He has had to bear so much responsibility at such a young age, taking care of a younger sibling in exceptional circumstances. UV afforded Mohammed the chance to develop his interests in an environment where he was given plenty of attention. He was able to develop a sense of belonging and build his confidence and self esteem.

Not all students have Mohammed's kind of motivation and self-discipline but discipline and professionalism are encouraged and expected throughout the UV programme. Some young people involved in crime and violence have difficulty reflecting on their experiences and taking responsibility for their actions. Choices and their consequences are presented together, and as students come to understand such implications, their growth enables them to take a more disciplined approach to their work and to each other.

> The only way to shift a culture is to change the way people think about themselves and what they do. That can only be done if they become aware of the effects upon others of their behaviour. (Phillips, 1996 p.340)

Reflection and thought of this nature, generated by the dialogical process, helps students put themselves in other people's shoes and consider the consequences of their actions and how they might affect the lives of others. This is part of the value-creating element of the project. Although no judgement is

placed on the students themselves, students are made familiar with the notion of reparation and how it affects them. Trying to encourage such young people to reflect upon the consequences of their actions in disrupting the lives of other people as well as their own is not easy and has to be handled sensitively. UV staff clearly outline acceptable and unacceptable behaviour during the dialogical process and they have observed positive changes of attitude and increased confidence in students as a consequence. The high level of professionalism expected from each student and the high expectations of achievement are further affirmations.

Urban Vision provides a space for a new beginning, where students are given simple choices, and the consequences for their choice are identified within a structure which puts responsibility back onto the individual. The project encourages young people to focus on the present in order to empower themselves. Students are shown that by changing their attitude and embracing a more positive set of values/beliefs about themselves, they have a chance to achieve something worthwhile that creates value in their own lives and for others around them.

Notes

1 SUS laws (stop-and-search) – a power used by police to stop and search any citizen whom the officer deems is 'under suspicion' of having committed or being about to commit a crime. This can be done openly in the street without arrest.

The much-hated laws were introduced in the 1960s, and police use of these powers contributed to the inner city riots of the early 1980s which led to its abolition. However, new legislation came into force and the inquiry that followed the murder of Stephen Lawrence in April 1993 (Macpherson, 1999) reported that Black people were five times more likely to be stopped and searched than their white counterparts. Five years later this disproportionality has increased dramatically, with Black people now eight times more likely to be stopped. It was only after Macpherson reported in 1999 that officers were required to record stop-and-search incidents.

2 The terms 'value' and 'value-creation' are used here because the process used reparation and transformation through dialogue reflects some of Tsunesaburo Makiguchi's (1871-1944) Value-creating pedagogy (see Bethel, 1989). In his book *Education For Creative Living*, Makiguchi states that the 'fundamental criterion for value ... is whether something adds to or detracts from, advances or hinders, the human condition.' (ca. 1923 p.17). He observes that

> Human life is a process of creating value, and education should guide us toward that end ... To live to ones full realisation of one's potential is to attain and actualise values. Helping us to learn and live as creators of value is the purpose of education. (p54)

9

Comique Absolu

Sarnath Banerjee

Many people in the English-speaking world regard comics as escapist pulp literature for children or adults that is obliged to be funny. This tends to marginalise the genre, putting it in a cultural closet. However this does have advantages: being free from the critical and institutional gaze of the arts establishment, comic artists have been able to redefine the medium by questioning formal and stylistic as well as cultural and political taboos. This has generated highly acclaimed and innovative works such as the Pulitzar Prize winning *Maus* by Art Speigelman, and Joe Sacco's *Palestine*.

Comic art started as underground activity and was soon recognised by the art establishment as an important art form. Speigelman used it to record a survivor's experience in Auschwitz. Amnesty International have used comic books to highlight their concerns on apartheid South Africa. American cartoonist and war correspondent Joe Sacco's first-hand experience of the Bosnian war zone was depicted in *The stories of Bosnia*, and four pages of his comics on the Palestine crisis appeared in *Time* magazine (March, 2001). Such work has given rise to a new form of journalism. Robert Crumb's chronicling of consumerist America made him a popular cultural figure. Will Eisner's work on the immigrant Jews of the New York Bronx made him a father figure of modern comics. Such work has redefined the comic form. It has become legitimised as a serious medium of visual communication that functions as a critical and social practice.

Apart from the relatively cheap cost of production, creating or reading comics is a sophisticated process that requires deep involvement. The comic's visual and textual form itself provides complexity through multivalent interpretive possibilities, multiple points of narrative and a unique sense of interiority.

Comics forge a deliberate, mutually reflective patterning between words and images by conjoining seemingly unrelated verbal and visual narratives. Also, the words and images magnify, undercut or otherwise comment upon each other. At points, the text and visuals become sharply fragmented and move in different directions. This produces conflicting simultaneous emotions, articulating both an event and how that event is experienced within a contained, coordinated space. Seemingly ordinary stories about the mundane can thus create a deep effect upon the reader's perception.

The *comique absolu* project

Comique absolu is a collaborative movement intended to publish a quarterly journal with changing subtitles around issues ranging from food, dislocation and abuse to urban conditions, developmental issues and other important aspects of culture. It seeks to explore interior spaces, creating a lifeboat for the best of the Asian, African and Caribbean narrators who may or may not have a graphics/comics background. Members of the project strive to forge uncomfortable pairings between a variety of cultural producers such as photographers, printmakers, performers, academics, musicians, filmmakers and people on the street. They are well aware that many of the artists and writers will have little in common either geographically, culturally or stylistically, although they expect them to be able to resonate with each other's work.

The project has started working with members of the south Asian community in the London borough of Tower Hamlets and with mainly African Caribbean people in Brixton. Members are making work about their lives and their communities, using the comic form to articulate narratives of existence in Britain today as experienced by members of their community. Few of these people are trained artists, let alone graphic artists. Rather, they are people with something to say, who are confident enough to attempt making work in this medium. As such making comic narratives should be seen as a popular art form in the truest sense, a visual practice that is open to everyone and a visual medium that provides a voice for ordinary people who wish to comment upon issues affecting their social existence.

The visual chapter that follows invites us to enter the world of a south Asian man whose thoughts drift in and out of different points of experience. It takes us on a physical and psychological journey and deposits us in a space that begs more questions about identity and belonging.

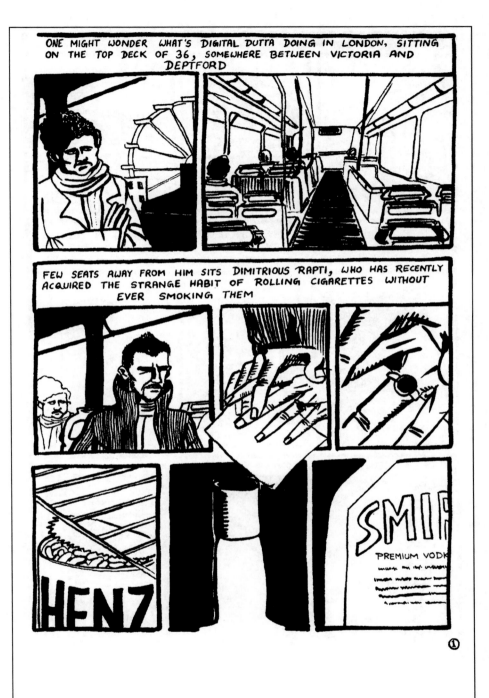

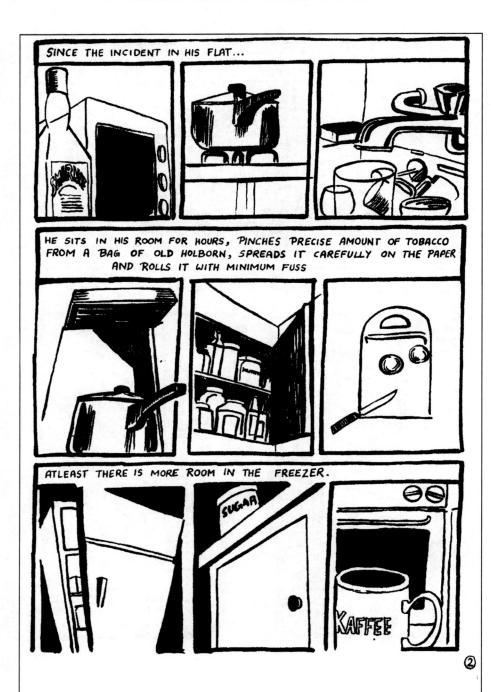

HIS FLATMATE MIGUEL PARRA MET UP WITH CLAIRE IN A POSH CAFE OFF OLD STREET, FOR THEIR FIRST DATE

THEY HAD THE MOST ENGAGING CONVERSATION AROUND GERMAN EXPRESSIONISM···

THEN, DURING A PAUSE

WILL YOU SLEEP WITH ME?

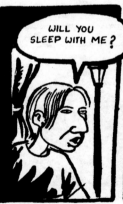

YOU WOULDN'T HAVE ASKED IF YOU REALLY MEANT IT

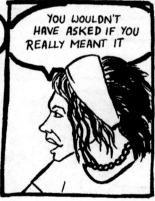

③

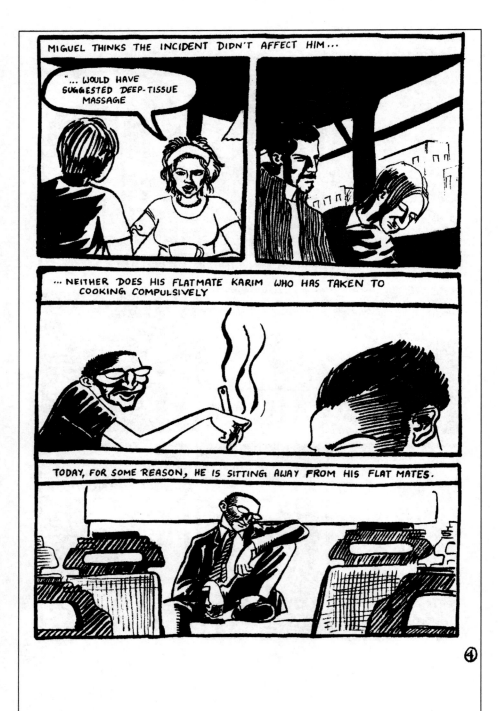

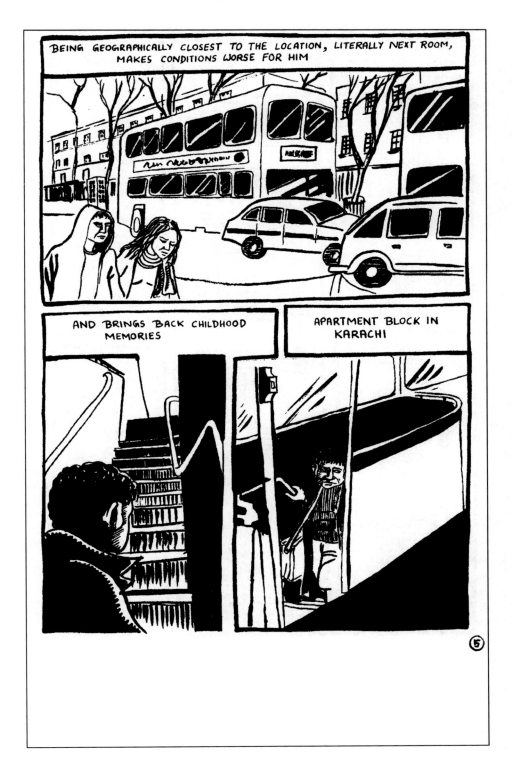

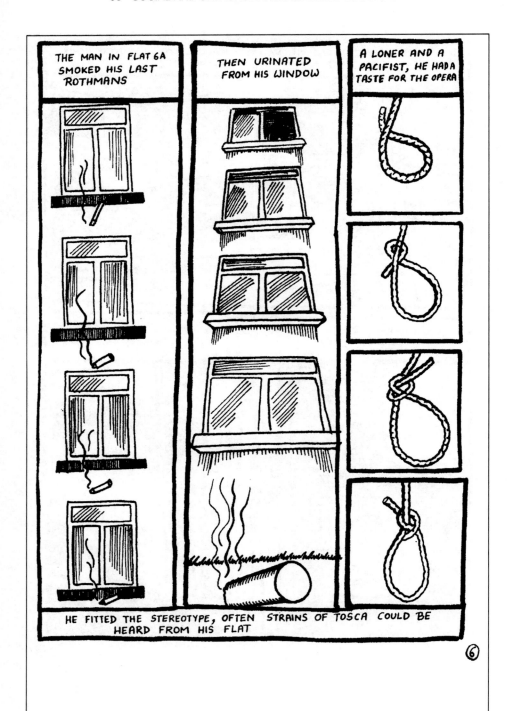

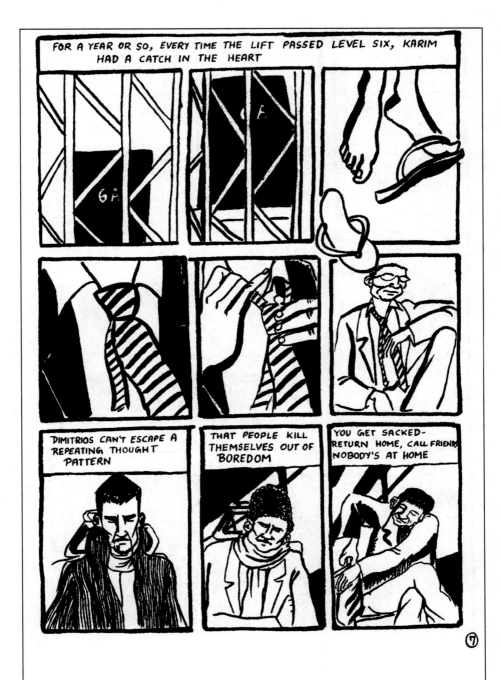

YOU ARE ABOUT TO CALL YOUR LOVER, BUT REALISE THAT YOU BROKE UP, YEARS AGO.

DESPERATE FOR A SIGN. YOU GO OUT ON THE STREETS

LONDON IS HIJACKED BY PRE-CHRISTMAS MADNESS — LIGHTS IN OXFORD STREET, HAPPY FAMILIES

YOU RETURN HOME, SWITCH ON THE TELEVISION, NOTHING'S ON

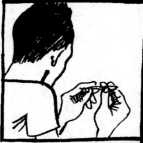

LIFE RESEMBLES A CIRCUS - A TRAPEZE ACT, YOU JUMP FROM ONE TO ANOTHER, EXCEPT NONE OF THE TRAPEZES ARE CONNECTED TO THE CEILING

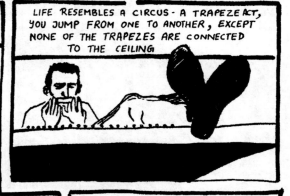

YOU FALL AND FALL, AS IF IN A VORTEX - IT GETS BORING

may the god who dances with creation...

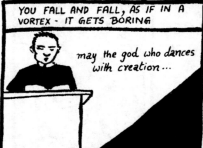

ONE OF THOSE DAYS, NOTHING SEEMS TO WORK, EXCEPT...

... who embrace us with human love

...THE HUNDRED ODD SLEEPING PILLS IN THE DRAWER

AND HALF AN EMPTY BOTTLE OF VODKA LYING IN THE KITCHEN

JUST ENOUGH NOT TO VOMIT

10

Outtakes[1]

susan pui san lok

... when you try to understand what things in you are Chinese, how do you separate what is peculiar to childhood, to poverty, insanities, one family, your mother who marked your growing with stories, from what is Chinese? What is Chinese tradition and what is the movies?

My silence was thickest – total – during the three years that I covered my school paintings with black paint. I painted layers of black over houses and flowers and suns, and when I drew on the blackboard I put a layer of chalk on top. I was making a stage curtain, and it was the moment before the curtain parted or rose. (Maxine Hong Kingston, *The Woman Warrior*, 1976)

Cutting In

If looks can kill, a glance might cut. Deflecting the glare of exoticising gazes, the artist defies mortification, dares to look back, and takes off with another (same and other), relenting, to be seen yet unseen. After her early confrontational self-portraits, Lesley Sanderson's work through the late 1980s and early 1990s offer a gradual deconstruction of Western art historical narratives of orientalised, objectified female bodies, consistently exploiting the tensions between figure, frame and gaze. Drawing, 'a precarious object' traditionally ranked as a working, in-process, anticipatory precursor to a 'final work' of art, continues to be mobilised within Sanderson's progressively object-based, interventionist and installation works for its 'peculiar attributes' of 'transience, incompleteness, contingency' against notions of originality, uniqueness, and authenticity.[2]

In *Negative* (1988) to *Self Portrait – Larger than Life* (1990), *Reproductions* (1991) and *These Colours Run* (1994), imaged subjects, image planes,

imaginary and actual frames (including those of the gallery), are subjected to persistent fragmentation and multiplication.[3] Looming large, looking back with several eyes, now masked, now screened, dispersing and disappearing between borders, the staging of subjectivities and identities via a series of literal and metaphorical unframings augments in scale and complexity, invoking painting, photography, curatorial conventions of re/presentation, and the orientalist paraphernalia that accompany the intertwined visual narratives of Western art history and contemporary popular tourism. As evidenced in such pieces as *He Took Fabulous Trips* (1990) and *Can't See the Wood for the Trees* (1992), Sanderson's 'bold omissions and minute depictions'[4] gently displace the whole. Props and accessories from sarongs to sandals, masks to shoes, seals to screens, hint inconclusively at 'other' visual and spatial narratives of culture and identity, evoking clichés of the exotic, primitive East or the modern progressive West, yet withholds the possibility of a behind-the-scenes-real; instead, Sanderson unfolds a succession of '*de-mises en scènes*' adrift with blankness – a signifier of silence, potential, absence and erasure, or an invisible and ubiquitous technological presence' – interrupted.[5]

Subjects slip out of view, evasive. Gestures and poses are ambiguous. Later, expansive landscapes of flesh invite scrutiny without mastery, their proximity and boundlessness deferring the delimiting of 'I', an envelope opened out. Disembodied and indeterminate in intimate monochrome, skin comes up close, a surface of feathery granite, the grain of a voice, ventriloquised.[6] *Fabrication and Reality* (1998) finds this porous, elusive landscape locked into a dyad with miniaturised twin towers, schematically delineated on carbon copy paper. A cheap wardrobe-husk braces the body-fragment, a strange, dense expanse dwarfing a duplicate double icon of identity, power, and birthplace. An emblematic home: Asia-as-landmark, Malaysia made toy-like and flimsy, diminished in ambiguous relation to an incorporated yet segregated subject. An eyehole punctures the boxed body shells, summoning voyeurs to peer into the blue: the substance of daydream, inside and out.

The de-centralised ex-centricity of Sanderson's own body, combined with her tactical use of the nude or exposed flesh, suggest an affinity with performance art. Her 'performances' are mediated through drawing as the medium of documentation, whose constructedness levers control over the spectacle, and distances the aura of 'authenticity' about imaginary encounters. As Coco Fusco has noted of the practices of contemporary African American artists, a context with which Sanderson's has been broadly aligned,[7] bodies are continuously returned to historical scenes (partially emptied, necessarily incomplete), demonstrating their imbrication in contemporary racial and cultural consciousness, whilst their increasing occupation of a muted 'fantasmatic realm of intertwined fear and desire' mirrors a paradigmatic shift in the 1990s away from emphases on 'the indexicality of images of racism'.[8]

If Lorna Simpson established a 'zero degree' in the late 1980s and early 1990s for rethinking the representation, exhibition and subversion of iconic Black female bodies, particularly via the photographic image, some of her tactics are echoed in Sanderson's practice: bodies slip in and out of frame, partially blocked, the relationship between subject and historical and socio-cultural context destabilised. Simpson's and Lyle Ashton Harris's use of 'props' to signify the constructedness of femininity, masculinity, Afrocentricity or African-ness, serve a similar function in Sanderson's work, theatricalising the coding and performance of gendered ethnicity, 'British Chinese-ness' and cultural otherness.

Paraphrasing Fusco, the shift might be elaborated as a move away from representing the 'oriental' to representing what it means to be orientalised, by offering and refusing the artists' own bodies as subjects and objects or, in Stuart Hall's terms, effecting a shift 'from a struggle over the relations of representation to a politics of representation itself.'[9] The intimation of unbounded, indeterminable bodies in Sanderson's later pieces, made in collaboration with artist Neil Conroy, hints furthermore at the possibility of a new humanism unhindered by 'race'; contradicting the 'triumphal tones of the anthropological discourses that were enthusiastically supportive of race-thinking in earlier, imperial times... conceived explicitly as a response to the sufferings that raciology has wrought,' Paul Gilroy (2000) expounds a 'univer-sality' where the constraints of bodily existence (being in the world) are admitted and even welcomed, though there is a strong inducement to see and value them differently as sources of identification and empathy. The recur-rence of pain, disease, humiliation and loss of dignity, grief, and care for those one loves can all contribute to an abstract sense of a human similarity power-ful enough to make solidarities based on cultural particularity appear sud-denly trivial. (p.17-18)

Having worked informally with Conroy over a number of years, *Fabrication and Reality* marked the beginning of Conroy/Sanderson's formal collaborative practice. Their dual agency and authorship foreground the mutual, historical, ideological and cultural imbrication of gendered and ethnicised cultural identities, whose ambiguity complicate the binary opposition of dominant/ marginal, male/female, white/black, same/other positionings, histories and genealogies. This intricacy is intimated in *He Took Fabulous Trips*, and most explicitly in *Fabrication* (1998), where both artists and their respective parents are nominally represented in primarily blank full length 'portraits' depicting only the foreheads of their subjects. Each panel is scanned by a red light, at the same time 'underscored' by a blue neon strip, which pulses to the accom-panying sound of lifts ascending and descending. Bodies are suspended, near-evaporated, made similar by the dissolution of physiognomic references to race and gender, eluding regulatory frames and electronic eyes.

Conroy/Sanderson's recent self-portraits effect a shift in tone and an abrupt return to physical, sensory bodies, focusing with dry humour on the intense alliance and antagonism that might arise in a partnership where identities and positionings are explicitly contingent. In so doing, they also respond to a fascination with culturally and ethnically 'mixed' relationships by performatively offering and denying themselves as spectacle. *Doctored* (2003), a series of photogaphic light boxes, finds Conroy/Sanderson variously concealed or muffled; doubled up in 'double happiness' (the doubling of a Chinese character symbolising marital bliss), s/he's captured, enraptured, enraged. Wrapped up, in arms, their faces-for-hands are tied. They become singular, a two-headed monster, an everyday abnormality staring out from pretty coloured strings, now mummified, now bandaged, or blind and mute behind cartoon mouths and eyes. Bandages suggest wounds in need of covering, broken skin, disfigurations; or indeed, deployed to such excess, they become a cover for invisibility, an '*aide memoire et voir.*' Literally clipped by the ears for 'wrong-doings', conjoined by choice and reparation, internalising the playground rhymes and jibes that normalise and racialise same/other bodies, the double-dealing, double-faced, double-hearted, double-tongued speak from the belly, *venter loqui*:

> chinese japanese dirty knees what are these / heads shoulders knees and toes knees and toes / chinese japanese / heads shoulders / dirty knees what are these / knees and toes knees and toes.[10]

Acting Out

'... mimicry represents an ironic compromise... mimicry emerges as the representation of a difference that is itself a process of disavowal' says Homi Bhabha in *Of Mimicry and Man*, (1994).

Sanderson's *Time for a Change* (1988), an early painting within a painting, is recalled by Yeu Lai Mo's *Geisha* (1994) and the later *Spitting* (1997), in a body of work that similarly features self-portraiture as a central device for negotiating dual positions as 'subject of the artist's self-reflexive gaze and object of the viewer's gaze.' In *Time for a Change*, the gaze of the artist-as-nude interrupts and returns by proxy that directed to the young, passive east Asian woman with downcast eyes depicted behind her, 'an Orientalist painting of a Malay or Chinese woman (or, more accurately, a popular reproduction of an orientalist painting) reproduced by the artist within the frame of her own work'.[11] *Geisha* finds Mo clad in Japanese hostess/prostitute's robes, accessorised with palette and paintbrushes, a conflation of exotic images: the sexually available oriental woman whose impassive demeanour is supplemented by tools evoking the modern, romantic, virile masculine ideal of uninhibited artistic self-expression; or the cross-cultural dressing western artist-outsider who swaps gender and paint-covered smock for the restrictive robes of a mysterious eastern muse...[12]

Geisha also shares commonalities with the work of a number of Asian American artists since the 1970s, touching on the complexities of Yasumasa Morimura's and Tiana Thi Thanh Nga's art historical and Hollywood drag, by which the mythologised heroes and heroines of the Western high art canon and popular cinema are impersonated and Asianised, refurnished with orientalised and transgendered Mona Lisas, Manets and Marilyns, and their accompanying bit-players – from 'high-kicking vice cops' to 'dragon ladys' to 'war brides' – reframed.[13] Mo, in turn, echoes earlier endeavours to claim the right to representation by imitation and usurpation, performing a double cultural drag (Chinese as Japanese, muse as maker), playing to the tendency to see all Asian cultures as interchangeable, and foregrounding the fiction of an authentic, ethnic self.

Turning to one contemporary image of young Chinese women, Yeu Lai Mo's video, *Service, Licking, Kissing* (1997) looks at the politics and economics of the Chinese takeaway as a public site of sexualised labour and cultural exchange. The artist films herself mouthing and repeating words of welcome, accommodation and gratitude, each miming denaturalising the utterance, the stance, the subject. Bending to kiss and lick the counter over which she smilingly presides, she translates her attitude of servitude and compliance from the verbal to the physical. This 'semiotics of the takeaway' invokes video as a historical means of staging, documenting and extending the impact of performance, especially for feminist art practices of the 1970s that sought 'a challenge to formalism... to negate the division between art and life, to explore relational dynamics between artist and audience and to understand art as social and experiential.'[14]

Self-Portrait

Service is reminiscent of several pieces by Martha Rosler, in particular *Semiotics of the Kitchen* (1975), *Service: A Trilogy on Colonisation* (1978), and *The East is Red and the West is Bending* (1977). Echoing Rosler's deadpan, absurd, yet politicised works dealing with class, gender and race-inflected relation-

ships between women, food, labour, class, and power (food production as a means of domestic entrapment and drudgery, economic independence or exploitation; and in its exotic 'gourmet' form, as a vehicle of cosmopolitan self-improvement and transformation into imperialist connoisseur of the other), Mo inhabits and oversees the public space of 'foreign' exchange, the 'exotic' accentuated as a metaphor for sexual and cultural consumption, served up in convenient packages for the alleviation and enhancement of contemporary lifestyles.

Centre-frame, centre-stage, eyes meeting the direct gaze of the lens, *Service* revisits the practical limitations of early video technology, aesthetically typified according to Straayer (1985) by 'long takes, little or no editing, little or no camera movement, and direct address of the viewer.'[15] Such traits led Rosalind Krauss to argue in the late 1970s that video art is in essence narcissistic, the 'camera-as-mirror' a metaphor for the artist's self-reflection or self-expression. The notion has since been complicated by psychoanalytic formulations of subjectivity and mis-recognition, and film theory.[16] The cumulative absurdity of Mo's behaviour serves to distance the artist from her performing self, not a 'true', narcissistic expression of authentic subjecthood, but an emphatically performative fiction whose parodic mimicry of feminine and ethnic 'types' hints at agency by appropriating, distinguishing and exceeding the limits of pervasive images. Just as Sanderson's 'self-portraits' are representations or articulations that mirror not the artist's self but wider networks of relationships of looking and power in which audiences are implicated, so video is frequently deployed to mirror back audiences' misidentifications and misrecognitions.

Shown in a number of combinations and contexts including an installation for a solo exhibition called *Yeu Lai's House* (which included part of a mocked up takeaway in a gallery space, complete with lino floor, formica counter and back-lit photographs of sample dishes on an imaginary menu), a key thematic emerges through the figure of 'Yeu Lai', a literal fabrication whose 'inauthenticity' or 'staged-ness' (like Thi Thanh Nga's various personae) is accentuated in degrees: by the monitor as a frame within the frame or stage-set of the inauthentic takeaway, in turn framed by the gallery. The anticipated frisson of a live encounter with the eponymous hostess is diffused: look closely, and the figure standing behind the counter, mirroring the character on screen, is no more real – a mere colour copy cut-out, the artist duplicated and duplicitous.[17]

The monitor is a familiar object in the takeaway, operating, as its name suggests, as a means of surveillance,[18] as well as a medium of display for the broadcasting of satellite TV for satellite cultures, that is, for the conspicuous consumption of the takeaway's workers rather than for its clientele (though

by made audience looking complicit

the latter might expect and enjoy it as an element of authenticity, along with Chinese figurines, bamboo and a fish tank). In *Service, Licking, Kissing*, the segregation of circuits of spectatorship and consumption is collapsed, the sole spectacle being the takeaway employee performing her compliance and conforming to type for both employer and client, made complicit through the act of looking. This act is later facilitated by the magnification of the subject/object under observation: 'Yeu Lai', in a catering pinafore, smiles down from a hanging scroll dominating a gallery wall. Scale monumentalises the mundane and otherwise unseen, yet also underscores the unreality, the fiction of the representation. Displacing mountain-water scenes or images of Chinese and East Asian landmarks with a latter day calendar-girl, the picture of contemporary 'British Chinese' femininity revisits with irony Cultural Revolution representations of industrious, unself-conscious young women, in contrast to their frivolous, pleasure seeking, Westernised forerunners.[19] Elsewhere, the notion of surveillance is picked up through the tapping of brief telephone encounters, in which appetites are divulged and assured imminent satisfaction, and banal utterances are given disembodied voice.[20]

Mo's own 'lexicon of rage and frustration' is alluded to in a photographic triptych, Pointing, Service and Spitting (1997), in which a smiling still from Service, Licking, Kissing is flanked by images of aggression and desire. In Pointing, artificial strip lights are supplanted by natural sunlight and catering clothes are ditched for the uniform of Western casual attire, a denim jacket; the artist, as the title suggests, points into the camera. In Spitting, she is seated, her head thrown back as globules of saliva arc towards the lens, arms held out as if bracing against the exertion. The frame crops another, that of a poster behind her revealing the curves of a beach babe (Pamela Anderson?), a tanned (decapitated) blonde fantasy body in front of which Mo's spitting reads as an emulated ejaculation. Beyond the confines of the takeaway, despite 'reality effects', Mo's persona is no more real; 'Yeu Lai' mimes another stereotype, that of the young yobbish English other, hateful and lustful. Though her gesturing and posturing might also be interpreted as the dissent of a hidden 'yellow, perilous' force, plotting in bedrooms, spilling onto the streets, Mo's serial mimicry forcefully demonstrates the entwining of deep-seated fears and desires perpetuating tired fictions, her replication and inversion of perceptions suggesting the preclusion of easy escape.

Making Of

... popular culture, commodified and stereotyped as it often is, is not at all, as we sometimes think of it, the arena where we find who we really are, the truth of our experience. It is an arena that is *profoundly* mythic. It is a theatre of popular desires, a theatre of popular fantasies. It is where we discover and play with the identifications of ourselves, where we are imagined, where we are represented, not only to the

audiences out there who do not get the message, but to ourselves for the first time. (Stuart Hall, 'What is this 'black' in black popular culture?', 1992)

Another set up: the staging of a crime scene redolent of 1970s American TV detective shows, with the requisite array of clues to be deciphered: a hand-made Hong Kong Phooey lies trussed up on the rug; nearby, a glass has been knocked over, leaving a stain on the swirly, brown-patterned carpet; an open suitcase reveals bundles of 'heaven/hell-money'; photographs – from a holi-day? – lie scattered; there is a Bruce Lee poster on the MDF wall, while a book of his fighting methods rests on the side of an armchair. In a corner, a TV has been left on, quietly transmitting noise, the broadcast long over.[21] Across the room, sleep and needles pin a prostrate, soft-sculptured dog to a foam-topped, glass-encased plinth. The artist sews and stuffs the look-alike-imposter for a second time, a cult cartoon character from another era, an animation made inanimate, a fabrication made material.

Doubling the double, a celluloid fiction aspires to fiction: Penry by day, a mild-mannered dog-janitor, and Hong Kong Phooey by night, a would-be kung-fu-kicking superhero, his crime-fighting success sealed by the sur-reptitious interventions of a feline side-kick, Spot.[22] The fur-deep hybrid of dubious heritage (a martial-arts craze influenced, orientalist US invention) dreams Chinese-Black-American dreams, lovable and laughable for his im-potent pretensions. His comic value derives from his status as the unknowing butt of the joke: haha, there is no real you. The pleasure and pain-staked hero and nemesis is a copy, a dummy, another addition to the tradition of Ching Chong Chinamen buffoons littering the galleries of Western popular culture, an idiot and surrogate victim/hero for the aggressions/ affections of the artist as victim/bully. Eyes closed, blacked out in black, she lays him to rest, an in-jurous love/hate dying, awaiting a fairytale truth.

In *Death of Hong Kong* (1998) and *A Cute Puncture* (1998), Mayling To's painstaking recreations play on an ambivalent relationship to a character at once sympathetic (as a 'second-generation immigrant' of confused heritage) and loathsome (a fool, for the very same reason, with pretensions to com-pensate). Its materialisation alludes to tangible and intangible forms of cul-tural and ideological consumption, the 'copy' covetable as an 'original' in place of one that never was, a doubling that pays homage to an absence, yet makes present a substitute upon which aggressions as well as affections can be played out. The monitor provides an anti-TV moment, highlighting an his-torically tense relationship between video and television, and an ambiguous distinction between illusion and reality. Hong Kong Phooey's fate here also serves as an idiosyncratic symbol of, and allegory for, the fortunes of its ter-ritorial namesake, Hong Kong, whose return to Chinese sovereignty displaces already displaced notions of origins, and familiar East/West formulations of

hybridity and in-between-ness. In the one scenario, the Hong Kong Phooey-copy lies dead or hurt; nearby, he reappears in another guise, an array of acupuncture needles applied through black traditional Chinese attire, an attempt to revive or curse, to further a metaphorical cultural return, or eternal banishment. What afterlife is there for this ambiguous entity, neither one nor other, here nor there?[23]

Materialising cartoon abstractions and conjuring unlikely urban migrant mascots, To explores the fascination and emulation of martial arts in the West, often through ambiguous hero-figures. Reinvented as uneasy embodiments of masculinity, with uncertain cultural affinities, To stages and directs displays of anxiety and fixation that not only question and deflate the lure of heroic martial arts mythologies, but also comment implicitly on cultures of copying, recycling and remaking.[24] If the making-of a movie points to the idea of a 'reality' behind the 'fiction', a reality that precedes fabrication, it is in itself a strange fiction – a construction of a reality based often on the juxtaposition of actors speaking 'as themselves' and performing in role, that is just as likely to have been 'made after'. Promising glimpses into the workings of the movie-machine whilst functioning as both publicity mechanism and money-making spin-off, the 'making of' responds to desires to see more, to get closer, to get to the reality behind the fiction. How close is close enough for the fiction to be 'true'?[25]

The pairing of *Making Of* and *Fight Sequence* (2001), two short looped video pieces, deconstructs the opposition of 'reality' and 'fiction', referencing the common practice in martial arts films of playing outtakes alongside the end credits, showing stunts going wrong and actors 'corpsing' (breaking with their character, for example, into laughter – an interesting metaphor for the collapse of an illusive reality), in some instances almost literally (when stunts prove near-fatal).[26] *Making Of* and *Fight Sequence* comprise the same shots, differently edited. One includes off-camera noises and remarks, that draw attention to the technical apparatus and wider context beyond the prescribed action, the other cuts these out. Convention encourages us to read the latter as more finished than the former, yet expectations of a forward-moving, plot-driving linearity are displaced by the juxtaposition and repetition of relatively long takes, the similarities and differences between the frames and angles of a single action, as well as the question of the would-be actor/stuntman's purpose.

The domestic, prosaic nature of the fight sequence throws into relief the normalisation of high-cost spectacle, and the degree to which audiences expect to be wowed by cinematic thrills, especially with the onset of digital technology (spilling open different cans of real and fictional worms), in a language of fast edits and jump-cuts that stress action and gesture over dia-

logue. As two young anonymous non-Chinese men perform and play to un-specified demographics, acting out pale and comparatively clumsy low-budget imitations of onscreen action hero-fictions, it is perhaps not so much the iconology of Bruce Lee, Jackie Chan or Jet Li *that* is invoked, but tele-vision and filmic traditions of wannabes, pretenders and admirers – among them, Hong Kong Phooey. Their willing participation in the staging of physical combat raises questions of identification with, desire for, and the per-formativity of a masculinity and ethnicity bound up in stylised violence, caught in a plotless loop.

Three works introduce another character to To's cast of martial arts anti-heroes, first appearing as a diminutive sculpture, later carried off as an ill-fitting disguise on an unidentified man. From fictitious martial arts lessons to home enlightenment (or enlight-entertainment?), a panda-suited-man-without-a-name appears as the protagonist of *Living* (2001), *Being* (2001) and *The Stranger* (2002). Whereas 'Hong Kong Phooey is an animal with a human personality... Panda is already a human; it jars to know that it's a man inside the costume.'[27] The character's misidentification and misrecognition is encapsulated in a moment before a full-length mirror, reflecting back a fake-furred, fake-skinned self-constructed or externally imposed artifice. If the panda serves as a symbol of China, its re-presentation and adoption in the form of a (bad) costume makes literal a comically excessive and impossible desire for identification and unification with a displaced cultural, philo-sophical and physical other. *Living* sees the pantomime panda performing martial arts moves in small, awkward domestic spaces, with improvised weaponry. *Being* finds the panda turning to a 'Teach Yourself Meditation' manual in an English garden with oriental pretensions (it features a pagoda), and reaching a higher plane in a dream levitation sequence that ends abruptly when he lands with a thud, and takes his frustrations out on a tree. Finally, *The Stranger* finds the panda collecting stuffed toys in his own image – idols in miniature, endangered nation-symbols, preserved. Caressing, cutting and mutilating, pulling synthetic insides out, he projects his self-love and loathing, desire, revulsion and regret.

Without character or plot exposition – the unanswered questions, what hap-pened to the Hong Kong Phooey-look-alike? Who is he? Who and why is the man in a panda-suit? – To's anti-heroes are fixed in the present (though fixated on an imaginary past), unable to move forwards or backwards. Despite action-flick gestures, their fundamental immobility is conveyed through troubled identifications with two-dimensional cartoon characters and cartoon-ish cultural symbols. Nameless (titles are borrowed or unspecified) and speechless (as subjects that are passively spoken rather than actively speaking), each character exists in a state of isolated staticity, foreign-ness, or briefly literal suspension; a momentary defiance of gravity and comical return

MT- Living

to earth, indicative of fascinations with and desires for an elsewhere, beyond the pathos of placelessness.[28]

Martial Art

Outtakes typically frame temporalities, spatialities, glances, words and gestures in excess of desired narratives, classifying that which falls out of or reflects upon favoured parameters, and regulating behaviours that endanger the illusion, that threaten to reveal the trickery behind the magic. Yet such excised excesses may, paradoxically, also become covetable when turned to the task of perpetuating a 'real' behind the fiction. Dispensing with assumptions of authenticities and realities awaiting revelation, the notion may nevertheless be useful in positioning the seemingly *ad hoc* posturings and performativity across practices whose coincident and divergent thematic concerns coalesce in the tactical invocation of spaces and subjectivities between and beyond discursive frames.

Playing on and replaying fictions behind fictions and ever-receding realities, actions are performed and repeated out of context, to absurdity; tableaux in two, three and four dimensions offer up circular and inconclusive narratives ridden with blanks and silences. From embodied replication to disembodied rebuttal, Sanderson, Mo, and To figure among artists whose strategies include stealing upon and 'tripping' on discursive spaces,[29] doubling, tripling and multiplying their 'selves' against ideological and cultural rule. Cutting into the action, 'act out' as a means of acting up, scenes are usurped and the scenery

rearranged, disturbed by the silences of implacable forays into 'West' and 'East'.

Notes and references

1 This essay is extracted from a chapter of the same title in A–Y: An Inventionry of 'British Chinese' Art (2004), PhD thesis, unpublished.

2 Gilane Tawadros, 'Working Drawings,' in These Colours Run (Eddie Chambers/ Wrexham Library Arts Centre, 1994), exhibition catalogue, pp.20-28.

3 Lesley Sanderson, Negative (1988), pencil on paper, laser copies, red signature stamp; Self Portrait – Larger than Life (1990), pencil on paper; Reproductions (1991), mixed media; These Colours Run (1994), mixed media.

4 Trinh T. Minh-ha, 'Bold Omissions and Minute Depictions,' in Trinh, When the Moon Waxes Red: Representation, Gender and Cultural Politics (New York and London: Rout- ledge, 1991) p.155-166.

5 See Jeremy Gilbert-Rolfe, 'Blankness as a Signifier,' in Gilbert-Rolfe, Beauty and the Contemporary Sublime (New York: Allworth Press, 1999) p.109-123.

6 'The 'grain' is the body in the voice as it sings, the hand as it writes, the limb as it performs...' Roland Barthes, 'The Grain of the Voice,' in Barthes, trans. Stephen Heath, Image, Music, Text (New York: Hill and Wang, 1977), p.188.

7 Sanderson's work has been included in 'Black Art: Plotting the Course,' 1988, Oldham Art Gallery and touring, 'Four x 4,' 1991, Harris Museum, Preston, and 'Transforming the Crown: African, Asian and Caribbean Artists in Britain,' The Bronx Museum and Studio Museum, New York, 1997-1998.

8 Coco Fusco, The Bodies That Were Not Ours (London: inIVA, 2001) p. 8-9.

9 Fusco, ibid., pp.14-16; Stuart Hall, 'New Ethnicities,' in David Morley and Kuan-Hsing Chen, eds. Stuart Hall: Critical Dialogues in Cultural Studies (New York and London: Routledge, 1996) pp.441-449.

10 Conroy/Sanderson, work in progress (2003), video.

11 Both citations in this paragraph from Tawadros, op.cit., p.22.

12 See for example the essay, 'God's Little Artist' in Rozsika Parker and Griselda Pollock, Old Mistresses: Women Art and Ideology (London: Pandora, 1981) pp.82-113 and Carol Duncan, 'Virility and Domination in Early 20th-Century Vanguard Painting,' Artforum, December 1973, pp. 30-39.

13 Yasumasa Morimura's digitally manipulated photographic self-portraits, such as the Self Portrait As Art History series, have been exhibited widely, including solo shows at the Museum of Contemporary Art, Chicago (1992), the Cartier Foundation for Contemporary Art, Jouy-en-Josas, France (1993), the Hara Art Museum, Hara, Japan (1994), and the Yokohama Museum of Art, Yokohama, Japan (1996), and the Centre for Contemporary Photography, Melbourne (1996). Tiana Thi Thanh Nga dir. From Hollywood to Hanoi (US, 1993), film, colour, 78 minutes, incorporates clips from Tiana Thi Thanh Nga's acting career under the name 'Tiana Alexandra.' Peter X Feng, Identities in Motion: Asian American Film and Video (Duke UP, 2002) pp.128-147.

14 Maria Troy, 'I Say I Am: Women's Performance Video from the 1970s,' also the title to a collection of 'early feminist tapes' curated by Troy as Associate Curator of Media at the Wexner Center in Columbus, Ohio. The title refers to Chris Straayer's essay, 'I Say I Am: Feminist Performance Video in the '70s,' Afterimage, November 1985, pp. 8-12. http://www.vdb.org/resources/resourceframe.html April 7, 2004.

15 Straayer, ibid., p.8.

16 'Even if the artist is narcissistically performing for the video-mirror, the spectator of the image of this behaviour is not. Conversely, if the spectator is performing for the mirror in a video installation, then the artist is not himself or herself seeking narcissistic gratification nor is the nature of the spectator's interaction with the installation necessarily narcissistic. Nor are all artists who appear in their own tapes simply seeking the self-affirmation of a narcissistic involvement...' Maureen Turim, 'The Cultural Logic of Video,' *Illuminating Video* op.cit., pp.331-342.

17 *Service, Licking, Kissing* was shown as part of a solo exhibition, 'Yeu Lai's House' (1997) at the Gallerette, London and Quay Art Gallery, Kingston upon Hull (2000); a group show, 'Number Six' (1998), TS2K, London; and a two-person show, 'Licked' (2000), Gasworks, London.

18 Dan Graham has noted the presence of video as a means of surveillance in private and public spaces in his essay, 'Video in Relation to Architecture,'in *Illuminating Video*, op.cit., p. 168-188.

19 Ellen Johnston Liang, 'The People's Republic of China and the 1930s Advertisement Calender Poster Artists,' paper presented at the symposium, 'On Contemporary Chinese Visual Culture,' University of Westminster, 6 February 2004, convened by Dr Katie Hill.

20 *Service, 1, 2, 3* (1997/2001), inkjet, mixed media and *Untitled (Sound Piece)* were shown in the exhibition, 'Ten Thousand Li' (2002), Open Eye Gallery, Liverpool and touring.

21 Mayling To, *Death of Hong Kong* (1998), installation with MDF, carpet, rug, TV, lamp, suitcase, books, ornaments, paper, photographs, wire, fabric, polyester, foam.

22 *Hong Kong Phooey*, a Hanna-Barbera creation, first aired in 1974 at the height of the popularity of martial arts in the film, television and comic industries. A brief 2001 revival saw the character buffed up by Time Warner Company's Cartoon Network, in an updated online adventure featuring a muscular, werewolf-like Hong Kong Phooey and Manga/animé styled martial arts action. http://www.cartoonnetwork.com/watch/web_shows/hkp/

23 Hong Kong Phooey returns in Mayling To's *Repertoire Dog* (1999), fabric, polyester, plastic guns, the title a pun on Quentin Tarantino's film, Reservoir Dogs (US, 1992), colour, 99 minutes.

24 The last three decades have seen the successes (to varying critical and commercial degrees) of Bruce Lee, Jackie Chan, Jet Li, Chow Yun Fat, Michelle Yeoh, all of whom found fame in Hong Kong before making an impact in Hollywood. The influence of Hong Kong action and martial arts film-making in terms of stylistics and aesthetics (from John Woo's 'balletic' gun play to the use of wires in martial arts fight sequences) is perhaps most evident in such projects as the Washowski Brothers' *The Matrix Trilogy* (US, 1999-2003), and Quentin Tarantino's homage to several genres, *Kill Bill: Vols. 1 and 2* (US, 2003-4).

25 See Richard Shiff, 'Closeness,' in Naomi Salaman and Ronnie Simpson eds., *Postcards on Photography: The Handmade Copy in Reproduction* (Cambridge Darkroom Gallery, 1998) p.11-36.

26 Mayling To, *Making Of* and *Fight Sequence* (2001), video, colour, 1 min 20 sec loop each. Jackie Chan in particular has made such outtakes something of a signature. As is widely known, this martial arts-skilled actor performs all his stunts himself; if errors of judgement reveal his vulnerability after all, they also paradoxically accentuate his 'superhuman' feats. Outtakes also figure in the end credits of Chan's long-time collaborator Samo Hung's *Martial Law*, a Chinese-in-America US TV cop drama that follows both in the fish-out-of-cultural-water tradition, as well as that of the comic, cod-philosophising

(pun unintended), de-sexualised, law-abiding 'oriental,' epitomised by his character's fictional detective predecessor, Charlie Chan.

27 Mayling To in conversation with Melanie Keen (2002) http://www.iniva.org/archive/resource/2255. *Pandemonium* (1998) sets a small stuffed panda upon a shallow brick plinth, adopting a combative, mock kung-fu stance, in defence of a countryside under siege, or a newly claimed urban territory. In *Learn How to be Hard Mutha* (1998), its pose is repeated in bill posters pasted on an external gallery wall, offering lessons in the fictitious 'Bamboo Forest Fist (Southern style)' from a 'Master Pang Dah'. Some respond territorially to the perceived act of trespass and vandalism by tearing the posters down, while others signal their approval with comments in graffiti ('cool'). Taken at face value, one passer-by asks if it is a man in a panda-suit; interestingly, he doesn't ask why. Mayling To, *Pandemonium* (1998), bricks, imitation grass, clay, aluminium, fabric, polyester; *Learn How to be a Hard Mutha* (1998), digital prints.

28 The levitation recalls the characterisation of economically mobile, privileged diasporic Chinese between residences in Hong Kong and abroad, as 'astronauts families' and 'satellite kids.' See Aihwa Ong, 'On the Edge of Empires: Flexible Citizenship Among Chinese in Diaspora,' in *Positions*, 1993, v.3 part 1, pp.745-778. The moment is also redolent of a fantasy sequence in Isaac Julien's *Baltimore* (2003), a three screen DVD projection with sound, which sees a be-wigged female character leap vertically to an impossible height, and hover, before landing precisely on her stiletto heels; a lower budget variation on a narrative of fleeting (failed?) transcendence?

29 I refer here to another 'monkey,' Wittman Ah Sing, the Chinese-American protagonist of Maxine Hong Kingston, *Tripmaster Monkey: His Fake Book* (New York: Knopf, 1989).

11

Cultural Demarcation, the African Diaspora[1] and Art Education

Paul Dash

We are not looking for the assimilation of minority communities into an unchanged dominant way of life: we are perhaps looking for the 'assimilation' of *all* groups within a redefined concept of what it means to live in British Society. (Swann Report, DES, 1985)

Culture is no longer viewed as contained within a certain land-form. Cultures intermingle, mix, and impose on each other, the result of which are crises that change the face of maps. (A. Efland, *et al,* 1996:23)

Each Saturday afternoon, after church on Sundays, during mid-week breaks and in the lengthening shadows of tropical dusk, gaggles of young men, their bodies taut with steely concentration, engaged their passion for playing cricket. They played everywhere, in gardens and on scrubland, on school grounds and in alleyways, on the back streets of village and town and on the many fine beaches that ring their small island community. 1950s Barbados, the island and period about which I speak and my country of birth, was indeed a cricket-obsessed country. Through our developing expertise in playing the game, we achieved success against our colonial masters and nations such as Australia and New Zealand. This success, coupled with our creative approach and devotion to cricket, inspired youths and adults to play it regularly. Cricket was a magnet that drew attention and required expression in any form and context where a version of it could be played. But this willingness to practice the sport in almost any environment required flexibility in the application of its rules and an acceptance of the need to reposition the boundaries of play to meet the demands of its players.

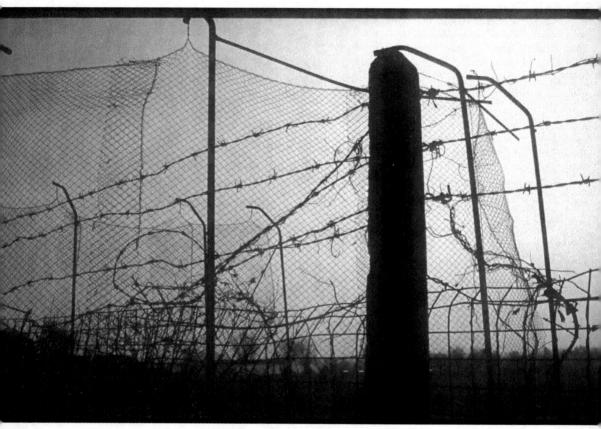

Fence image: Matthew Godman

Boundaries in cricket are obstacles, barriers that one side aims to penetrate in order to maximise scoring while their opponents try to stop them. Boundaries are also lines of demarcation that separate the field of play, normally the size of a baseball field or athletics ground, from the wider environment. But Barbados is a small, densely populated island with relatively few large open spaces. As a result cricket enthusiasts devised rules that deviated from the 'norm', enabling them to shift boundaries to positions that accommodated the players in the different circumstances in which they played. Marble cricket, for instance, had the bowler and batsman – with a shortened bat – facing up to each other from kneeling positions while the fielders stood. The amount of power the batsman could exert in striking the ball while in this position was markedly restricted and the boundaries suitably reduced in distance from the batting area. Tip-and-run was a version of cricket that didn't require any boundaries at all – you simply scored by running for as long as you could get away with it.

These adaptations of the rules of cricket, particularly the placement of boundaries, remind us of the need for flexibility where artificial means of separation determine the life patterns of individuals and groups. Yet we often perceive socially or politically determined forms of separation as inviolable touchstones of identity. Sarup (1996) references Kai Erikson, who draws on Durkheim in suggesting that 'the only material for marking boundaries is the behaviour of its participants' (p.11). He continues,

> Within the boundary, the norm has jurisdiction. Durkheim, asserted, first, that a social norm is rarely expressed as a firm rule; it is really an accumulation of decisions made by a community over a long period of time.

Social structures and paradigms, particularly in our rapidly changing world where previous givens are today's contested truths, need constantly to be reevaluated and where necessary, challenged. Employing the binary metaphor 'Island' and 'World', Timothy Garton Ash[2] cites examples of change that destroy the notion of stasis in the way we live and the values regarded as essential to a notion of Englishness.

> 'Island' is the Britain, but more especially the England of the parish church, the pub, the club, the college; of the retired colonel ... reading the *Daily Telegraph* and the gardener reading the *Daily Mail*, of country lanes, cricket, warm beer and shepherd's pie. (Ash, 2004; p. 4)

'World' is the environment outside the area of our immediate cultural organisation. Yet somehow that notion of world can often become conflated with an idea of English cultural heritage.

> The world has now come to the island because the island first went to the world. England expanded, initially absorbing all the other parts of these offshore islands in an internal empire, then scattering across the high seas, to every corner of the earth, its own language, goods, customs and people – now including the Scots, Welsh and Irish as well as the English. In the process, Britain became already by the 19th century a 'world island'. While remaining an 'island world' it was also an island engaged throughout the world, at once stubbornly insular and relentlessly international. (Ash, 2004:5)

Evidence of this cultural interpenetration can be seen in the inner city. Walking along Putney High Street in London the pedestrian

> ... will see: Hot Wok Express, Il Peperone Pizzeria, Enoteca (an Italian restaurant), the Odeon cinema (probably showing an American movie), Sydney (an Australian bar-restaurant), La Mancha (a Spanish tapas bar and restaurant), Pizza Hut, Blockbuster Video, La Noche (another Spanish restaurant), Superdrug, McDonald's and right next to it the coffee places Costa, Caffe Nero, Starbucks, then United Colours of Benetton, Prêt à Manger, Burger King, Rogerio's café, the Piccolo bar – and that's only up to the railway station. (Ash, 2004:4)

Other changes to island Britain not addressed here are playing a similarly if not more important role in shaping modern lifestyles. The black subject, once positioned as savage and inferior, now has a voice to challenge such constructs and demands full representation in new social regimes; the woman once press-ganged into the kitchen and positioned as 'obedient wife' and 'doting mother' under the authority of 'the superior male', demands the right to a career and the sharing out of household responsibilities; the gay lovers once derided as queer and perverted articulate their right to fullness of expression and an acceptance of difference of lifestyle in mutually respectful relationships. These societal changes have an impact on the way we construct each other socially and ultimately should influence how we teach and what we learn.

Educational change

Boundaries that define the contents of educational curricula are as contested as social, historical, religious or geographical barriers. Indeed educational content is largely determined by such discourses. The politics of inclusion and exclusion in education, what we teach children and how that teaching is done, can determine how young people see themselves as learners and the way they position themselves relative to others. Constantly presenting Black children with learning content that celebrates the achievements of other ethnic groups, without drawing also on successes from people who look like themselves, can only undermine their self-confidence and self-esteem. This has the potential to affect their educational attainment negatively. Yet, traditionally, though situated within Western communities, Black people are not seen as meaningful contributors to our shared way of life outside of areas such as sport and popular music, which do not tax the intellect. In fact curricula content in England, remains traditionalist and largely shaped by white, Western epistemological frameworks. David Pascall (1992), then Chairman of the National Curriculum Council,3 justified this approach in a speech given at the Royal Society of Arts in 1992:

> In thinking about the education we offer our children we need to identify the important strands from our culture which mesh to define and enrich our present way of life. I am thinking here, to select a number of illustrations, of the Christian faith, the Greco-Roman influence, the Liberal Enlightenment, romanticism, and the development of modern humanism. (p. 5)

By implying that the 'Christian faith, the Greco-Roman influence, the Liberal Enlightenment, romanticism, and the development of modern humanism' should be *the* 'important strands' in the fabric of teaching and learning in 'our' culture, without signalling a need for a more inclusive curriculum model, Pascall illustrated the distance between the established position on curricula content, and progressive educationalists and culture workers. I

think, for example, of Friere (1990), hooks (1994), Bolton (1979), Hall (1997), Sarup (1996), Searle (2001), Tomlinson (1990). Prioritising the Christian faith as central to the delivery of education, in an environment where in many schools the vast majority of children have different faith values, raises the issue of representation and right of access.

Though much important work could be done even within his traditionalist model to overturn the myth of European superiority, there is no clear indication in Pascall's speech that educationalists should adopt such approaches. I think here of a model for teaching that demonstrates how civilisations in, say, Africa and the Middle East impacted on ancient Europe (Bernal, 1988). Chalmers (1996 p.21) quotes Walter Crane, who in *The Bases of Design* (1925) '... acknowledges early Greek art as 'differing little in method of treatment and in use of ornament from the Asiatic race, the Assyrian and Egyptian and Persian.' Efland *et al* (1996 p. 48), quoting Freedman (1991), assert that teaching in our postmodern multicultural world should instead promote curricula that are, '...conceptualised as unstable, non-linear, culturally integrated, identity specific, and highly interpretive.' A Greco-Roman paradigm in art education that implies a notional linear progression through a uniquely Western cultural heritage, apart from being inaccurate, would be antithetical to a pedagogic stance that celebrates difference and acknowledges the borrowing and cross-fertilisation that has always taken place in world civilisations.

Multicultural art teaching content and Diaspora children

The social disturbances of the 1980s in Britain were a call from the streets for change. Black youth and white in inner city areas such as Brixton, Toxteth and Liverpool 8 took to the streets, smashing windows, stoning the police and torching cars. Many at the forefront of the unrest were of African Caribbean heritage. Parliament debated the issue and reports were commissioned, among them the Rampton Report (1981), which looked into the education of 'West Indian' children in 'our' schools. The final more wide ranging Swann Report (1985) that considered the education of children from nine ethnic minority groups. Tomlinson (1990) notes that Swann

> ... stressed the relevance to schools and LEAs of changing the curriculum, producing policies, and generally ensuring that a more appropriate education would, in future, be offered to all pupils. (p.12)

By this time many teachers, particularly in primary schools, had been experimenting with multicultural approaches for some years (Mason, 1995). Phil Slight observed that

> From the late 1960s there was a shift towards cultural pluralism and integration and with this came a move from denial of culture to concern about culture. Two

assumptions were made: these were that racial equality could be achieved through cultural diversity, and that negative self-images of ethnic minority children could be addressed by means of cultural compensation. (*Changing Traditions*, 1987:8)

Nick Stanley, Phil Slight and Helga Loeb (1987), and Iain Macleod-Brudenell (1986) demonstrated a range of approaches to teaching in art and design that foreground cultural norms and practices from different cultures and traditions[4]. A range of multicultural resources for the art and design classroom explored themes such as Islamic calligraphy, Persian rugs, Aboriginal paintings and Benin bronzes. These could also be accessed through a growing number of multicultural resource centres and more especially by visits to museums and galleries. Diaspora cultures, however, for all the call for change, the recognition on the part of the authorities for more inclusive curricula and the demand for visibility, were still not effectively represented. Apart from Carnival, few books dealt with Diaspora cultural material, the museums simply did not regard such civilisations as significant and offered little of value. Len Garrison's London-based African Caribbean Educational Resource (ACER) in Lambeth was one of the few resource bases in Britain to provide material that could support teaching and learning in this area. Carnival studies, though popular in primary schools, often focuses on the colour and fun of the event without looking in depth at the political, sociological and historical connotations of mas[5] (Burgess-Macey, 2003). By focusing so narrowly teachers ran the risk of further stereotyping Diaspora people as fun-loving, superficial and lacking discipline (Boime, 1990). Black cultural histories and events were under-represented or projected from narrow European hegemonic viewpoints that served to undermine our understanding of Caribbean cultures and history.

Diaspora syncretisms

African Diaspora identities are formed from a melange of African, South Asian, Middle Eastern, Chinese, indigenous American, European and other cultural and ethnic influences. Stuart Hall (1997) asserts that,

> Diaspora identities are those which are constantly producing and reproducing themselves anew, through transformation and difference. One can only think here of what is uniquely – 'essentially' – Caribbean: precisely the mixes of colour, pigmentation, physiognomic type; the 'blends' of tastes that is Caribbean cuisine; the aesthetics of the 'cross-overs', of 'cut-and-mix', to borrow Dick Hebdige's telling phrase, which is the heart and soul of Black music. (p. 58)

Bhabha (1994) sees this cross-fertilisation as fundamental to an understanding of all identity formation. About Renee Green, the African American artist who engaged this theme in an installation in the Institute of Contemporary Art, Long island, New York, he observes:

Green's 'architectural' site-specific work, Sites of Genealogy (Out of Site, the Institute of Contemporary Art, Long island City, New York), displays and displaces the binary logic through which identities of difference are often constructed – Black/White, Self/Other. Green makes a metaphor of the Museum building itself, rather than simply using the gallery space:

> I used architecture literally as a reference, using the attic, the boiler room, and the stairwell to make associations between certain binary divisions such as higher and lower and heaven and hell. The stairwell became a liminal space, a pathway between the upper and lower areas, each of which was annotated with plaques referring to blackness and whiteness. (p.3-4).

This framing of identity and difference and placing the notions of flux and cross-fertilisation at the centre of identity construction, brings into play the invisibility that ironically gives definition to the Diaspora subject. Constant reference to the binary black/white and African/European, through which generalisations are made about people in a manner of claiming histories determined by the white hegemony, only serves to render the Diaspora black invisible. We can only be made visible by demonstrating the fusions and boundary crossing that undergird all human life, and recognising that one cannot exist without recognition of the other.

Diaspora cultures shape the mainstream as much as they were affected by the dominant culture. The wealth generated by the slave trade, for instance, has enriched countries in the Western hemisphere, none more than Great Britain. Knight (1990) states that

> ... until eclipsed by India in the nineteenth century, the Caribbean islands became the most valued possessions in the overseas imperial world, 'lying in the very belly of all commerce,' as Carew Reynell (1636-1690) so aptly described Jamaica in the seventeenth century. (p. 55)

The signs of that wealth are still evident in cities such as Bath, where elegant architecture housed the managers of empire who traded and worked in nearby Bristol, a major trading port at the centre of the slave trade. Bath Abbey holds a number of tablets that celebrate the lives of Britons who saw service in overseas colonies during the days of empire. These tablets are an unwitting memorial to empire and the people who suffered under British rule at that time. As a person of Barbadian birth, I am aware of the legacy that British imperialism bequeathed to everyone with allegiance to the Caribbean island. I think of Nicholas Abbey, Morgan Lewis Mill and Codrington College – buildings built in the interest of the white imperialists who occupied them. That they now fall under the auspices of the largely Black state of Barbados is incidental. The city of Bath, though located in a different geographical space and in sovereignty of the British, is integral to an understanding of Barbadian as well as British historical identity.

To divorce those historical sites on grounds of sovereignty and geographical separation is artificial and counterproductive. Yet that is exactly what we are conditioned to do. This negation, the inability to expose hidden historical links that give meaning to our lives, particularly Diaspora lives, alienates Diaspora children and leaves their historical legacy without definition. We need to teach children to take a more holistic view of cultural heritages and identity. If a Barbadian child can take pride in Nicholas Abbey, they should be encouraged to make a link with Royal Crescent in Bath, because the broken bodies of their ancestors lie embedded there as much as they do beneath the Caribbean building. A more appropriate pedagogy, therefore, would locate Diaspora children in a wider geographical space. It would also confront white children with a new model of identity, that would demonstrate the cross-fertilisation that underpins their existence as subjects. Boundaries would be shown not to be permanent but subject to change.

Implications for practice in the classroom

Graeme Chalmers (1996) lists five approaches to multicultural teaching:

- The first approach is simply to add lessons and units with some ethnic content.

- The second approach focuses on cross-cultural celebrations, such as holiday art, and is intended to foster classroom goodwill and harmony.

- The third approach emphasises the art of particular groups – for example, African American art or women's art – for reasons of equity and social justice.

- The fourth approach tries to reflect socio-cultural diversity in a curriculum designed to be both multiethnic and multicultural.

- The fifth approach, decision-making and social action, requires teachers and students to move beyond acknowledgement of diversity and to question and challenge the dominant culture's art world canons and structures. In this approach, art education becomes an agent for social reconstruction, and students get involved in studying and using art to expose and challenge all types of oppression. Although this last approach may not be multicultural per se, students will probably be dealing with issues that cross many cultural boundaries. (p.45)

Many teachers already experiment with one or a combination of the first three approaches (Chalmers, 1996; Efland et al, 1996). The fourth and more especially the fifth approaches, engage with how 'art education becomes an agent for social reconstruction' and inevitably crosses many cultural boundaries.

The challenging of 'the dominant culture's art world canons and structures' must involve a revisiting of the way we look at works of art, their content and the environments in which they were made. On being taken to galleries, Black children are often confronted by problematic depictions of the Black figure but are rarely presented with any explanation. I think of Sarah in *Manet's Olympia* (1863), the servant in Mattia Peti's *Marriage at Cana* (circa 1692) and countless representations in historical works of art (Boime, 1990). Artists such as Keith Piper, Sonia Boyce and Eddie Chambers, alongside theorists like David Dabydeen (1987) and Gen Doy (2000) are engaged in critical work that engage some of these concerns, possibly leading to curriculum development. Historical links should also be made through the arts in history, across geographic and continental entities, to further illustrate our inter-relatedness and further enrich teaching and learning for all.

Conclusion

The presence of African Diaspora peoples, with their history of enslavement and exclusion, in the Western mainstream demands a change in attitudes to mainstream cultural heritages. Meaningful learning requires the reform of traditionalist pedagogies and a shifting of the boundaries of identity and representation. Such change should bring about a new and more repre-sentative understanding of Britishness, one that is closely interlocked with other cultures, peoples and practices.

As a Black British subject with roots in the Diaspora, my sense of self is em-bedded in a history that is not specific to a geographical location. It draws on Europe as heavily as it draws on Africa and possibly even the Caribbean. It is the task of the educator in the 21st century to construct pedagogies that acknowledge the debt we owe to peoples from different cultures and social strata for the way we live today. If this is done, all children will begin to be placed at the centre of learning.

Notes and references

1 Diaspora is used here to mean people of African ancestry who were descended from enslaved people

2 The Janus Dilemma, Saturday *Guardian Review* Supplement, June 5 2004, p.4.

3 The Education Reform Act 1988 introduced a National Curriculum which determined the content of learning for children in state schools in England and Wales

4 See Ian Macleod Brudenell's series of Nottingham Supplies Cross-Cultural Art Booklets (1986) and Development Education World Studies Art in Action: Music, Drama, Visual art (1984).

5 Mas or masquerade is the popular term for carnival in the Caribbean.

12

The Friendly Interventionist:
Reflections on the relationship
between critical practice and artist/
teachers in secondary schools

Nicholas Addison and Lesley Burgess

Built into the British national curricula... are structural safeguards against 'too much creativity', too much initiative and too much critical thinking, which are typical of corporate management. First, effective creativity can be limited by devaluing and demoting the morale, self-image and social status of [art teachers] by changing them from a potentially critical, autonomous, creative, meaning-making and intellectual force... into conforming 'managers' through an intensive period of teacher training where they undergo an ideological initiation. (Dalton, 2001: 132-133)

In this chapter we examine the relationship between the school subject art and design and the field of contemporary art. We investigate how the dominant values of art within schooling support or contest the critical practices of many contemporary artists. The locus of our investigation is the interface between the two fields as they come together in the context of initial teacher education (ITE), a place where the disjunction between the two is in sharpest relief. If a dialogue can be set up between contemporary practice and schools then critical practices do not have to be elided or denied, especially where intervention and exchange ameliorate the one way process of induction implicit in Dalton's 'ideological initiation'. Our argument is developed in response to the experiences of artist/teachers who have followed the part-time PGCE initiated at the Institute of Education, University of London (IoE) in September 2000.

The emerging dynamic between artist/teachers and school culture has high-lighted the differences between contemporary critical practices and the com-mercial culture and reproductive schooling that dominate the lives of most young people (Bourdieu and Passerson, 1970). We discuss the possibility of resistance to ideologies of consumption and reproduction by examining artist/ teachers' evaluations of the interventionist residencies they undertake during their final school placements. These evaluations are part of an end-of-course assignment through which artist/teachers begin to articulate and embody their developing philosophy for art education. We analyse and interpret these assignments to understand the relationship between making and teaching art and the ways in which these two activities demand a different sense of self. And we refer to statements made by artist/teachers during a focus group dis-cussion in order to estimate the extent to which the course militates against an 'ideological initiation' that inevitably negates one persona for another.

Student teachers' expectations about their contribution to the development of the art curriculum has not matched their subsequent experience in secondary schools. Although they enter art departments with a deep knowledge of the production of art, craft and design in contemporary society they find they are rarely allowed to translate this knowledge into classroom practice. Such resistance to their expertise is partly the result of the retrospective and formulaic traditions of school art (Hughes, 1998; Steers, 2003). In addition, they are subsumed within a culture of schooling that valorises conformity in order to provide consistency and continuity for young learners. This process is not peculiar to art and design. It has been theorised as the dominant disciplinary process of social regulation in 'so called' liberal democracies (Bourdieu and Passerson, 1970; Foucault, 1977; Walkerdinem, 1988). However, the resulting disjunction between disciplinary and pedagogic personas is perhaps more pronounced in art and design than in other school curriculum subjects. We identify the difference between the social and political roles of artist and teacher, as they are mythologised in the literature (hooks, 1994; Miliband, 2003) and the media (Burchill, 1997; Howells, 2002) as the primary catalyst for a training regime that destroys one persona to replace it with another.

Atkinson (2003) observes that in initial teacher education

> ... the Standards discourse constructs an ideal image of teaching which fails to embrace the idiosyncratic and fragile states of student teachers learning how to teach. When presented with the Standards inventory student teachers often pathologise themselves according to its demands. (p.197)

The ideological initiation that Dalton points to is interpreted by Atkinson as process in which the student is reconstituted as the voice of the art depart-ment, and therefore as part of the symbolic order of the institution. This act

of reconstitution, from artist to art teacher, is therefore experienced as a difficult, even traumatic process in which one identity is collapsed to make room for the other. Unfortunately, many artists find this teacher persona alien to their sense of self. What is the voice of the art department in the institution of schooling?

The values of art and design within the secondary school curriculum

Art and design has been a part of the curriculum in primary and secondary schools for over a hundred years and is thus an integral part of modernist, mass education. But it can be argued that mass education was first introduced for the purpose of social containment rather than personal advancement (Dewey, 1916). Schooling is a form of social engineering through which young people are inculcated into those values considered necessary to ensure conformist social behaviour in support of the state (Bourdieu and Passerson, 1970). Foucault (1977) defines the school as the pre-eminent site for discipline. Through schooling the ideal subject takes the form of the 'docile body', a way of being that in the collective ensures a governable population. Obedience is achieved through a mechanistic pedagogy in which learning and assessment are based on repetition and replication (Skinner, 1953). This process is regulated by examinations. It mirrors the factory production line and the etiquette of bureaucratic control, a process called 'social efficiency', but with the added weight of traditional moral authority rather than bald national and economic necessity (Kanpol, 1994: 6-8; Dalton, 2001). Stephen Ball (2001) suggests that since the 1980s, far from this model being overturned, it has become more entrenched. He insists that the primary concern of the government agencies responsible for education is the 'taming of the teacher', exposing the bureaucratic apparatus by which a once respected voice in the community is now being both silenced and de-centred:

> What is being achieved is the redistribution of significant voices. As always it is not just a matter of what is said but who is entitled to speak. The teacher is increasingly the absent presence in the discourses of education policy, an object rather than a subject of discourse. (p.12)

The rhetoric of art and design extols a set of values that appear antithetical to this vision of social efficiency. The mantras of the art teacher: creativity, imagination, autonomy, self-expression and so on, suggest that the art department is perceived as 'a kind of oasis', a part of the timetable where 'isolationist and territorial teachers' are free from the constraints of the tightly structured programmes imposed on other curriculum subjects (Tallack, 2000). Dalton too doubts that the alliance between progressive pedagogy and psychology implicit within these mantras has generated a developmental model based on individual growth. She claims that teachers and students do not 'see the

systems and structures to which they are subjected. They have become so successfully internalised and are so invisible, that teachers believe themselves to be acting spontaneously and freely choosing their own actions' (2001: 66).

Experiences of the artist/teacher PGCE

We have found that artist/teachers who join the course at the IoE are not necessarily in thrall to the progressive myth, nor are they willing to succumb to the instrumental models that are resurfacing in the name of vocational education. The following comment from a course essay indicates the difficulties artist/teachers face when navigating the gap between official imperatives and personal experience:

> I am not only [new to] this edifice of learning, but a foreigner, non-British, bilingual, dual citizen. This impurity always already at play, is not to be ignored (an impossibility) as an educator in English, in art and design, in a nation enlightened by the philosophy of the logos, that has its own logic, its own legitimation, its own law... The conflict of an ideology of education and the difficulty of thinking education today, is my task... The task today is to stop looking up or down, forth or back, but looking sideways, looking around, looking horizontally. (Toft, 2003)

The new artist/teacher PGCE is in many ways a hybrid model in which the relationship between artist and teacher is one of co-existence rather than substitution. This may be an uncomfortable relationship, and artist/teachers often experience an oscillation between roles. Nonetheless, this to-ing and fro-ing can lead to reciprocity between pedagogic and artistic practice that revisits the model of the teacher/practitioner promoted by the Gulbenkian Report and its disciples (Robinson, 1982; Taylor, 1986; Prentice, 1995). However, rather than the artist informing the teacher, the influence of one set of practices on the other may be experienced in reverse. As one artist/teacher notes: 'I'm just so much more able to communicate my ideas [and] organise and be an effective artist in lots of ways. It is very rarely looked at from that way round – it's usually: 'how can you be a better teacher by being an artist?'... I really notice it; I feel I have much stronger skills to go forward with my practice in the future' (Focus group, 2004).

By learning to become artist/teachers within the frameworks of both critical and reproductive pedagogies, the formation of the artist/teacher's identity is always multiple and dynamic rather than singular and static. This hybrid identity provides a space in which the relationship between the two roles is not one of loss or ethical gain but of potential, a space where the stereotype of unequal and antithetical partners can be questioned and tested. The artist/teacher Martina Geccelli (2003) used the metaphor of a bacterium to represent her potential role in education:

> The idea of the art bacteria came to me when I thought about what purpose art could still have. For example, it could help society to become aware of the different structures within its body. It could make people understand what is going on in a different way to the way the mass media might show it... I would like to act like a small, but effective, bacterium becoming part of an organism. My intervention doesn't need to be grand and risky. It needs to be thoughtfully inserted into a system which tends to control via chemicals rather than allowing the 'body' to be regulated by itself.

This metaphor posits a complementary difference as the basis for a healthy constitution. It is a metaphor that enables the artist/teacher to critique the parts of the curriculum that thrive on artificial supplements whilst simultaneously contributing to a partnership in which the well-being of the whole is the primary concern.

It is through a programme of judicious partnerships, of which the artist/teacher PGCE is just one, that any remaining resistance to a critical art education in secondary schooling can be gradually eroded. With this in mind, the course has been designed to draw on the strategies and tactics of a range of radical pedagogies, including critical and engaged pedagogy (Freire, 1990; hooks, 1994; Giroux and Shannon, 1997). Why are these radical traditions still important if progressive education is nothing but a myth?

Calls for a mythic unity

Recent calls for a return to mythic and ritualistic forms of art as the mainstay of art and design education can be seen to elide the historical changes that have rendered transparent the incommensurability of some differences (Burbules, 2000). For example, Cunliffe (2003) suggests that art and design education should give 'priority to connectivity (myth) over difference (parable) by drawing on meta-narratives overlooked by postmodern thought' (p.305). Such desire for unity at all costs has its dangers. In the twentieth century the wish to hide difference within a fictive unity manifested itself in extreme forms, such as the 'meta-narratives' of Herbert Read's Jungian symbolic order (1950) or the totalitarian aestheticisation of politics from both left and right (Ades et al, 1995; Taylor and van der Will, 1990). What we advocate is an education in which artist/teacher, art teachers and their students become aware of the histories of art and design through a critical engagement with their mythologies. However, it is not only the mythologies of art and artists that are of concern but the mythologies of teaching and the teacher.

The values of art within critical pedagogy

In Henry Giroux's interpretation of critical pedagogy students and teachers work together in a critical partnership (1992). Through this collaborative process they interrogate the way power is perpetuated by cultural institutions

(including schools) and examine their own positions and potential agency within those same institutional structures. The result is an interventionist and oppositional pedagogy situated in dialectical relationship to conventional forms. Learning is no longer relegated to the *acquisition* of 'objective' knowledges or skills but is *productive* 'of knowledge, identities, and desires' (p.166). Giroux suggests that radical educators:

> Must make an attempt to develop a *shared language* around the issue of pedagogy and struggle, develop a *set of relevancies* that can be recognised in each other's work, and articulate a *common political project* that addresses the relationship between pedagogical work and the reconstruction of *oppositional spheres*. Second, we need to form alliances around the issue of censorship both in and out of the schools. The question of *representation* is central to issues of pedagogy as a form of cultural politics and cultural politics as practice *related to the struggles of everyday life*. Third, we need to articulate these issues in a public manner, in which ... we're really addressing a *variety of cultural workers* and not simply a narrowly defined audience. This points to the need to broaden the definition of culture and political struggle and in doing so *invite others to participate* in both the purpose and practice central to such tasks. (p. 159)

If one purpose of critical pedagogy is to help students understand how they exist in the world and how they can come to inform and change that world, in what ways can the practice of art inform this process?

Friendly interventions

Aileen Glen, video artist, introduced a group of seventeen-year-old AVCE students from a specialist arts school to the work of video artists. Her intention was to highlight the difference between artists' video and commercially made television. In focusing students' attention on the role of television soaps and adverts as products designed to construct local and national identities, she encouraged them to 'become aware of the medium's false sense of intimacy' (Rush, 1999: 102). The students were invited to work collaboratively in their local communities to record the habits and rhythms of their daily lives. Aileen inducted students into the editing strategies of video artists and then asked them to edit their own footage with both artists' and commercial techniques in mind. Through this activity students were able to demonstrate their understanding of how media representations construct rather than mirror popular identities, and how subtle interventions rather than grand gestures can question or indeed undermine the tropes of popular culture. For her curriculum assignment Aileen juxtaposed and overlaid images of herself with sequences taken from *EastEnders*.

She said that through these interventions she wished to:

Figure 1

...draw attention to television as a site of instruction in how to behave, and also to question the dichotomy of viewer and subject... I attempt to bring an off-centred perspective to the emotionally charged scenes in *EastEnders*, creating new images that give insight into the processes involved in making the fictions so often seen as real. I believe it is vital to actively encourage young people to question these fictions and allow space for a dialogue where conventional media practices can be questioned. The deconstruction of these practices makes possible the re-making and re-thinking of dominant narratives in a less predictable and stereotypical way. (Glen 2002)

An alternative strategy is to deploy a relatively new technology such as film, to parody the craft based practices of traditional fine art. For example Martin Toft takes on the persona of the male painter in his video practice, and toys with some of the sacred mantras and procedures of modernist creativity. The main targets of his humour are the existential, but he also tackles the ritualised practices of the Abstract Expressionists, particularly as they are theorised in relation to Hans Namuth's filmed sequences of Jackson Pollock painting in 1950. By mimicking the artist 'moving at various speeds alongside the canvas, bending and straightening, stopping and stepping back, throwing in wide arcs or repeated small stitches of paint from the can' (Clark, 1999: 327), Martin parodies the idea that 'art is the externalisation of the internal feelings and mental contents of this distinctive type of personality – the artist – [and that] the primary object of art [is] the artist whose being is expressed in it' (Pollock, 1996:56). Martin films himself in the act of carrying out modernist procedures, but in the manner of the 'idiot of the bourgeois family' (Bourdieu, 1993: 165). When he 'takes a line for a walk' he abandons the graphic tools preferred by Paul Klee in favour of a roll of paper. Wandering through a rural landscape he literally takes the roll for a walk, unravelling it to form a line tracing his movements. (Figure 2)

Figure 2

He marks his journey with a medium that is more usually used as the 'ground' for holding the artist's improvised, graphic gestures and, perhaps unwittingly, references a well known television advertisement in which a puppy playfully unravels a roll of toilet tissue (no doubt readily referenced by pupils). By using this everyday 'stuff' he makes fun of the transcendental tenets of modernist processes, even suggesting that the free, graphic traces left by the artist are little more than everyday, bodily traces. The result is a cleverly crafted parody that mimics both the serious art documentary and the slapstick of early, modernist comics such as W. C. Fields, Charlie Chaplin and Buster Keaton.

For his final school placement, Martin involved students in an exploration of the possible relationship between parody and a 'national treasure', the work of John Constable. Constable was the son of a miller and landowner, and Michael Rosenthal (1987) argues that his landscapes represent an idyllic, rural vision of England in which the working classes contentedly rehearse the agrarian myths of antiquity as exemplified in Virgil's *Georgics* (AD197-204). As such Constable is seen to perpetuate a myth of unity favoured by the old landed classes. After introducing sixth form students to the ephemeral and temporal work of 1960s performance-related Land Art, Martin took them to one of Constable's favourite locations, the pond at Sandy Heath on the edge of Hampstead. There, he invited them to make spatial interventions into the site. One student used digital photography to document a series of interventions in which he changed the physical environment. He thus moved beyond the traditional roles of the landscape painter as topographer or the 'Romantic' artist who uses the landscape as a vehicle on which to project their feelings. Instead he engaged in a practice that acknowledges the artist as a bodily presence *in* the landscape and highlighted the shift in function from a site once associated with agrarian production to one of recreation and play.

Martin chose to locate his intervention in a formative and canonical sites of an English school. Hermione Allsop located hers in the British Museum, a canonical site for the construction of national identity. Under the banner of social inclusion, the government has recently identified galleries and museums as vital 'partners for the new learning society' – institutions capable not only of regional regeneration but also of building and uniting communities (Anderson, 1999; DCMS, 2001; 2001a). Hermione is more sceptical:

> The traditional, National museum, as a space, is not just a place to view art/ artefact it is a shop, a label, an identity, a package and a lifestyle; a place where myths of national identity are both culturally produced and consumed. (2003:11)

In her visual display for the end of course exhibition she presented examples of the 'official' confectionary sold as souvenirs by the British Museum (representing spectacular examples of Egyptian and Roman art) and juxtaposed

Figure 3

them with chocolate casts of fetishes and bones. In this work, she draws attention to the way artefacts are recontextualised and reconfigured through processes of display and popular modes of consumption, acknowledging that although the processes of commercial culture are transformative, they erase difference and elide the representational value of the artefacts as objects of history.

In her own work, *Chocolate Box Museum* 2002 (figure 3) Hermione had already played with the relationship between museum and commercial display by exhibiting a figurative sculpture in such a way as to suggest either an archaeological specimen or a department store 'confabulation'. The installation comprises a vitrine surrounded by white flowers in which a chocolate cast of a woman's body is laid out like a mummified corpse/giant cake. Here the female body is consumed, as it were, by a scopofilic public, a public that expects the artist to transgress social norms just as the museum transgresses the taboo in British culture against public display of corpses. If the contemporary artist presents her/ himself to be consumed as performance, the 'charismatic' art teacher is likewise there to perform, inviting a process of consumption that nourishes and sustains. In schools, however, the teacher's traditional role does not invite the transgression of social norms; their role is rather to exemplify and reproduce norms through their students.

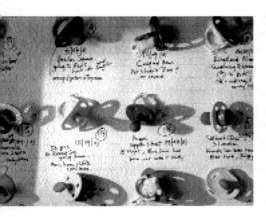

Artist/teacher Samantha Marsh has a personal passion for collecting everyday objects. Like Baudrillard (1968), she emphasises the passion and desire inherent in collecting, but does not pathologise the process. Sam maintains that 'everyone collects something; we live in a culture so obsessed by possessions that one has to consciously decide not to collect' (Marsh, 2002). Since 1992 she has collected used babies' dummies or pacifiers,

Figure 4

which she has found on the street, rescued, recorded, labelled and displayed as art (Figure 4). For her, these lost, discarded objects are imbued with Freudian connotations:

> Dummies can be seen as a substitute for the mother's breast; the collection illustrates a missing connection, a sentimental museum for the plastic relationships between mother and child. The objects exemplify loss, the emotional investment implicit in personal possessions, incomplete, misplaced, fallen from narration and never to be returned.

Sam's collections parody in order to challenge the more traditional approaches to classification (taxonomy) and curation employed by galleries and museums. She claims that as an artist she is aware of the role of the institution in the construction of meaning, and the ways in which juxtaposition, intertextuality and signage all influence the reading and reception of artefacts. But she still finds it 'difficult to connect with artefacts displayed in galleries and museums... where the atmosphere of the institution can be unnerving and alien'. Her work is inspired by – amongst others[1] – artist Susan Hiller who in response to Freud's own collecting habit, produced *After the Freud Museum* (1991-7), a series of boxed collections. Hiller asserted that her collection offered symbols and references to the outsiders who do not understand the way established collections are supposed to be objective, self-evident representations.

> The work I find most interesting is a very sophisticated play on accepted and recognised systems of representation, format and so on, with a desire to subvert, modify, change and, through this interplay, create a space, gap, hiatus, or absence in which something new can come into being. (Hiller, 2001: 367)

The collections housed in museums and galleries are significant cultural representations determined by people whose historical and social situations may be quite different from those of school students today. One role of the art teacher is to enable young people to investigate this difference. Sam argues that using young people's personal collections as a starting point to investigate meaning, value and context is more accessible than focusing exclusively on institutional collections. It is a way of 'looking sideways, looking around, looking horizontally'.

> Indeed, if there is a significant justification for personal collecting it is that the collector, in establishing a different order of things, removes authority away from such institutions and identifies a different system of value and meaning. (Marsh, 2002)

Sam believes that by locating the act of collecting within the domestic sphere young people can be encouraged to analyse and represent themselves as desiring subjects. This analysis can lead them to an understanding of their

motivations for collecting and can, in turn, be used as a basis for investigating institutional collectors. Through this process, galleries and museums can be understood as collections brought together to tell a story, one motivated by the interests and subject positions of the collector rather than being fragments of a fixed reality (Belk, 2001; Pearce, 1998; Cheek and Lavers, 1999). Young people's relationship to commercial culture and the mass media is not as passive as sometimes supposed; they use the products of these industries as resources from which to make meaning (McRobbie, 1999; Foster, 2002). Accordingly, it is important that art teachers acknowledge young people's personal investment in these products and resist taking up either the dismissive positions of the universalists (Fuller, 1983; Abbs, 1987; Cunliffe, 2003) or the oppositional positions of historical, critical theorists (Adorno and Horkheimer, 1999).

Conclusion

The artist/teacher PGCE presents an opportunity to consider the interface between school art and contemporary practice. The way artist/teachers on the course have managed to construct a hybrid identity encapsulating multiple roles suggests that the strong ideological initiation implicit in current models for teacher training does not inevitably have to dilute the critical practices of many contemporary artists. Art teachers need to recognise that the alternatives offered by the aesthetic practices of artists, craftspeople and designers today differ from traditional school art. Of particular importance is how they relate new technologies and theoretical positions to somatic and material practices that have deep historical and cultural significance. Traditional aesthetic practices should therefore be explored in dialogue with the digital and the virtual, a mainstay of popular global culture. Although aesthetic practices have been valorised in modernism, the artist has often had the role of critical agent within it. To forget this role in the rush for normative standards, examination success and increased status is to deny the history of modernism. And to fall prey to such collective amnesia is to deny what is most valuable about art in modern culture.

Note

1 Christine Borland, Christian Boltanski, Michael Landy, Tomoko Takashi and Sophie Calle.

References

Abbs, P. (ed.) (1987) *Living Powers: the arts and education*. London: Falmer

Ades, D., Benton, T., Elliott, D. and Boyd Whyte, I. (1995) *Art and Power: Europe under the dictators 1930-45*. London: Thames and Hudson in association with Hayward Gallery

Adorno, T. and Horkheimer, M. (1999) 'The Culture industry: Enlightenment as Mass Deception'. In: S. During (ed.) *The Cultural Studies Reader*. London: Routledge

Agamben, G. (1999) *The Man Without Content*. Stanford: Stanford University Press

Allsop, H. (2003) Unpublished PGCE assignment. London: IoE

Anderson, D. (1999) *A Common Wealth: Museums and Learning in the United Kingdom*. London: DCMS.

Ash, T. (Saturday June 5th 2004). The Janus Dilemma. *Guardian Review*

Atkinson, D. (2002) *Art in Education: Identity and Practice*. Dordrecht, Boston, London: Kluwer Academic Press

Atkinson, D. (2003) 'Forming teacher identities in initial teacher education'. In: N. Addison and L. Burgess (eds) *Issues in Art and Design Teaching*. London: Routledge

Avery, G. (1997) *Ghostly Matters: Haunting and the Sociological Imagination*, Minnesota: University of Minnesota Press

Ball, S. (2001) 'Better read: theorising the teacher!' In Dillon, J. and Maguire, M. (eds) *Becoming a Teacher: Issues in Secondary Teaching*. Buckingham/Phildelphia: Open University Press

Barrell, J. (1980) *The dark side of the landscape: the rural poor in English painting 1730-1840*. Cambridge: Cambridge University Press

Baudrillard, J. (1968) 'The System of Collecting'. In J. Elsner and R. Cardinal (eds) (1994) *The Cultures of Collecting*. London: Reaktion Books

Belk, R. (2001) *Collecting in a Consumer Society*. London: Routledge

Bernal, M. (1988) *Black Athena: The Afroasiatic Roots of Classical Civilisation*. London: Vintage

Bethel D. (ed.) (1989) *Education for Creative Living. Ideas and Proposals of Tsunesaburo Makiguchi*. Iowa: Iowa State University Press

Bhabha, H. (1994) *The Location of Culture*. London and New York: Routledge

Binch, N. (1994) 'The Implications of the National Curriculum Orders for Art', *Journal of Art and Design Education*, Vol. 13, No. 2 pp. 117-31

Boime, A. (1990) *The Art of Exclusion: Representing Blacks in the Nineteenth Century*. London: Thames and Hudson

Bolton, E. (1979) 'Education in a Multiracial Society' *Trends in Education*, No. 4, pp. 3-7

Boswell, D. and Evans J, (1999) *Representing the Nation: a Reader.* London: Routledge

Bourdieu, P. (1993) 'Field of Power, Literary Field and Habitus'. In *The Field of Cultural Reproduction.* Cambridge: Polity Press

Bourdieu, P. and Passeron, J-C. (1970) *Reproduction in Education, Society and Culture.* Trans R. Nice, London: Sage

Bourriaud, N. (1998) *Relational Aesthetics.* Dijon-Quetigny: Les Presses du Reel

Burbules, N. C. (2000) 'The Limits of Dialogue as a Critical Pedagogy'. In P. Trifonas (ed.) *Revolutionary Pedagogies.* New York, London: Routledge/Falmer

Burchill, J. (1997) 'Death of innocence' *Guardian G2,* 12 November

Burgess-Macey, C. (2003) 'School Mas' – Catching Them Young.' In Nindi P. (ed.) *On Route: the art of carnival.* London: Arts Council England, pp.21-28

Butler, J. (1996) *The Psychic Life of Power.* Stanford: Stanford University Press

Chalmers, G. (1996) *Celebrating Pluralism: Art Education and Cultural Diversity.* University of British Colombia: Getty

Cheek and Lavers (1999) *Things Not Worth Keeping.* Cambridge: Object Books

Clark, T. J. (1999) *Farewell to an Idea: Episodes in a History of Modernism.* New Haven, London: Yale University Press

Crane, S. (ed. 2000) *Museums and Memory.* Stanford: Stanford University Press

Csikszentmihalyi, M. and R. E. Robinson. (1990) *The Art of Seeing, an Interpretation of the Aesthetic Encounter.* California: The J. Paul Getty Trust Office of Publications

Cunliffe, L. (2003) 'Connectivity for Showing and Saying Across Differences in Art Educartion', *The International Journal of Art and Design Education,* 22 (3).

Dabydeen, D. (1987) *Hogarth's Blacks: Images of Blacks in Eighteenth Century English Art.* Manchester University Press

Dalton, P. (2001) *The Gendering of Art Education.* Buckingham: Open University Press.

Davison, P. (1998) *Negotiating the Past: the making of memory in South Africa.* Oxford Publishers

Desai, P. and Thomas, A, (1999) *Cultural Diversity: Attitudes of Ethnic Minority Populations Towards Museums and Galleries.* London: Museum and Galleries Commission (MGC) Report, BMRB International

DCMS (2001) *Culture and Creativity: The Next Ten Years.* London: DCMS.

DCMS (2001a) *Libraries, Museums, Galleries and Archives for All: Cooperating Across the Sectors to Tackle Social Problems.* London: DCMS

Dewey, J. (1916) *Democracy and Education.* (1999 edition) New York: Free Press

Doy, G. (2000) *Black Visual Culture: Modernity and Postmodernity,* London and New York: I.B. Tauris

Efland, A., Freedman, K., Stuhr, P. (1996) *Postmodern Art Education: An Approach to Curriculum.* Virginia: The National Art Education Association

Eisner, E. (1985) *The Educational Imagination.* New York: Macmillan

Falk, J. H. and Dierking, L. (1992) *The Museum Experience.* Washington: Whaleback Books

Fentress and Wickham, (1992) *Social Memory.* Oxford: Blackwell Publishers

Fineberg, J. (1997) *The Innocent Eye.* Princeton University Press

Focus Group (2004) audio recording of a discussion by artist/teachers of the Art and Design, Part Time PGCE. London: IoE

Foster, H. (1996) *The Return to the Real.* Cambridge: Massachusetts: MIT Press

Foster, H. (2002) *Design and Crime: and Other Diatribes.* London: Verso Press

Foucault, M. (1977) *Discipline and Punish.* Trans. A. Sheridan, New York: Vintage

Foucault, M. (1980) *Power/Knowledge.* Hemel Hempstead: Harvester Press

Fuller, P. (1983) 'The Necessity of Art Education' In *The Naked Artist.* London: Writers and Readers Publishing Cooperative

Freire, P. (1990) *Pedagogy of the Oppressed.* New York: Continuum

Freud, S. (1953-74) 'Mourning and Melancholia' *The Standard Edition of the Complete Psychological Works Of Sigmund Freud,* J. Strachey (ed.), London: Hogarth

Gadamer, H. G. (1981) *Truth and Method.* London: Sheed and Ward

Geccelli, M. (2003) Unpublished PGCE assignment. London: IoE

Gibson. J. (Oct. 2003) *Lambeth Youth Offending Team. Conversations with the author.* London: 198 Gallery

Gillborn, D. and C. Gipps, (1996) *Recent Research on the Achievements of Ethnic Minority Pupils.* London: Ofsted

Gilroy, P. (2000) *Between Camps: Nations, Cultures and the Allure of Race.* London: Penguin

Giroux, H. (1992) *Border Crossings: Cultural Workers and the Politics of Education.* London: Routledge

Giroux, H. and Shannon, P. (1997) *Education and Cultural Studies: Towards a performative practice.* London: Routledge

Glen, A. (2002) Unpublished PGCE assignment. London: IoE

Golding, V. (1997) 'Meaning and truth in multicultural museum education'. In E. Hooper-Greenhill (ed.), *Cultural Diversity. Developing Museum Audiences in Britain.* Leicester: Leicester University Press

Golding, V. (2000) New Voices and Visibilities at the Museum Frontiers. Unpublished PhD thesis, University of Leicester

Golding, V. (2004a) 'A field-site of creative collaboration: Inspiration Africa!' In the *Journal of Museum Ethnography* 16: 19-36

Golding, V. (2004b) forthcoming, 'Carnival Connections: challenging racism as the unsaid at the museum/school frontiers with feminist-hermeneutics.' In J. Anin-Addo (ed) *Swinging Her Breasts at History.* London: Whiting and Birch

Gordon, A. (1997) *Ghostly Matters: Haunting and the Sociological Imagination.* Minnesota: University of Minnesota

Hall, S. (1980) 'Teaching Race.' *Multiracial Education,* 9 (1), p.3-13

Hall, S. (1989) 'New Ethnicities'. In Mercer, K. (ed.) *ICA Documents 7: Black Film, British Cinema.* London: ICA

Hall, S. (1997) 'Cultural Identity and Diaspora'. In K. Woodward (ed.), *Identity and Difference.* London: Sage

Hardy, T. (2002) 'AS Level Art: Farewell to the 'Wow' Factor,' *Journal of Art and Design Education,* 21, 1. pp.52-59

Hill-Collins, P. (1991) *Black Feminist Thought: Knowledge, consciousness and the politics of empowerment,* London: Routledge

Hiller, S. (2001) 'Anthropology into Art'. In: H. Robinson (ed.) *Feminism Art Theory.* Oxford: Blackwell

hooks, b. (1992) *Black Looks, Race and Representation.* Boston: South End Press

hooks, b. (1994) *Teaching to Transgress.* New York; London: Routledge

Hooper-Greenhill, E. (1994) *Museum and Gallery Education*, Leicester: Leicester University Press

Howells, K. (2002) quoted in Howells of Protest: Minister talks Turkey over the Turner Prize The *Guardian* p.2 1 November 2002

Hughes, A. (1998) 'Reconceptualising the art curriculum', *Journal of Art and Design Education.* 17 (1). Oxford: Blackwell

John, G. (2003) *Towards a Vision of Excellence. London Schools and the Black Child Conference, 2002 Conference Report.* London: Greater London Authority

Kanpol, B. (1994) *Critical Pedagogy: An introduction.* Westport, Conn.; London: Bergin and Garvey

Kingston, M. H. (1981) *The Woman Warrior.* London: Picador

Knight. F.W. (1990) *Caribbean Book: The Genesis of a Fragmented Nationalism.* Oxford: Oxford University Press

Lewis-Williams., D. (2002) *The Mind in the Cave.* London: Thames and Hudson

Loeb, H. (ed.) (1987) *Changing Traditions 11.* Department of Art, Birmingham Polytechnic

Loeb, H. *et al* (1987) *Changing Traditions: Exhibition and Conference Catalogue,* Department of Art, Birmingham Polytechnic

London Borough of Lambeth (2000) *Challenging racism and promoting race equality: guidance to schools,* Lambeth

Mason, R. (1995) *Art Education and Multiculturalism.* NSEAD Wiltshire

Marsh, S. (2002) Unpublished PGCE assignment. London: IoE

Macleod Brudenell's, I. (1986) *Cross-Cultural Art Booklets.* Nottingham: Nottingham Educational Supplies

Mckenzie, A. and Pike, G. (eds) (1984) *Art in Action: Music, Drama, Visual Art.* York: World Studies Teacher Training Centre University of York

Macpherson, W. *et al* (1999) *The Stephen Lawrence Inquiry.* London: The Stationery Office

McRobbie, A. (1999) *In a Culture Society: Art, Fashion and Popular Music.* London: Routledge

Miles, M. and M. Huberman, (1994) *Qualitative Data Analysis, An Expanded Sourcebook.* London: Sage

Miliband, D. (2003) Vocational Education: Quality and Status. Speech at the Annual Conference of the Association of Colleges, Cambridge 18 June 2003

Mintz and Price, (1976) *The Birth of African American Culture: An Anthropological Perspective.* Boston: Boston Press

Morrison, T. (1988) *Beloved.* London: Picador

Oxlade, R. (2001) 'Good Drawing or Real Draughtsmanship.' *Blunt Edge.* Issue 1. The Peter Fuller Memorial Foundation

Pascall, D. (1992) The Cultural Dimension in Education. Paper given at the Royal Society of Arts, London, November 1992

Pearce, S. (1998) *Collecting in Contemporary Practice.* London: Sage

Philip, M. Nourbese (1992) *Frontiers. Essays and Writings on Racism and Culture.* Ontario: The Mercury Press

Phillips, M. (1996) *All Must Have Prizes.* London: Little, Brown.

Pohlandt-McCormick, H. (2000) 'Violence and the Construction of Memory,' History and Theory Studies in the Philosophy of History. *Theme* Issue 39, Wesleyan University

Pollock, G. (1996) 'Art, Artists and Women'. In L. Dawtrey *et al* (eds) *Critical Studies and Modern Art.* Milton Keynes: Open University Press

Prentice, R. (1995) *Teaching Art and Design: addressing issues and identifying directions.* London: Cassell

Rabinow, P. (1989) 'Representations are Social Facts: Modernity and Post-Modernity in Anthropology'. In Clifford, J. and G. E. Marcus, [eds.] (1989), *Writing Culture. The Poetics and Politics of Ethnography.* California: University of California Press

Rampton, A. (1981) *West Indian Children in Our Schools*: Interim Report of the Committee of Inquiry into the Education of Children from Ethnic Minority Groups, HMSO 1981

Read, H. (1950) *Education for Peace.* London: Routledge and Kegan Paul

Roberts, L. C. (1997) *From Knowledge to Narrative, Educators and the Changing Museum.* Washington: Smithsonian Institution Press

Robinson, K. (ed.) (1982) *The Arts in Schools.* London: Calouste Gulbenkian Foundation

Rosenthal, M. (1987) *Constable.* London: Thames and Hudson

Rush, M. (1999) *Video Art.* London: Thames and Hudson

Sandell, R. (2002) (ed) *Museums, Society, Inequality,* Routledge, London

Sarup, M. (1996) *Identity, Culture and the Postmodern World.* Edinburgh University Press

Scarman (1981) *The Brixton Disorders: the Scarman Report.* London: HMSO

Searle, C. (2001) *An Exclusive Education: Race, Class and Exclusion in British Schools.* London: Lawrence and Wishart

Siraj-Blatchford, (1994) *The Early Years. Laying the foundations for racial equality.* Stoke on Trent: Trentham

Skinner, B. (1953) *Science and Human Behaviour.* New York: Macmillan

Slight P. (1987) 'Insiders, Outsiders, and Cultural Mobility'. In *Changing Traditions 11.* Birmingham Polytechnic

Solani, N. (2000) Memory and Representation: Robben Island Museum 1997-1999. MA Thesis

Souness, D. (2003) *What Age Can You Start being An Artist?* West Highland Museum, p.32

Steers, J. (2003) 'Art and Design'. In J. White (ed.) *Rethinking the School Curriculum: Values, Aims and Purposes.* London: Routledge/Falmer

Steers, J. (2003a) 'Art and design in the UK: the theory gap'. In: N. Addison and L. Burgess (eds) *Issues in Art and Design Teaching.* London: RoutledgeFalmer

Straayer, C. (1985) I Say I Am: Feminist Performance Video in the '70s. *Afterimage,* p.8-12

Swann, M (1985) *Education for All: The Report of the Committee of Inquiry into the Education of Children from Ethnic Minority Groups.* London: HMSO

Tallack, M (2000) 'Critical Studies: Values at the Heart of Art Education', in R. Hickman, *Art Education 11-18: Meaning, Purpose and Direction.* London: Continuum

Tawadros, G. (1994) 'Working Drawings,' in *These Colours Run,* E. Chambers, Wrexham Library Arts Centre, exhibition catalogue, p.20-28

Taylor, B. and van der Will, W. (1990) *The Nazification of Art: Art, design, music, architecture and film in the Third Reich.* Winchester: The Winchester Press

Taylor, R. (1986) *Educating for Art.* Burnt Mill: Longman.

Toft, M. (2003) Unpublished PGCE assignment. London: IoE.

Tomlinson, S. (1990) *Multicultural Education in White Schools.* London: Batsford

Trinh T. M-ha. (1991) *When the Moon Waxes Red.* London: Routledge

Trouillot, M.R. (1993) *Silencing the Past*. Boston: Beacon Press

Walkerdine, (1988) *The Mastery of Reason: Cognitive Development and the Production of Rationality*. London: Routledge

Williams K. (2003) Urban Vision Project Manager. Conversations with the author. London: 198 Gallery

Young, J. (1995) *The Texture of Memory*. Yale University Press

Zizek, S. (1989) *The Sublime Object of Ideology*. London: Verso

INDEX